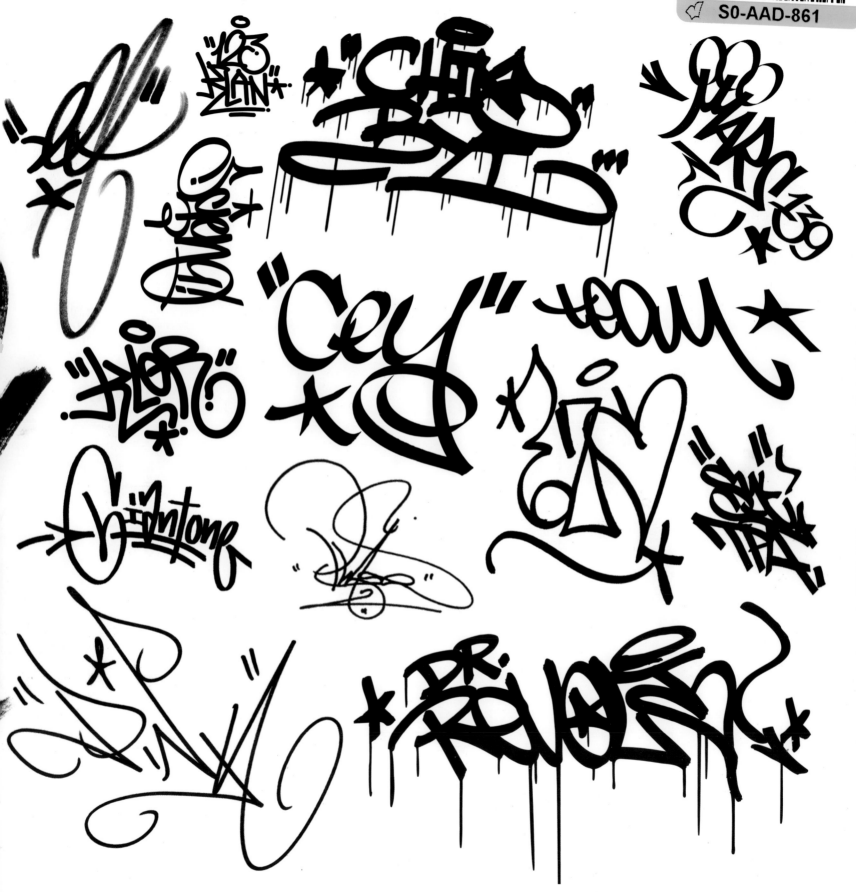

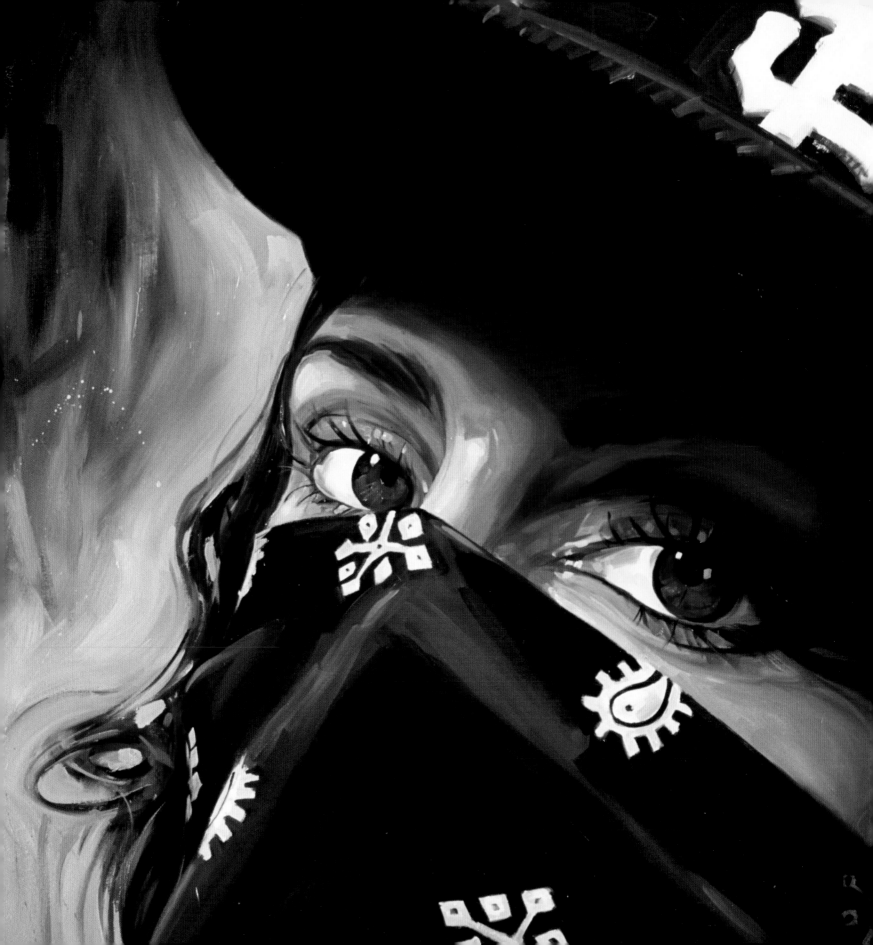

DEFINITION

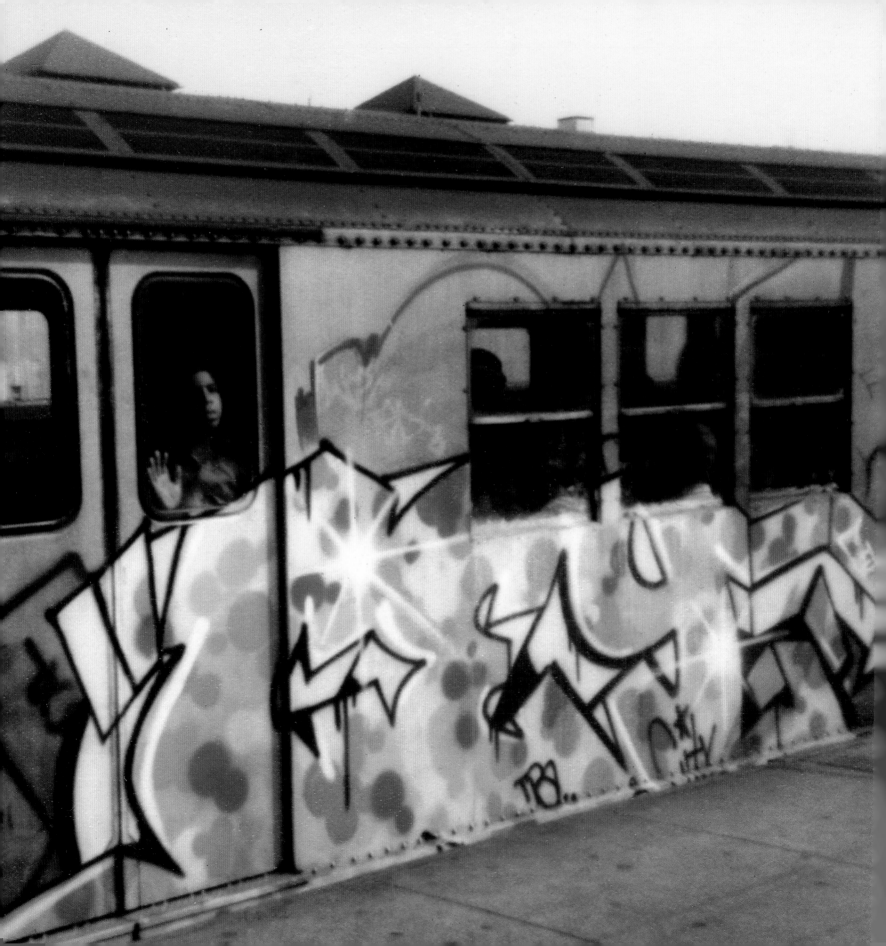

DEFINITION

THE ART AND DESIGN OF HIP-HOP

CEY ADAMS WITH BILL ADLER
FOREWORD BY RUSSELL SIMMONS

COLLINS DESIGN

An Imprint of HarperCollinsPublishers

To the memory of Dave Scilken, who always made me laugh.

SUNNY BAK
Dave Scilken, 1987

CONTENTS

Page 2:
ERIC BAILEY
Bright Eyes, 2005,
Oil on canvas,
56 x 49 inches

Page 4:
CEY ADAMS
Cey City, 1981,
Spray paint on subway car

FOREWORD

When I was a young man, *The Cosby Show* was one of the few depictions of African-American life on television. I always thought it was a great show, but there was so much about my life and the lives of my family and friends that it left out. In contrast, working with rappers was very satisfying to me because I knew that the average African-American was more like LL Cool J than Dr. Huxtable. The amazing and beautiful thing is that the specific reality of working-class black lives—as expressed in the stories told by these young hip-hoppers—has always been universally and eternally appealing. We all understand where 50 Cent comes from. We don't know where the hell *Father Knows Best* comes from.

In fact, from the start, hip-hop culture has been inspiring to all sorts of people and all sorts of media. But when hip-hop meets business, often-times the business people and their designers—none of whom are deeply familiar with the culture—get it wrong. And if you get it wrong, you will never win over the young people who really live the culture. Hip-hop is about honesty and if you're fake, you lose.

But I love hip-hop and I want every-one, including the business people, to get it right. And I also want the people who create the culture to acquire some equity in the businesses that profit from their creativity. So over the years I've become involved in all sorts of businesses as a way of helping these industries to keep it real. And in the process it's been my privilege to usher in a lot of creative people who are from the culture into these business environments, which benefits everybody.

My old friend Cey Adams has been a key creative player in hip-hop from the very beginning and he's still active and relevant today. Cey and Steve Carr, his partner at the Drawing Board, were responsible for the image of Def Jam for fifteen years and for a great part of hip-hop culture in general. He's always had a knack for knowing what's next and there's nothing more hip-hop than that.

JOHNNY NUÑEZ
Russell Simmons in Dubai, 2007

INTRODUCTION

BILL ADLER

At its birth, hip-hop culture was an uptown and outer-borough phenomenon. Indeed, this isolation was a prime source of its strength. Out of sight and mind of the official culture's gatekeepers in glittering midtown Manhattan, the young people of the Bronx, Brooklyn, and Harlem invented a panoply of arts out of nothing more than the meager materials they had at hand and their own creativity. When New York City cut the public schools' arts budget in the mid-1970s, those kids who were musically inclined transformed their parents' turntables and old records into instruments—and themselves into one-man bands. Wannabe dancers turned to the streets, transforming a flattened-out piece of cardboard into a stage on which to showcase a new vocabulary of athletic and competitive dance moves. Aspiring painters reached for aerosol cans and transformed city walls and subway trains into their canvases. Would-be performing artists chose not to sing but to rap, putting a sparse beat beneath their lyrics. In more rarefied quarters, this form of expression was called "performance poetry."

The partisans of these new art forms—deejaying, emceeing (or rapping), b-boying (or break dancing), and writing (or graffiti)—were aware of what the kids devoted to the other disciplines were doing. But it was Afrika Bambaataa, the great visionary deejay of the South Bronx, who first understood that all of this creative energy was emanating from one community—New York City's young people of color—and that it comprised a collective culture of its own. By the end of the 1970s, he had dubbed this culture *hip-hop.*

Although the kids themselves undertook these activities strictly for fun, the city's authorities viewed them with suspicion and hostility from the beginning. Graffiti, considered vandalism, was outlawed by the city. Break dancing contests were sometimes misconstrued as gang fights by the police, and the dancers arrested. Deejays and emcees rocked parties all night long, but none of them knew anything about the music business or about how to make records, while the rare music biz pro who did encounter the new music tended to dismiss it as noise. Consequently, the first rap records didn't appear until some five years after the first rappers hit the scene.

In truth, much of this new hip-hop culture *was* alien and rough-edged. True to its outer-borough origins, it could seem literally outlandish. But then a veteran producer named Sylvia Robinson cut a song called "Rapper's Delight" with a group she assembled and dubbed the Sug-arhill Gang. Released in the fall of 1979, "Rapper's Delight" was to hip-hop what Bill Haley's "Rock Around the Clock" was to rock 'n' roll—the shot heard 'round the world. The record not only climbed to number four on the Hot R&B Singles charts in America, it went to number one on the pop charts in Canada and Holland, to number three in England, to number four in West Germany, and charted in South Africa and Israel as well.

This amazing success opened the doors for hip-hop artists in every medium. In New York, a small crew of young artists and promoters began to book hip-hop's emcees, deejays, writers, and break dancing b-boys into Manhattan's downtown nightclubs, which in turn alerted influential adults and media companies that something exciting was afoot. By 1980, the writers were showing their work in downtown art galleries. In April 1981, New York's *Village Voice* splashed a photo on its cover of Frosty Freeze of the Rock Steady Crew, a pioneering group of b-boys, inspiring a spate of Hollywood films about break dancing and generating international tours for some of the hottest crews. Charlie Ahearn's *Wild Style*, an independent film focusing on all the new culture, earned wide acclaim upon its release in 1983. In December 1984, a *Wall Street Journal* profile about a young rap artist manager named Russell Simmons convinced the Warner Bros. film studio to shoot and release Michael Schultz's *Krush Groove* by the following spring. In short, whatever reservations the police may have harbored about hip-hop, young people everywhere seemed to love it.

And why not? Unlike punk rock, its subcultural contemporary, hip-hop was not animated by anger, nor was it anti-fashion. Hip-hop was friendly and party oriented and liked to dress up. Afrika Bambaataa has always declared that the Zulu Nation—the nation that comes together whenever and wherever in the world Bambaataa is deejaying a party—is dedicated to peace, love, harmony, and having fun.

A pure soul, Bambaataa neglected to add "making money" to that list. Most hip-hoppers have always liked money as much as they like peace, love, et cetera, reasoning that if some-damn-body is going to make money selling hip-hop, why shouldn't the hip-hopper himself get a slice of the pie? This money-minded practicality—and the recognition of the mutual interest between hip-hop and business—long ago accomplished the crossover success of hip-hop. Hip-hop's most talented figures have been getting

HIP-HOP FROM THE JUMP: PEACE, LOVE, UNITY, HAVING FUN . . . AND MAKING MONEY

into bed with America's blue-chip brands for years. Def Jam was independently distributed for exactly one calendar year before they signed on with CBS—then the largest record company in the world—in a deal that ran from 1985 through 1994. Spike Lee made *Do the Right Thing* for Universal Studios in 1989. Fox Broadcasting Network carried *In Living Color* from 1990 to 1994. *Vibe* magazine was brought into existence by Time Warner in 1993. Foxy Brown endorsed Calvin Klein jeans in 1999. Charles Stone III created his "Whassup?" television ad for Budweiser in 1999. Today, who's surprised to learn that Funkmaster Flex has designed a signature model SUV for the Ford Motor Company or that Jay-Z endorses Hewlett-Packard computers?

But this begs the question: What makes hip-hop so sexy to the mainstream? The two-word answer is authenticity and creativity. As early as 1996, *American Demographics* magazine declared that "core hip-hoppers display an almost fanatical obsession with authenticity. Sanitizing any element of hip-hop culture to make it more palatable for middle-class suburban whites is likely to result in failure, because the core hip-hop audience will reject it. And other groups look to this core for their cues." In other words, hip-hop is prized for its honesty and integrity, a message that hip-hop mogul Russell Simmons has always maintained.

This authenticity goes hand in hand with a creativity so potent that it's sometimes hard to credit. Alex Kuczynski, writing for the *New York Times* in the spring of 2006, asserted it was "Nike [that] transformed sportswear into a lifestyle, [turning] sneakers into status symbols" during the 1980s. Close but no cigar. It was *hip-hop* that turned sneakers into status symbols; Nike was merely the beneficiary. Nike's Air Force One was an athletic shoe that didn't sell until Jay-Z started wearing a pair in all of his videos. All of a sudden, the shoe became a smash hit. No one understands this phenomenon more clearly than the writer, actor, and hip-hop bon vivant Bonz Malone. Interviewed for a 2006 documentary entitled *Just for Kicks*, Malone said, "The Air Force One is a planet unto itself, but hip-hop runs that planet. How else do you think Nike grossed $26 billion this year? There ain't that many joggers in the world."

Which brings us to this book. *DEFinition: The Art and Design of Hip-Hop* is devoted to exploring the visual impact of hip-hop on culture and to the visual artists who helped shape its influence. As Cey Adams maintains, hip-hop has been every bit as important to the visual world as it has been to the music world. Self-identified hip-hoppers have had significant success in virtually every aspect of the visual media. The sum of their work has changed the way the world looks. This book is an attempt to see the world anew, through a hip-hop lens, and identify these changes. To see it, in effect, as Adams sees it. (Although Adams did not write this book, he is its author, as his vision guided its content and his perspective shaped much of its words. He was extensively interviewed on every subject.)

The longtime creative director at Def Jam, Adams is legendary for his generosity to other artists and his appreciation of their work. Like the rapper and car collector Busta Rhymes, Adams asserts that there is a core hip-hop sensibility uniting the creative expressions of rappers, car customizers, fashion designers, moviemakers, fine artists, and graphic designers. The art world may have long ago certified Keith Haring and Jean-Michel Basquiat as two of their own, but it's been slower to embrace the hip-hop-dipped fine artists who have emerged in the last twenty-five years. Not Adams, who is delighted to show work by the likes of Cbabi Bayoc, Cycle, Mike Thompson, Muck, and Nika Sarabi. The world of fashion, more liberal than the art world, now gladly counts Sean "Diddy" Combs, Kimora Lee, and Jay-Z as certified members of their club. But Adams, like the Jimmy Castor Bunch, needs to take us back, *way* back, to the thoughtful and stylish gear worn by writers in the 1970s and to the days of early fashion icons, including the rapper Slick Rick and the designer Dapper Dan, hip-hop's first couturier to the stars. Like the critic Armond White, Adams sees that unmistakable hip-hop energy in the movies of Spike Lee, the music videos of Hype Williams, and in a thousand television commercials. If it seems unlikely that both the painter Kehinde Wiley and, say, the custom sneaker designer Chef of GourmetKickz take their inspiration from the same source, well, we invite you to read what the creators themselves have to say.

At a bare minimum, today's self-styled visual artists, for all of their diversity, seem to share an affection for graffiti and the rap records of their youth, and an identification with the movement that comes together in the name of peace, love, unity, and having fun.

— New York City, November 2007

LAURA LEVINE
Afrika Bambaataa, 1983

Right:
MARTHA COOPER
Cey Painting at Graffiti Above Ground, 1981

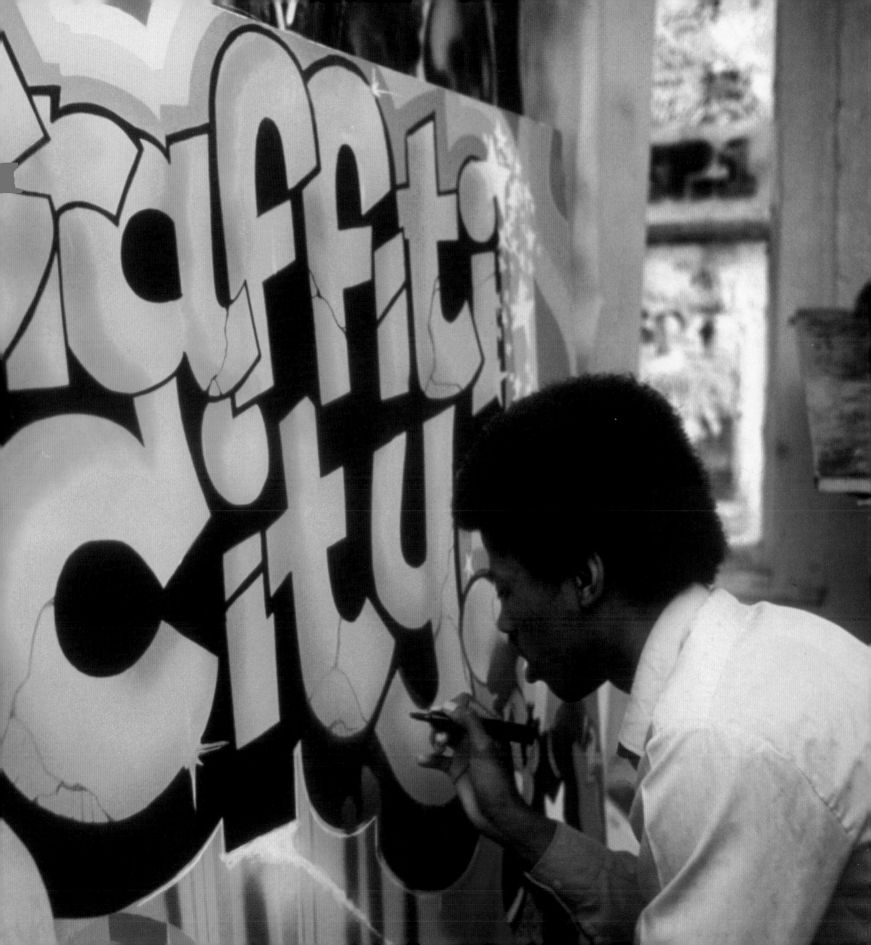

GETTING UP HIP-HOP & STREET ART GETTING OVER TOGETHER

BY SACHA JENKINS & FRANKLIN SIRMANS

MIKE THOMPSON
2PAC, 2005,
DIGITAL PAINTING, COREL PAINTER,
14 x 14 INCHES

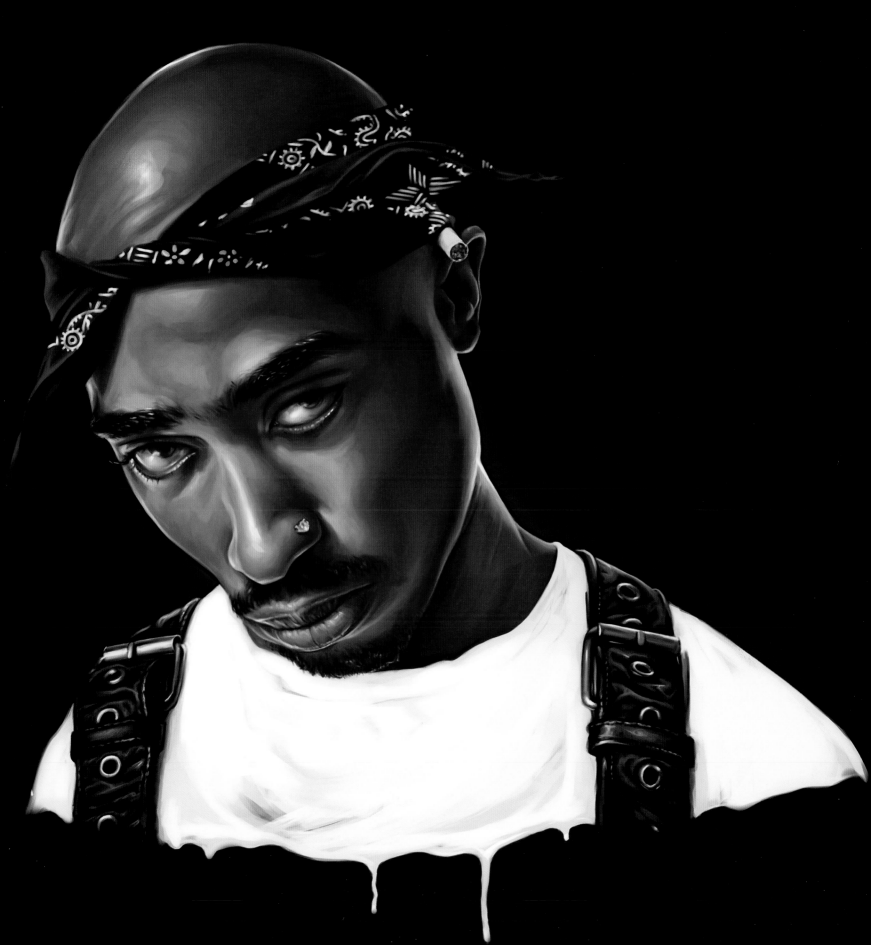

FDT56
Spray paint on wall,
Brooklyn, 2007

PART ONE:
NEW YORK UNDERGROUND,
1969 TO 1980
SACHA JENKINS

The 1969 New York Metropolitans were outta sight, man, oh, man! Up until that season, the Mets were well-established losers, with fans mostly consisting of heart-broken former Brooklyn Dodger fans. (The Dodgers had broken for Los Angeles during the 1958 season.) Shea Stadium, the Mets' home in Flushing, Queens, didn't have the same kind of cultural legacy that the Bronx's Yankee Stadium did. If the Yankees were Coca-Cola, then the Mets were Royal Crown.

The season had started out fecal; the team's batting was a mess. Flushing was an all too appropriate name for the Mets' home base. Fortunately, the Mets did have a great pitching staff (word to Tom Seaver)—their ability to throw it down helped them win the National League Championship. By season's end, they wound up winning the World Series over the seemingly superior Baltimore Orioles.

In 1969, the kids who ran the streets of New York had great pitching arms, too, only they were throwing their names up on walls around their respective neighborhoods. They called this new sport *writing*: adults called it graffiti. While their older brothers were fighting in Vietnam, these kids watched as man landed on the moon, and listened to bands like Sly & the Family Stone and Led Zeppelin. The political climate was rife with war, civil rights, Puerto Rican liberation, the women's movement, and sexual liberation.

Gangs—like the Black Spades, the Savage Skulls, the Savage Nomads, the 7 Immortals, and the Ghetto Brothers—were in full effect in the so-called inner city. Members marked their turf with housepaint and paintbrush. The idea, they said, was to protect the neighborhood from outsiders. The painting meant: *This is ours and if you're not one of us, then all of us will bust yo ass, bro.* While gang members tended not to stray from their turf's borders, writers had no boundaries; their turf was everywhere.

Writers were the loudest quiet cats you'd ever meet. Quiet in the sense that they were working without microphones. Loud in the sense that they wanted their monikers to have the same brand-name recognition—or volume—that Coca-Cola did. Kids got into graf writing for different reasons. Some felt beat down by the system and sought release through writing. Others were bored vagabonds with itchy spray-trigger fingers. Regardless of how they came to the art, it was a conscious conceit for these kids to get their names up in as many places as possible. This was what really mattered. This was where their heads were really at.

As individualistic as they were, the writers also had crews—a handful of guys and gals whose primary focus was graf writing and petty crime, like stealing spray paint. They quietly roamed into various gang territories without much fear; local gang members felt no threat from writers

who blew in like the wind and left behind colorful bombs that hurt no one. (The writers thought of their work as *bombs* because once you got your name up, you made serious impact, created maximum damage. Dominated. Bombed.)

The Brooklyn-founded Ex Vandals are an early example of a writing crew that moved like tumbleweed 'round the city. At one time, their ranks included FDT56, the senior artist in this book. Born Frank Del Toro in the South Bronx to a Cuban father and a Puerto Rican mother, he started bombing trains in 1971 and helped revolutionize the graf writing movement. In addition to being a member of the Ex Vandals, Del Toro was in half a dozen other writing crews, including the 56 Boys. Along with Tracy 168 and Phase 2, he made writing more elaborate, helping to develop it as an art form. His younger brother, Ronnie, a.k.a. Kid 56, went on to achieve fame as one of the most prolific bombers of the late 1970s. His work could be seen on the IRT, BMT, and IND subway lines.

Some writers went by their real names. Julio 204, for example, was a kid named Julio who lived in Harlem on 204th Street. Others writers took aliases that spoke to the times. Apollo 5 named himself in tribute to the spacecraft that went to the moon. King 2 wanted to walk in Dr. Martin Luther King, Jr.'s footsteps. The aliases also came from family nicknames (Taki 183, for example. Taki being

FDT56
The 56 family in front of 156 Grand Concourse, 1975, Bronx, New York

Left to right: Carmen (FDT's sister), Lefty (Clyde56's brother, behind Carmen), Yvonne53, Diana53, Michael (YAZ56's little brother), YAZ56 (on bike), and FDT56 (on top of truck)

FDT56
Franky the Love Bug, 1975, Yvonne53 and FDT56, Van Cortlandt Park, Bronx, New York

KID56
Kid56, 2007,
Spray paint on wall,
Graffiti Hall of Fame, Harlem, USA

shorthand for the Greek name Demetrius), cleaning agents (Ajax and Comet), and spins on superherodom (Super Kool 223, App Super Hog, and Super Strut). Circa 1969, the writers' signatures were simple enough to read. This was several years before the writer Tracy 168 invented *wild style*, a letter form so ornate that it takes a trained eye to decipher the signature. A Philadelphia writer known as Corn Bread understood the need for clarity and simplicity early on; he wrote signatures that average people could read. He and his partner, Cool Earl, helped start a serious writing scene that predated New York's by some years. The more acclaim he received, the more hardcore his get-up missions became. He acquired international fame when he hit the Jackson 5's private plane.

A funny thing happened on the New York City subway trains in 1971. Writers realized that trains were canvases. Kids figured out that they could write their name on the inside of a train in the Bronx and that same signature would then travel to Brooklyn (and through Manhattan) several times during the course of a day. Instead of having to wander into a strange neighborhood to flex their handiwork, their art could be seen by more people than ever before. Not only that, but their audience expanded to include regular working Joes, tax payers, strap hangers, and *abuelitas*.

Soon the writing crews were like baseball teams and kids all over the city were competing to see who would win the World Series of Bombing on their native transit lines. Writers would either get up over the advertisements that were posted inside the cars or tear them down completely and reclaim the "pay-to-play" advertising spots for themselves. These advertising spots were *prime time*, baby. While these writers hadn't gone to school for marketing, sales, or advertising, they clearly understood that the mighty dollar was behind the most desirable eye space. Big money equaled big ad space. (Not that that stopped them from writing on the ceiling, too.)

By 1972, signatures got more and more elaborate. Writers were starting to favor a flavor and taste that only the writers themselves could truly understand and appreciate.

Signatures included elaborate drawings of arrows and stars that aligned like the moon and stars. Letters took on new shapes and swirls. The letters grew bigger, bolder, more colorful, more technical, and more abstract. Writers copied the work of others and added on, creating an evolutionary game of hot potato that ended with a select few setting the standard for any given phase of a particular style. Writers refocused their sense of marketing dollars—time spent getting up = money earned—on solely appealing to fans who belonged to the subculture. General fame was cool, but respect from writing peers became more prized. Writing was an act of rebellion, something kids did knowing that it was against the law; it was an act punishable by the authorities and parents, at least among kids who had parents. The fact that it was bad is what made it so good in the minds of these young explorers.

The writing got so competitive that it touched off "style wars." The first "shots" were fired because there was no more room left on the subway lines; nearly every inch of train car was covered with signatures. There was one rule of engagement in these battles: Bigger fish could consume smaller fish. As the letters evolved and grew like steroid-riddled ivy on the sides of the subways, a bubble-lettered, two-color, two-dimensional form held more weight than a stylized one-dimensional *tag* (signature). Showdowns occurred over who was the biggest writer. Mental scorecards kept track of who went from having a bubbleish piece one-eighth the size of a train car to having one name that engulfed an entire side, windows and all. But as the art evolved and the writers themselves started to apply aesthetic value to their masterpieces, bigger no longer constituted better. "Art" still wasn't necessarily a part of the conversation at this point. These kids were simply writers who wrote a bunch of stuff on a bunch of different surfaces—with style.

By 1973, writers began to expect more. Unless drips were intended, drips were considered a no-no. Drips were for *toys* (inexperienced writers). Paint control was a valued skill acquired by masters, the ones who put in hours of work, stole the paint, and got

dirty in the train yards and tunnels—the dedicated. Two writing schools emerged. School A embraced the master writer who mainly painted *pieces*. (A shortened form of *masterpiece*, pieces were ambitious, detailed, multicolored works featuring characters, scenery, and words or phrases. If a piece was painted on a train, rather than a wall, it often covered a whole car.) School B embraced the hardcore bomber—the individuals who focused on tagging the inside of subway cars and doing throw ups on the outside of trains. (In contrast to pieces, throw ups were relatively quick and sketchy works. The formula, according to Cey Adams, was "simple fill-in, simple outline.") The master writers were more concerned with quality whereas the bombers placed more value on quantity. Still, the schools coexisted and shared mutual respect for one another. The ultimate graf king had a master's degree from both the piecing and bombing institutes.

Newly invented tools of the trade helped further instigate the expansion of the writing culture. Homemade magic markers were created with the felt from blackboard erasers, emptied-out roll-on bottles, and the purple ink used in supermarkets to stamp prices. The stock caps on Wet Look and Red Devil spray paint cans were replaced by the stock caps on Jiffoam oven cleaner cans. These *fat caps* dramatically increased the paint coverage. Masterpiece books—black-covered sketchbooks filled with drawings—were also very important. These books were passed from high school to high school and borough to borough. Inside these pages, writers witnessed firsthand the styles that were specific to crews and individuals. The drawings in these books were also used directly as references for the work that leapt onto the trains. Writers were no longer spontaneous vandals. Instead, they were becoming hip to the fact that what they were doing had a meaning greater than the me, me, me message that writing your name over and over and over conveyed.

Jack Stewart, the first nonwriter to seriously document the movement via photographs and critical writing, suggests that every year represented a full generation of new blood, and that by 1978, every technical innovation had been executed by the mad bombers. That the art experienced such rapid growth is a stunning assertion, but one that's not too far from being

true. By 1978, it had all been done: Whole trains were painted with bubbly cartoon characters, their interiors covered with drippy tags, and their exteriors decorated with thousands of throw ups. The graf alphabet expanded to include amazing three-dimensional letters that pierced neighboring letters. Now many generations in the making, the writing game had become a city-wide recognized sport, with legendary teams like the Crazy 5, the IND's, the Ebony Dukes, Wanted, Fabulous 5, and the Death Squad all leaving their indelible mark on the transit system.

Within a couple of years, writers like Lee Quiñones, Fab 5 Freddy, Lady Pink, Zephyr, Dondi, Daze, Futura 2000, Sharp, Crash, Cey, Blade, Revolt, Noc 167, A-One, Toxic, Rammellzee, Mare 139, Kel 1st, Erni, Caine 1 (R.I.P.), and Quik were cold bum-rushing art galleries with their work. We're going to focus on the work of Quik, Zephyr, and Lady Pink.

Quik, born Lin Felton and raised in Hollis, Queens, had been tagging from the mid-1970s onward. "Quik was a huge graffiti king," recalls Adams. "In the early 1980s you would have been hard-pressed to find a train in New York City that didn't have a 'QK' on it." Quik graduated from high school in 1976, then went to American University in Washington, D.C., then to Pratt University to study art. "I thought art school was a crock of shit, because I was putting out whole train cars top to bottom every evening, then coming home and doing my homework," he says. "I would look at the people next to me and think their work looked real good and they were gonna make lots of money on Madison Avenue. But there was something about what I was doing that they'd never get. I knew that people were going to know my type of work. I was just determined that I would not be anonymous."

In the wake of his early New York shows, which saw him transfer his graffiti skills from trains to canvas, Quik followed some of his European customers back to Europe. He now lives in Holland where he paints "a lot about the racism in America."

As the creator of the immortal logo for Charlie Ahearn's *Wild Style* movie in 1982, Zephyr has been at it since 1975, and is considered one of the most important figures of the modern graffiti movement. Although he's shown his work in galleries since the early 1980s, Zephyr

does not believe that canvas is the ideal medium for graffiti. He prefers to paint on trains and walls. According to Adams, he is known for "his amazing commitment to letter form and to bright sunburst colors . . . not to mention the absolute consistency of his tag." As one of the movement's founding fathers, Zephyr understands that the graf game is fundamentally for the kids. "Graffiti is a youth movement: art designed by young people for young people," he says. "If it doesn't speak to you, that's because it's not trying to."

Lady Pink has been an active writer and painter since 1979. Born in Ecuador and raised in New York, she painted subways trains until the mid-1980s, and was one of the few women writers willing to compete in the otherwise all-male graf culture. Pink and her then-boyfriend, the artist Lee Quiñones, were cast as the stars of Ahearn's *Wild Style*. "Pink was Lee Krasner to Lee's Jackson Pollock. She's been an inspiration to two generations of female artists," says Adams. Today Pink, working on canvas, creates abstract and representational art pieces using aerosol techniques or oil and brushes as the mood strikes her.

The writer who made the biggest splash in the gallery scene was Jean-Michel Basquiat. While many purists argue that Basquiat was not a true writer, he employed the writer's tactic of making a name for himself by getting up and getting seen. He was also at the right place at the right time. Basquiat's message, words, colors, and images of distorted, half-eaten figures made sense to artists living in the heroin-addled squats of Manhattan's Lower East Side.

In 1980, a graf-oriented exhibition called the *Times Square Show* gave mainstream attention to graf-oriented artists, including Basquiat, Fab 5 Freddy, Keith Haring, and Kenny Scharf, alongside better known artists like Jane Dickson, Tom Otterness, Kiki Smith, Jenny Holzer, and Barbara Kruger. The show ignited the art establishment's interest in raw, untamed flavor from the streets.

PART TWO:
OUT OF THE SUBWAYS AND INTO
THE WORLD, 1980 TO THE PRESENT
FRANKLIN SIRMANS

Ever since Jean-Michel Basquiat and Keith Haring crashed the art scene with their street-smart graffiti-inflected paintings, hip-hop as a style or at least as a reference in contemporary art has become so pervasive that it is almost unremarkable today. By the end of the 1990s, it was possible to organize a show about hip-hop around artists who had no propensity for the culture's original visual element—graffiti.

What propelled Basquiat and Haring, aside from sheer talent, was their ability to translate the language of the street into the language and history of modern art. In effect, their sophisticated and rigorous challenge to the status quo is a reflection of what hip-hop has been doing ever since the 1980s: insinuating itself into every nook and cranny of American popular culture with the voraciousness of the best hustler or Series 7–licensed Wall Street trader. Basquiat, a Haitian-Puerto Rican boy from Brooklyn, and Haring, a white boy from a lily-white town in eastern Pennsylvania, helped open the doors for all the other graf-oriented artists. Both were influenced by the graffiti heads from uptown, and both were later adopted by the downtown art scene whose god was Andy Warhol. The pair thus spearheaded the confluence of the uptown and downtown art scenes, which helped hip-hop evolve from an outer-borough park party to a pop-culture phenomenon, invigorating the contemporary art scene in the process.

In a December 1987 *Artforum* article entitled "The Radiant Child," Rene Ricard, a Warhol protégé who has worked as a poet, artist, and critic, spelled out the challenge facing the graffiti artists, writing, "It seemed clear that whoever was going to get out of the subway was going to have to figure out a way of sophisticating their work into scale, to avoid the cloying naiveté and preciousness that inspire more condescension and 'isn't that charming' than, say, awe in the viewer."

Perhaps unknowingly, Ricard's words seem prescient in light of the fact that an MFA degree is just as important in today's art world as an MBA is in the world of finance. While artists should be studied in their craft, the moment of ascendance that coincided with graf artists going into the galleries also seems to have contributed to a backlash that is felt today. Today, the dreaded term *self-taught* means worse than naïve. It means closeted, or worse,

mad and deranged. Over the last two decades, numerous artists have sought to "wear the mask," or at least, employ a *degree* of double-consciousness when it comes to their careers in the world of contemporary art. ("Wearing the mask" was the poet Paul Laurence Dunbar's elaboration of W.E.B. Dubois's notion of *double consciousness*, namely the ability of black people to put on one face among white people and remove it when among other blacks. Graf artists often employ similar strategies regardless of race.) There are also countless other artists who answer the call of the marketplace created by hip-hop, visualizing the evolving styles for new generations, giving the people what they think they want. They have turned their awareness of the confluence of the American corporate culture and hustling—often one and the same—into top dollars while marketing urban culture. And still there are graffiti writers who remain vigilant and live the ethos of getting up, under duress, strain, and the threat of the law. Like the Dadaists and the Surrealists, the pure writer is one who pushes the envelope, breaks the rules a little bit, and, in the process, is a thorn in the side of the status quo and conformity—a necessary role in a democratic society where those in power are known to consistently flout the rules themselves. Like any other artist, the writer makes art because he or she has to. Guided by a streak of good old-fashioned antiauthoritarian ambition and driven by an urge to be heard, these writers feel their art in their souls. As graf king Lee Quiñones has said, "Graffiti is an art and if art is a crime, let God forgive all."

In order to keep up with the increasing militarization of civic police, today's rebels have retained the graf pioneer's sense of guerrilla tactics and elaborate planning. The following artists have not only embraced hip-hop's rebellious attitude but are legends in their own right who continue to champion hip-hop's original sense of flavor.

A descendant of the skateboarding culture, Shepard Fairey, a graduate of Rhode Island School of Design, maintains a street presence while showing at galleries around the world, much like the artist Barry McGee. The skateboarding culture, mainly comprised of young white suburban rebels, has always admired the edgy music and attitude of hip-hop's young black urban rebels. Historically, the two cultures have fed on each other, with rappers as recent as Pharrell, Kanye West, and Lupe Fiasco taking

up skateboarding. Fiasco even had a huge hit in 2006 with an ode to skateboarding called "Kick Push." McGee is known on the streets of San Francisco for his sad sack portraits—drawings of an old, bald, stubble-faced white man, rendered in a cartoonish style that predates cartoonist George Baker's 1940s Sad Sack comic book character. Fairey is known on the streets of New York for his OBEY giant stickers and stencils, which depict the cartoonish abstraction of the world-famous wrestler Andre the Giant juxtaposed with the word OBEY. Fairey, who sees his work as "manufacturing quality dissent," says that the OBEY campaign is an attempt "to bring people to question . . . their relationship with their surroundings." While both artists' work is rooted in the spontaneity of graffiti, they are also driven by the desire to communicate on varied platforms. For Fairey and McGee, the imagery of graffiti is not limited to walls.

David Ellis's career demonstrates how truly far-flung the effects of hip-hop have been. Born in North Carolina in 1971, his initial inspiration as an artist was a viewing of *Style Wars*, the seminal documentary about New York's graffiti scene that first aired on PBS in 1983. Around the same time, he began absorbing the *Super Mix* radio show broadcast out of Fort Bragg. "Each week a new style of early New York hip-hop found its way into the mind of a twelve-year-old boy living in the attic of a log cabin in North Carolina," he recalled in a 2006 interview with Houston's Rice Gallery. "Those beats have been in the back of my mind all my life." After going to art school in New York City, Ellis returned to North Carolina in 1999 and recruited a crew of fellow artists to begin painting graffiti on the area's old and abandoned wooden tobacco barns. They call themselves the Barnstormers and their project is an ongoing affair. Ellis thinks of the work as a way of joining together two disparate parts of his life: his rural youth and his urban early adulthood.

For William Cordova, born in Peru and raised in Miami, graffiti has been a vernacular link to broader cultural issues. *World Famo History Paintings* (2004–2005) is a huge work based on over eighty illustrations from a 1930s art history survey book entitled *World-Famous Paintings*. Cordova tore out pages from this book and drew on them, literally inserting himself into the canon of art history. In effect, he also invites women,

people of color, and writers into the party—whole classes of artists whose work had previously been excluded.

Although he began his career writing graffiti, Carlos Rodriguez, a.k.a. Mare 139, turned to sculpture by the late 1980s. Having always been interested in visual abstraction, Rodriguez's studies in light, form, and space have informed many of his sculptural creations, including the prototype of Black Entertainment Television's BET Award. Influenced by modern sculpture as much as by the culture of hip-hop, Rodriguez's work shares some affinities with those of David Smith and Eduardo Chillida, while remaining thoroughly original and of their moment.

Mike Thompson, who has been called "the hip-hop Norman Rockwell," has distinguished himself as a painter of hyperrealistic portraits of some of the culture's greatest figures, including Tupac, the Notorious B.I.G., Jam Master Jay, Dave Chappelle, T.I., and many others. Much of this work was undertaken from 1997 to 2003, when Thompson worked as the art director at Ecko Unlimited, designing T-shirts and advertisements alike. Indeed, it was through the Ecko ads in *The Source, Vibe,* and *XXL* that Cey Adams was introduced to Thompson's work. "Most professional illustrators—especially the ones with great technique—pride themselves on their range and versatility," Adams notes. "If he wanted to, Thompson could certainly be making illustrations of George Clooney or the president of the United States. And yet, at least in his early years, he chose to devote himself exclusively to portraits of the great rappers. I found that fascinating."

Mike Giant made a reputation for himself for being eclectic. He is proficient in many media, including fine art, graffiti, tattoo, and skateboard design. His work, which references graphic novels and Mexican murals in equal measure, as well as Gothic skulls and griffins, is stark and meticulously rendered. In 2005, he and Shepard Fairey shared a joint show called *Giant vs Giant* at the Voice 1156 Gallery in San Diego.

Greg LaMarche got his start as an artist writing graffiti in the early 1980s in Queens, where he tagged successively as Spanky, SPY, and SP One. Currently, his work combines graffiti and collage, with an emphasis on brightly colored letters in a variety of fonts. It is a style that falls, he says, "somewhere between Kurt Schwitters and the RTW Crew"—Schwitters being a playful, typography-obsessed German artist of the first half of the twentieth century, and the RTW Crew (short for Rolling Thunder Writers) being an all-star graf team founded in 1976 comprised of Ali, Revolt, Zephyr, Min-One, Quik, and Haze. Alternating between commercial assignments and fine art, LaMarche has enjoyed the occasional opportunity to create large pieces for galleries, such as a 16-foot-high by 40-foot-long painted mural for *Other Possibilities,* a group show at the Track 16 Gallery in Santa Monica, California, in 2005. In an interview with Caleb Neelon for *Juxtapoz* magazine in March 2007, LaMarche said the scale of the piece reminded him of his roots as a graffiti muralist.

Kehinde Wiley is one of the few contemporary artists of color to enjoy Basquiat-level recognition. Born in Los Angeles and based in New York City, he received an MFA from Yale in 2001 and then went on to a residency at the Studio Museum of Harlem. Wiley is a portrait painter who places himself in the tradition of Gainsborough, Titian, and Ingres. His signature method is to apply "the signs and visual rhetoric of the heroic, powerful, opulent, majestic, and sublime in his representations of young, urban black men." He sees himself as "interrogating the notion of the master painter, at once critical and complicit."

Dalek made his reputation painting variations on a character of his own creation: the grinning and malevolent Space Monkey. They are, he says, "my little version of humans. We send monkeys into space, teach them to push buttons, and jump though hoops. I think some human behavior is like that." A political science student at Virginia Commonwealth University in the late 1980s, Dalek went to Chicago to study art in 1992. It was there that he discovered graffiti. His present-day style, even when it tends toward abstraction, reflects an enduring affection for *Yellow Submarine, The Monty Python Show,* and *The Simpsons.* The artist takes his pseudonym from the human-destroying robots on the BBC sci-fi show *Dr. Who.*

The painter Jeff Soto has established himself as a young master of the dystopian landscape, a space made dark by human carelessness in his opinion. A 2002 graduate of the Art Center College of Design in California, Soto's early influences included skateboarding, graffiti, and rap. Although the darkness of his work recalls the drawings of Ralph Steadman, it is occasionally brightened by drawings of rainbows. "There's always a hint of optimism in my paintings," he says. "I think we can make things better somehow."

Justin Bua builds his devotion to hip-hop right into his last name, which he turned into an acronym for the Beat of Urban Art. A native New Yorker, Bua got into break dancing and graffiti as a youth while attending the city's High School of Music & Performing Arts. He earned his BFA in illustration at the Art Center College of Design in Pasadena, California. Like many of the artists profiled in this chapter, Bua moves comfortably between the worlds of commercial art and fine art, having designed sneakers, skateboards, CD covers, and advertisements. He has also ventured into animation, designing for videogames, television, and films. Bua characterizes his style as "distorted urban realism," in which key elements of his compositions are enlarged and caricatured for emphasis. This distortion, applied to Bua's chief subject matter—New York's streets and its denizens—is reminiscent of the work of the painter Ernie Barnes a generation ago. One of Bua's proudest accomplishments is a series of four canvases, one for each of the four elements of hip-hop: b-boying, graf writing, deejaying, and emceeing.

Raised in Brooklyn and schooled at Spelman College and the Atlanta College of Art, Fahamu Pecou has been creating a lengthy and amusing series of paintings, videos, and performances entitled *Fahamu Pecou Is the Shit* for years. The series consists of fantasy images of the artist himself on the cover of various fine art magazines. "This project was a response to the grassroots and oftentimes aggressive marketing campaigns that surround artists in the music industry," he says. Style-wise, the work demonstrates a conscious debt to Jean-Michel Basquiat. Attitude-wise, Pecou is pure rap swagger. Cey Adams says, "I love his work. Like Muhammad Ali at the start of his career, he's going to be his own biggest cheerleader. The rest of the world will catch on later."

All of the artists in this chapter are defined, in Adams's opinion, by hip-hop's do-it-yourself ethic. "There's still an outlaw element to it," he says. "It's not elitist; it's open to anyone. Whether or not the artist has formal training, he thinks of himself as a member of this self-anointed club of outsiders." Perhaps more importantly, these artists are hip-hoppers simply by virtue of working during the hip-hop era. "I can't tell you how many times someone has told me, 'I didn't write graffiti, but I was influenced by it,'" says Adams. "It's graffiti and a love of rap music that unites everyone." In short, these artists belong to hip-hop just as Ralph Steadman belongs to rock.

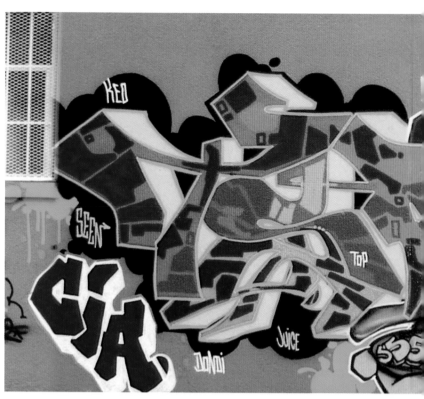

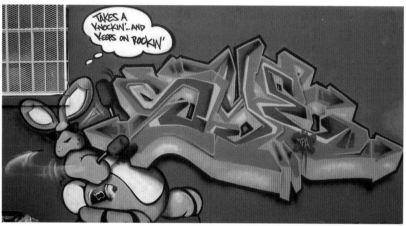

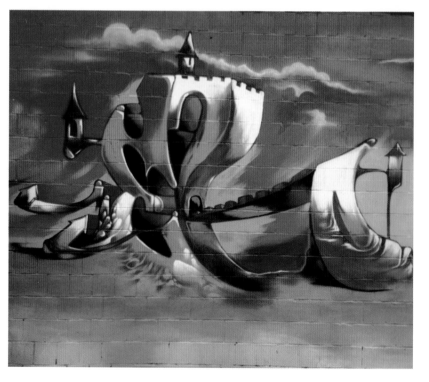

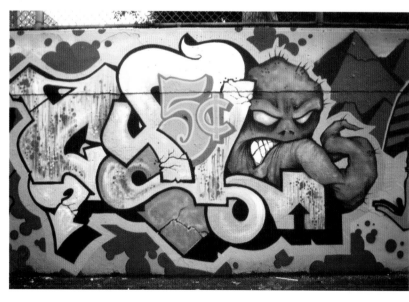

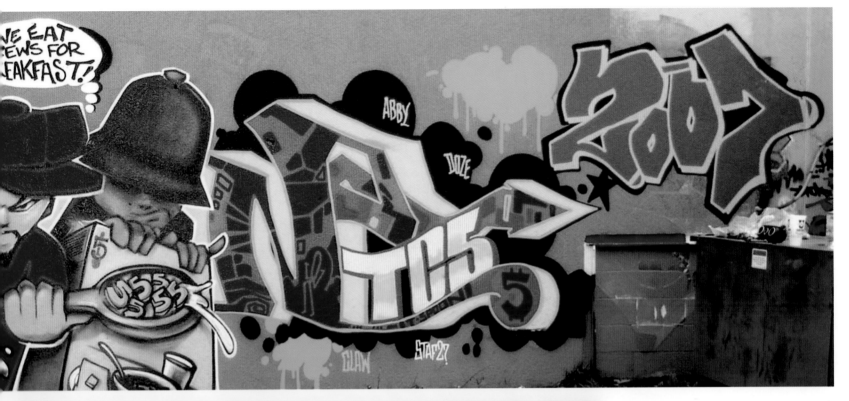

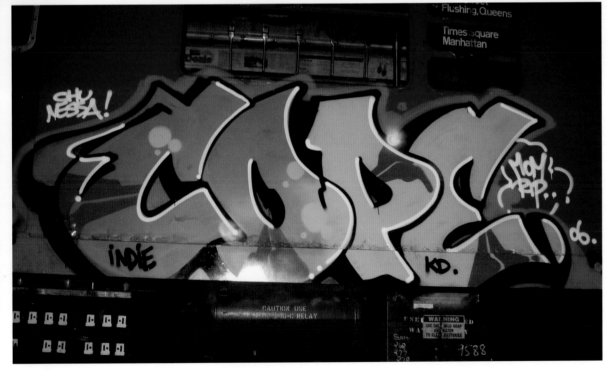

Opposite, top left:
TEAM
Garden Shack, 2006,
Spray paint on wall

Opposite, middle left:
SYE
Takes a Knockin', 2007,
Spray paint on wall

Opposite, bottom left:
CYCLE
5¢, 2005,
Spray paint on wall,
Graffiti Hall of Fame, Harlem, USA

Above:
DOC TC5
TSpoon, 2007,
Spray paint on wall

Opposite, bottom:
EZO
Ezo, 2006,
Spray paint on wall

Left:
COPE2
Cope2, 2006,
Spray paint on subway car

Page 24:
KEITH HARING
Untitled, 1983 (Paparoni),
Acrylic on tarp,
73 x 73 inches,
© The Estate of Keith Haring

Page 25:
KEITH HARING
Untitled, 1983 (Taschen),
Acrylic on tarp,
73 x 73 inches,
© The Estate of Keith Haring

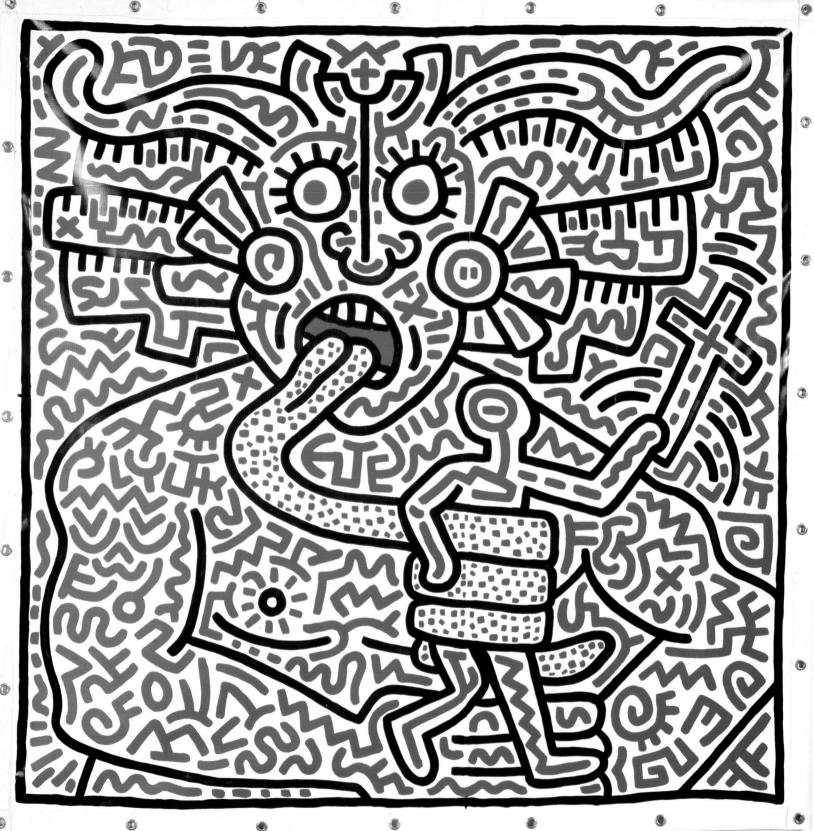

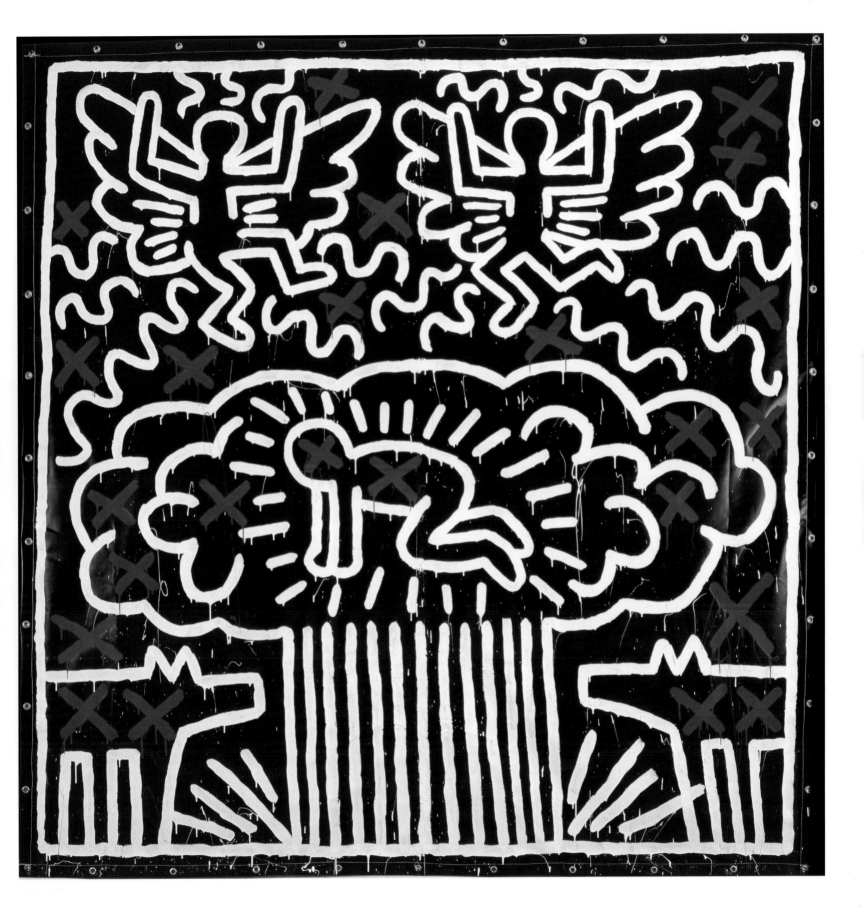

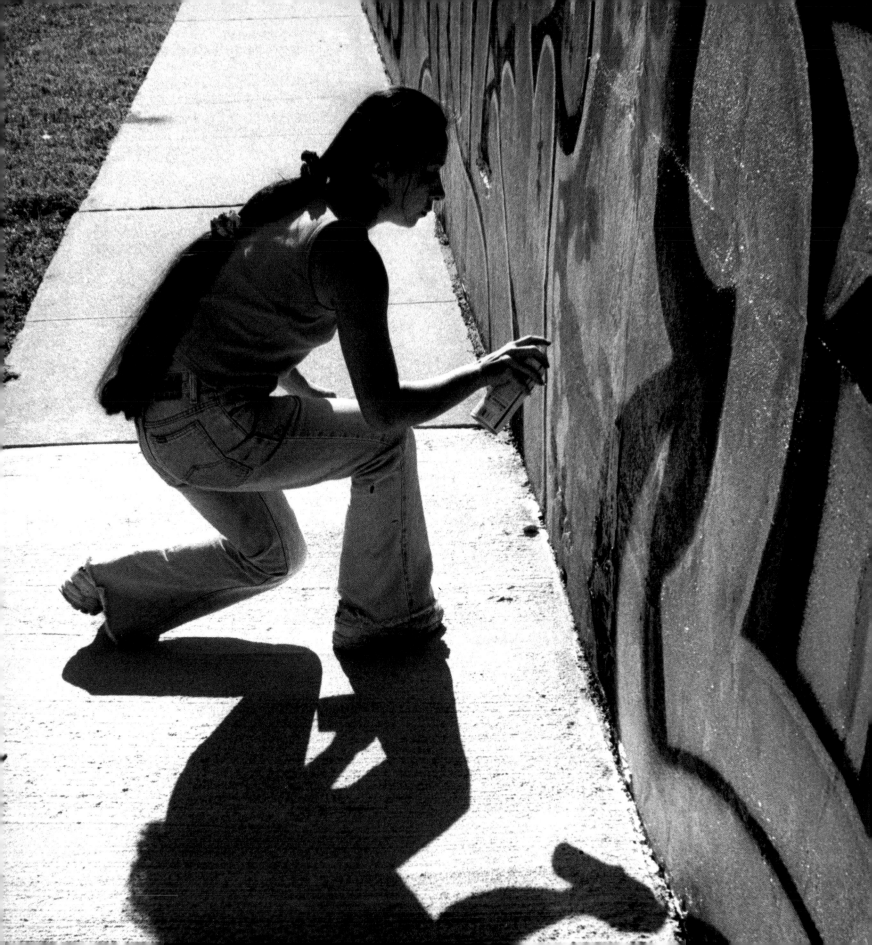

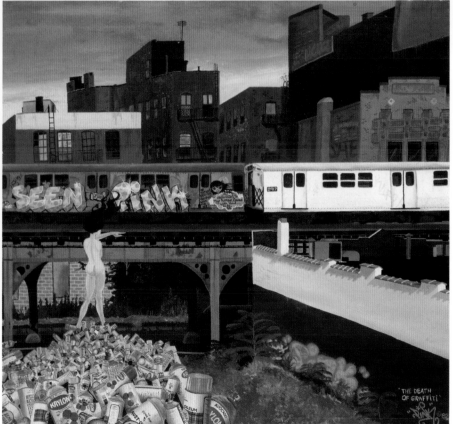

Opposite:
MATT WEBER
Pink Painting, 2004,
Long Island City, New York

Above:
LADY PINK
Pink Piece, 1996,
Acrylic on canvas,
28 x 52 inches

Left:
LADY PINK
The Death of Graffiti, 1982,
Acrylic on canvas,
36 x 36 inches

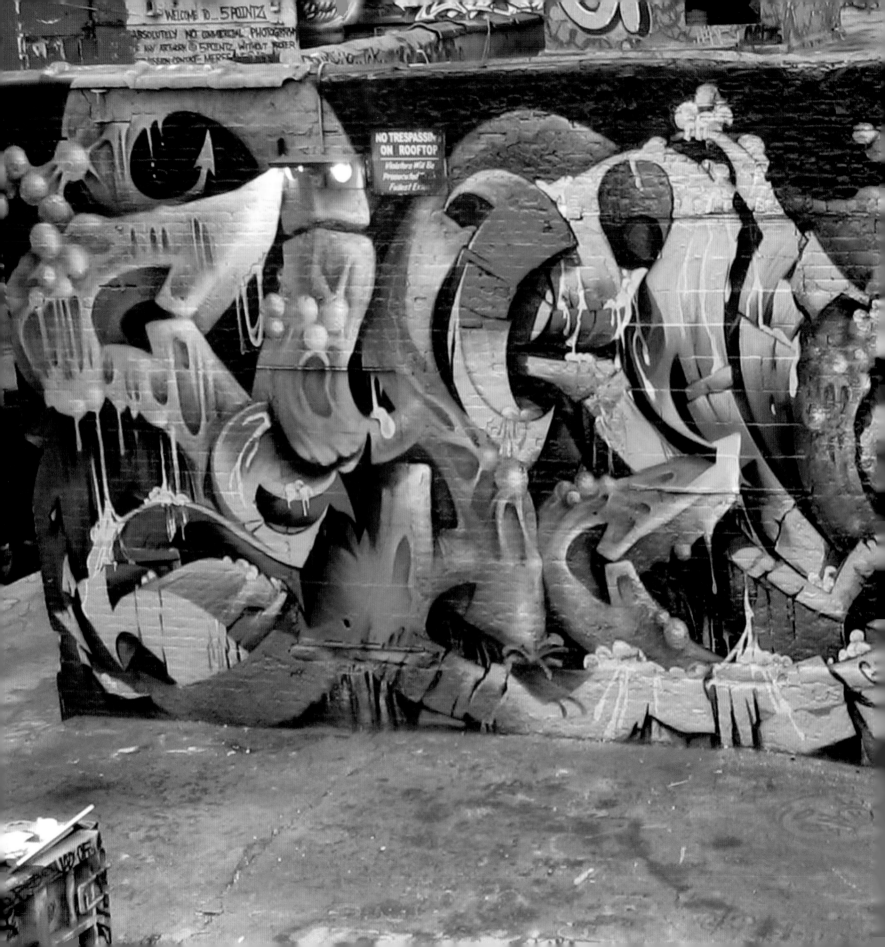

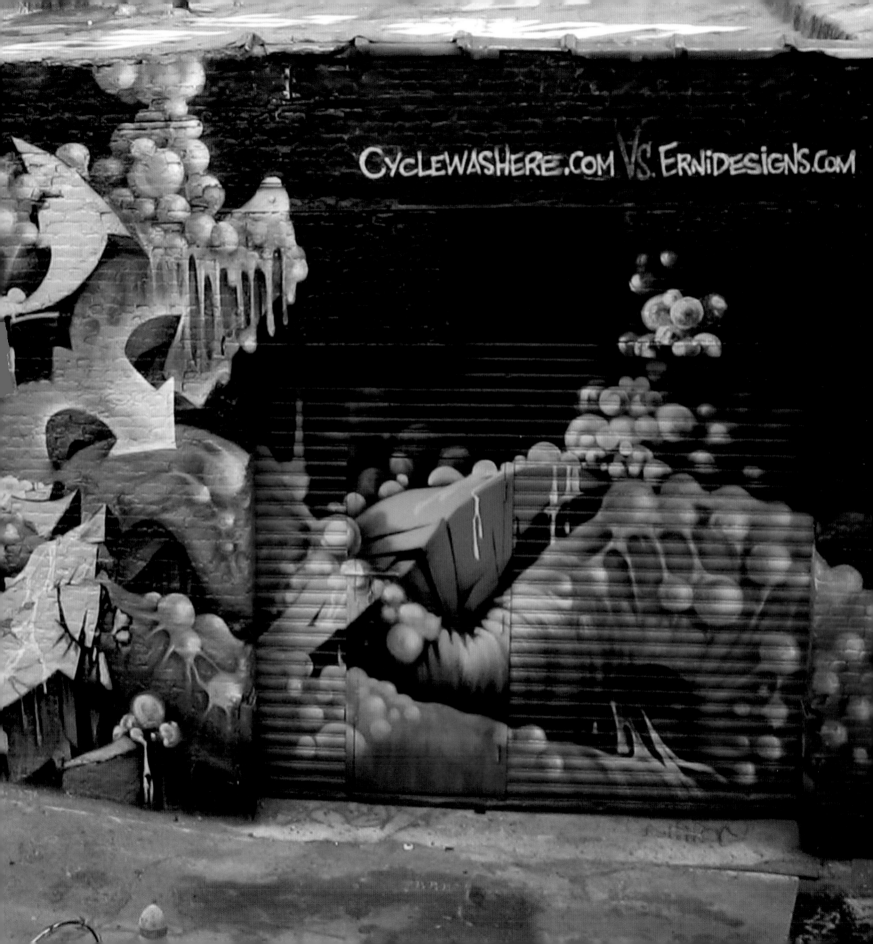

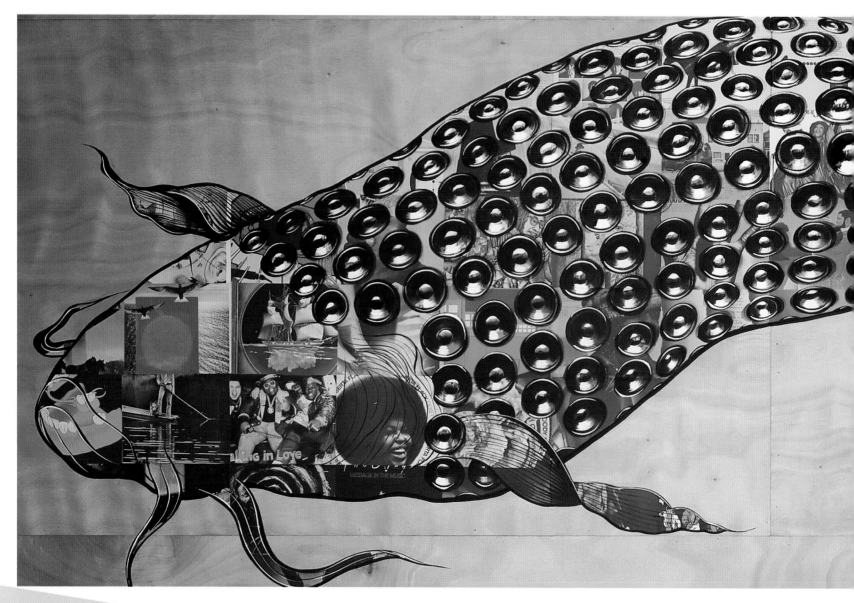

Pages 28–29:
CYCLE VS ERNI
Cyclewashere.com vs Ernidesigns.com, 2007,
Spray paint on wall

Above:
DAVID ELLIS
Speakers Catfish, 2006,
Album covers, matte medium, matte varnish,
black gesso, engrossing ink, neo megilp,
aluminum enamel on Luan panels

Right:
DAVID ELLIS
Snake 1200 (Stylus), 2003,
Ink and tobacco stain on watercolor paper,
30 x 25 inches

Opposite, bottom left:
DAVID ELLIS
Marsea Cloud, 2007,
Flashe and sumi ink on linen,
6 x 8 inches

Opposite, bottom right:
MAYA HAYUK
Explosion, David Ellis Painting, 2007,
Auberive Abbey, France

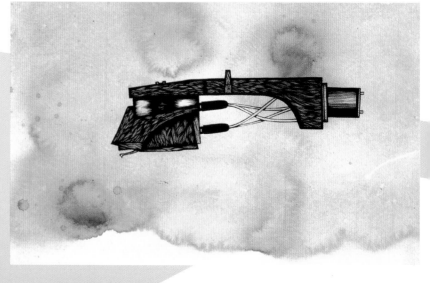

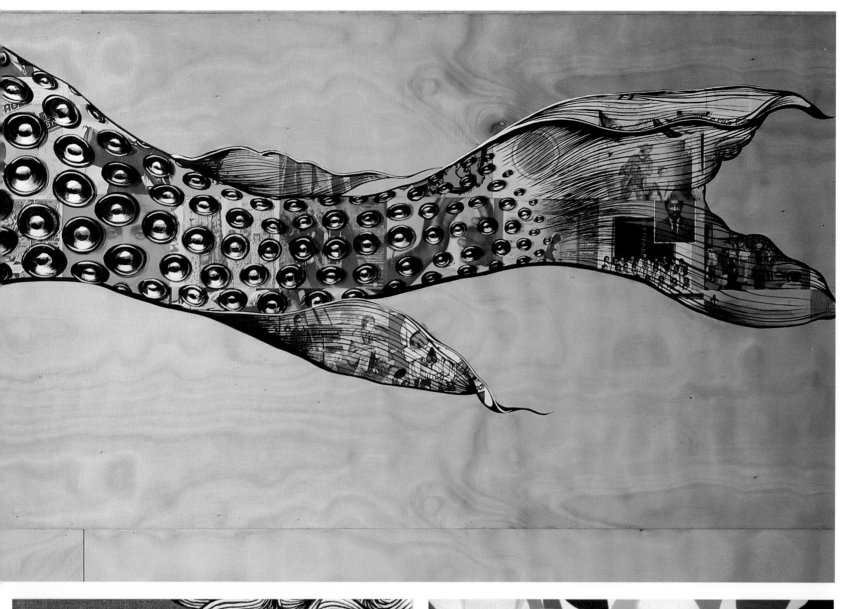

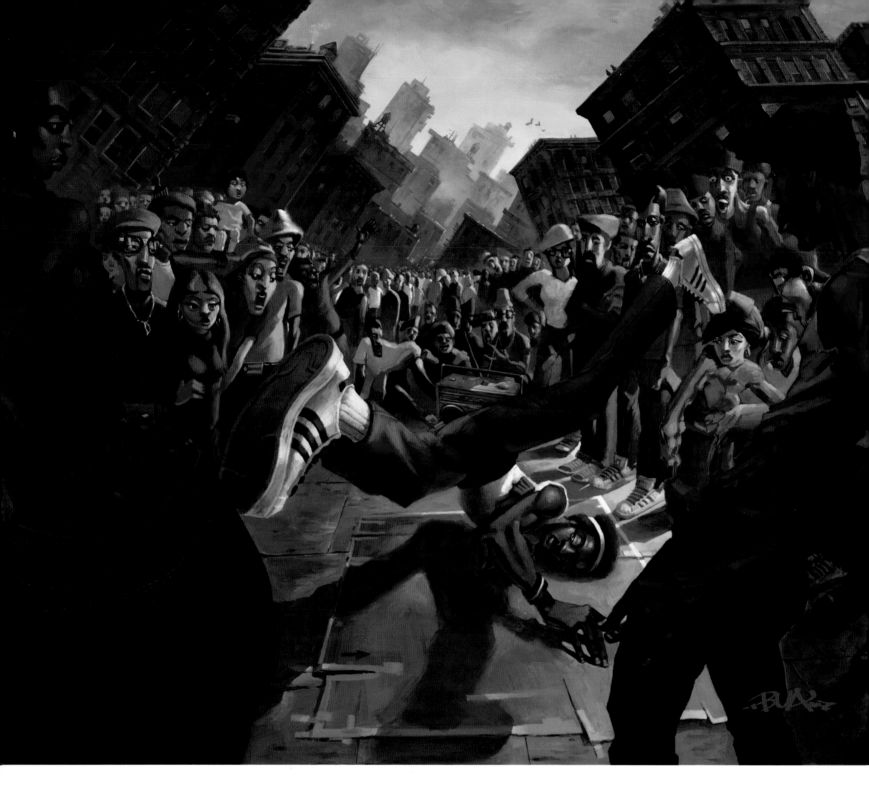

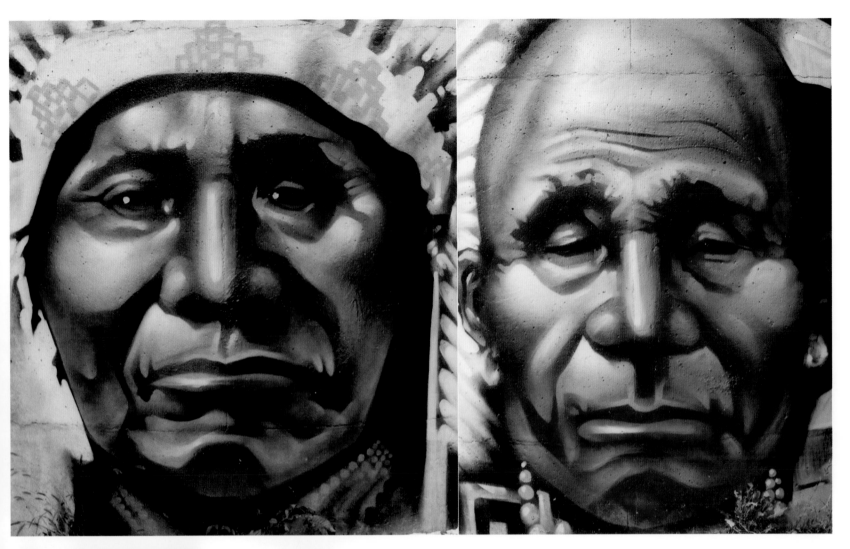

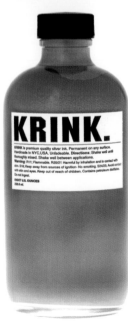

Opposite:
JUSTIN BUA
1981, 2005,
Acrylic on illustration board,
30 x 22 inches

Above:
CHUCHO
Indian Chiefs, 1995,
Spray paint on wall,
Chicago, IL

Far left:
CRAIG COSTELLO
Krink NYC, 2005,
Bleecker Street, New York

Near left:
KRINK
Krink Ink Bottle, 2002

"The evolution of KR's ink…into a brand available in slick retail settings
mirrors the way graffiti—or the graffiti aesthetic—has been absorbed
into pop culture over a period of decades."
　　　　—Rob Walker, "Tag Sale," *The New York Times*, 2008

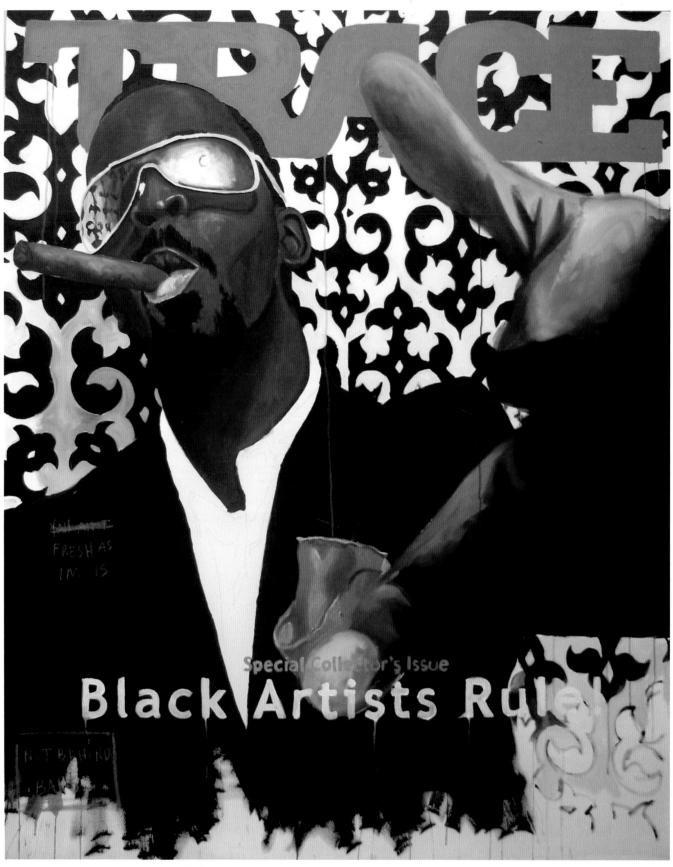

Left:
FAHAMU PECOU
Fresh As I'm Is, 2007,
Acrylic, oilstick on canvas,
60 x 72 inches

Opposite:
MUCK
Lil Kim, 2007,
Spray paint on wall

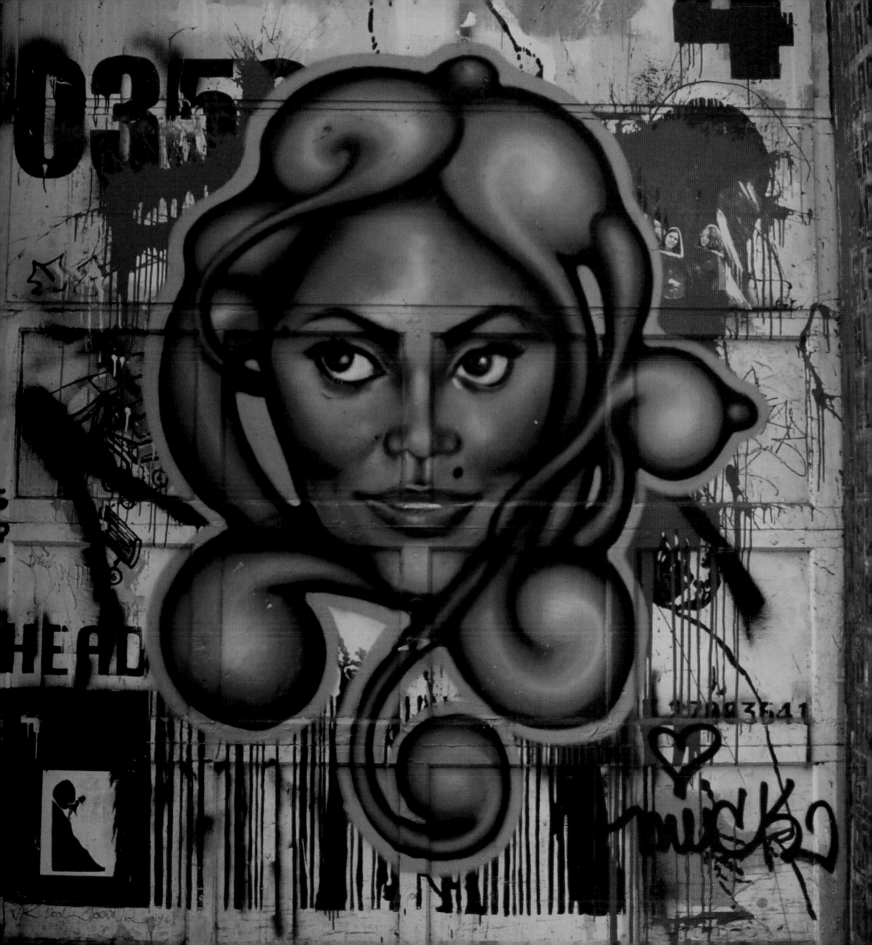

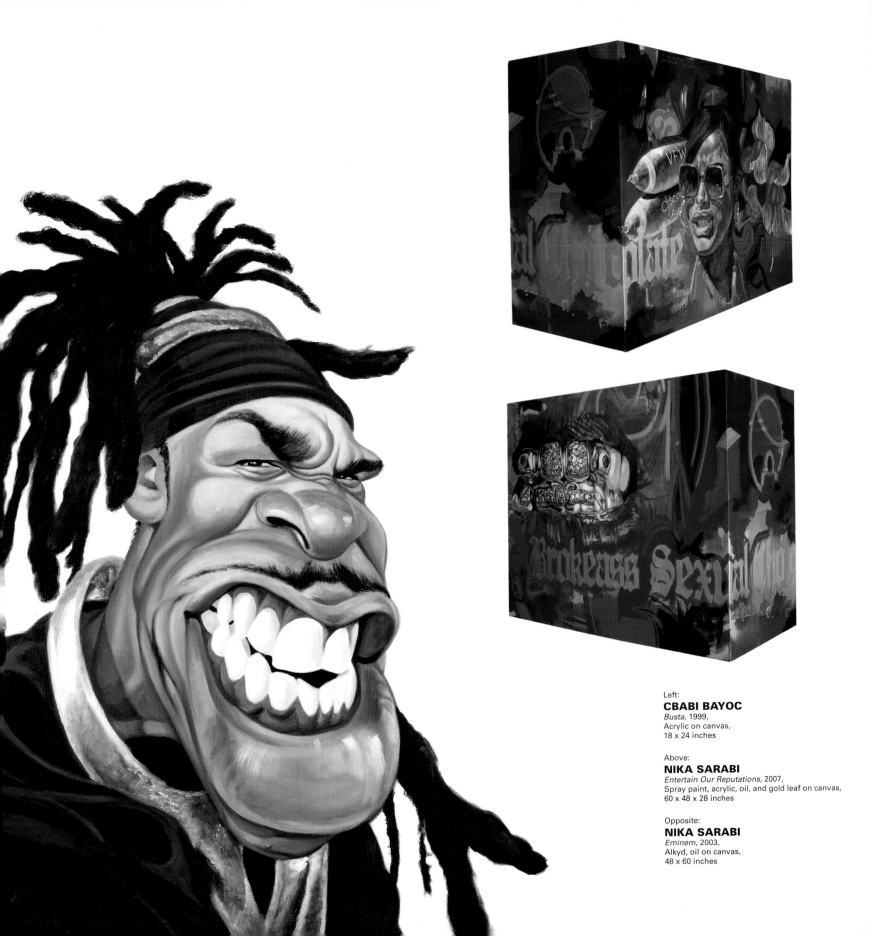

Left:
CBABI BAYOC
Busta, 1999,
Acrylic on canvas,
18 x 24 inches

Above:
NIKA SARABI
Entertain Our Reputations, 2007,
Spray paint, acrylic, oil, and gold leaf on canvas,
60 x 48 x 28 inches

Opposite:
NIKA SARABI
Eminem, 2003,
Alkyd, oil on canvas,
48 x 60 inches

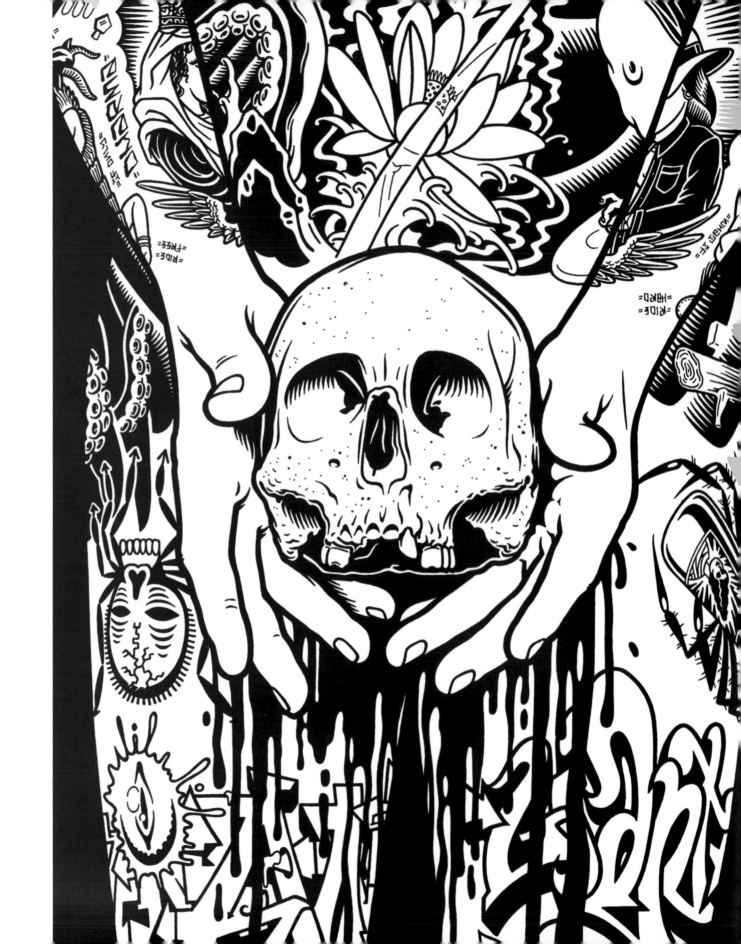

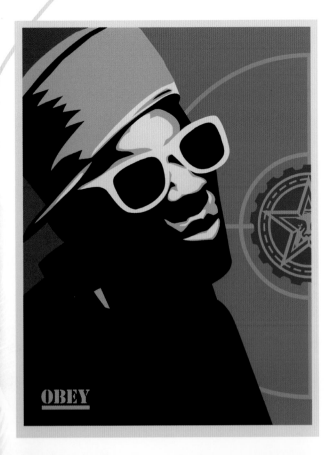

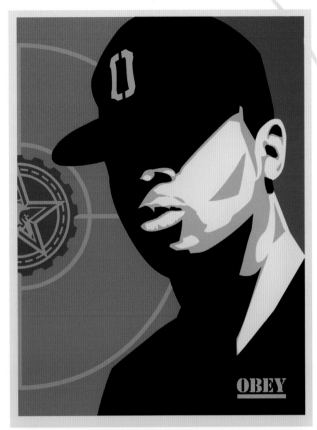

Opposite:
GIANT
Portrait Skull, 2005,
Ink on paper,
18 x 24 inches

Top left:
SHEPARD FAIREY
Obey Flavor Flav, 2002,
Screen print on paper,
18 x 24 inches

Top right:
SHEPARD FAIREY
Obey Chuck D, 2002,
Screen print on paper,
18 x 24 inches

Bottom left:
SHEPARD FAIREY
Obey LL Cool J Red, 2004,
Screen print on paper,
18 x 24 inches

Bottom right:
SHEPARD FAIREY
Obey Slick Rick, 2004,
Screen print on paper,
18 x 24 inches

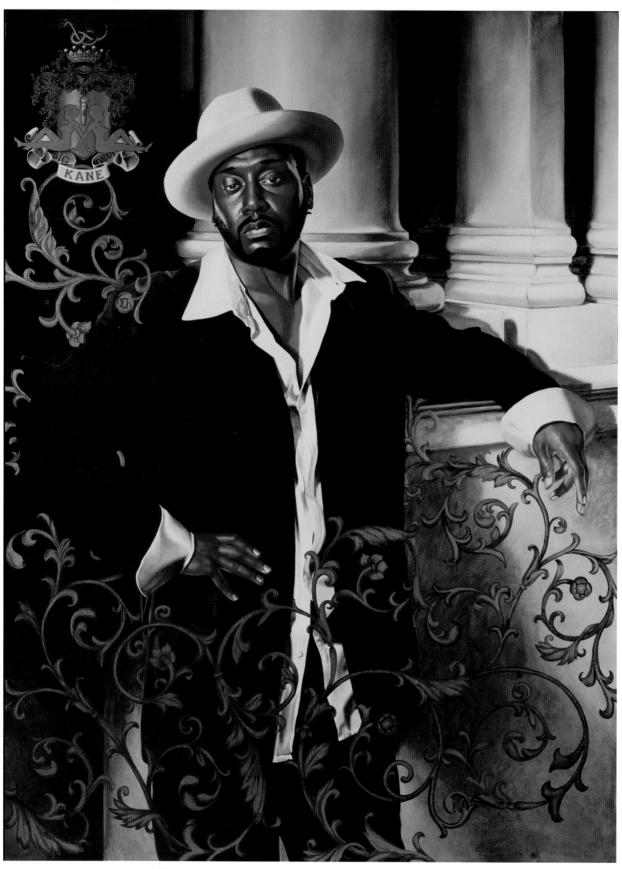

KEHINDE WILEY
Big Daddy Kane, 2005,
Oil, enamel on canvas,
96 x 72 inches

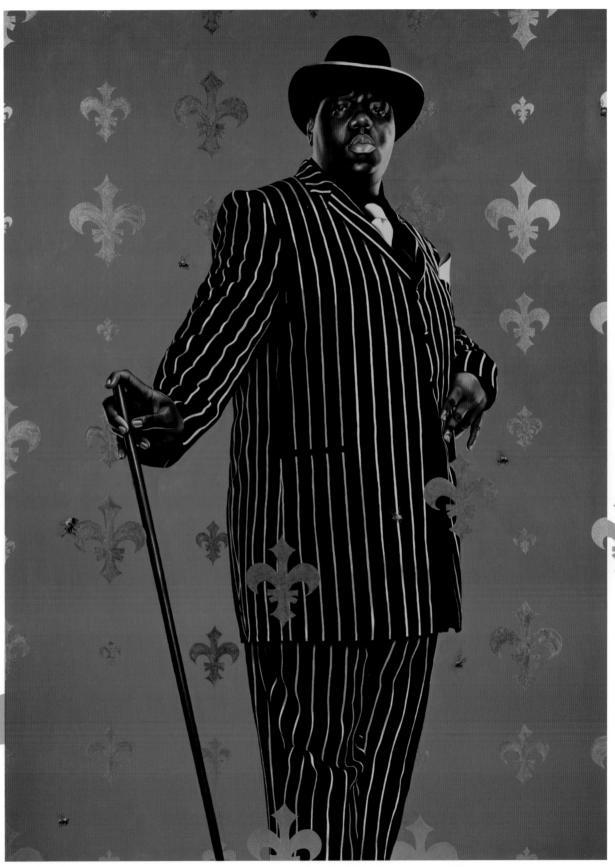

KEHINDE WILEY
Biggie, 2005,
Oil, enamel on canvas,
96 x 72 inches

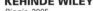

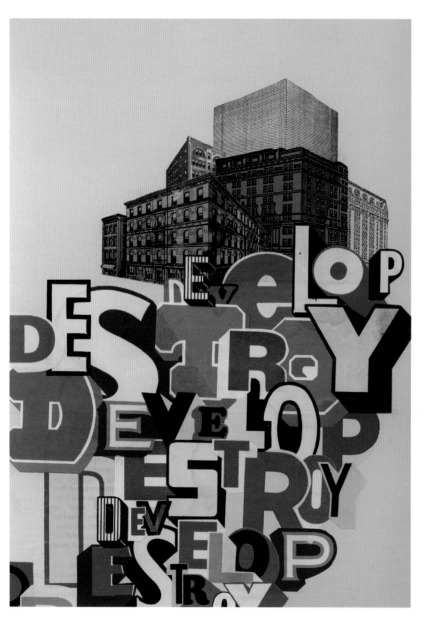

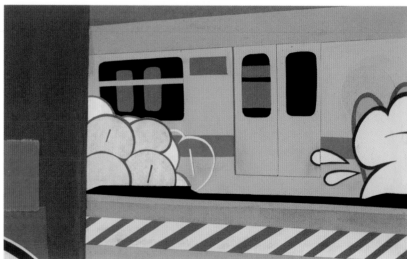

Above:
GREG LAMARCHE
Develop Destroy, 2005,
Paper collage,
7.5 x 10.5 inches

Top:
GREG LAMARCHE
Junior's Livin', 2006,
Paper collage,
8.5 x 8.5 inches

Bottom:
GREG LAMARCHE
Smashing Shit Lovely, 2006,
Paper collage,
6.5 x 9.5 inches

QUIK
Felix, 2007,
Spray paint on canvas,
64 x 64 inches

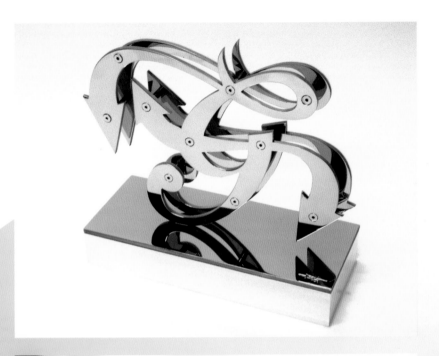

Opposite:
DALEK
Untitled, 2007,
Acrylic on wood panel,
24 x 24 inches

Far Left:
CARLOS (MARE 139) RODRIGUEZ
BET Award, 2004,
Polished stainless steel,
13.5 x 9.5 x 8.5 inches

Top:
CARLOS (MARE 139) RODRIGUEZ
G-Unit Award, 2005,
Polished stainless steel,
12.5 x 7.5 x 12 inches

Bottom:
CARLOS (MARE 139) RODRIGUEZ
WU Style Writer, 2006,
Steel,
48 x 60 x 84 inches,
Wuppertal, Germany

"In 1985 I abandoned university, and
soon after laid down the groundwork
for graffiti-style sculpture. No longer
was my competition Noc167, Dondi, or
Kel 1st. It became Picasso, Julio Gonzales,
Frank Stella, and Vladimir Tatin."

—Mare 139, 2007

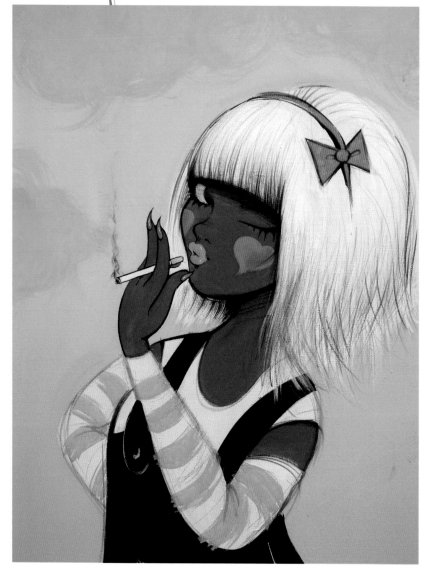

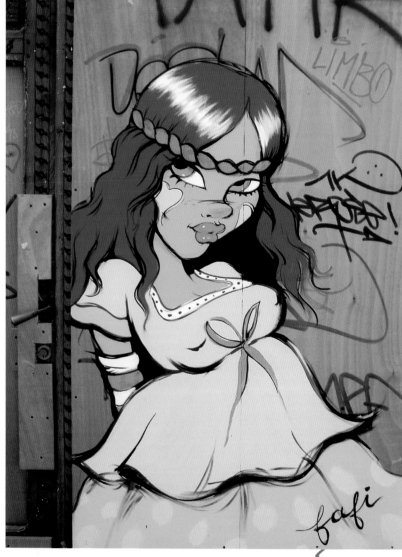

Top left:
FAFI
Smoking Kills, 2006,
Acrylic on canvas,
20 x 25 inches

Top right:
FAFI
Fafinette Is Having a Baby, 2005,
Acrylic on wood,
Rue de Metz, Toulouse, France

Bottom:
FAFI
Red Stripe Fafi Painting, 2007,
Melbourne, Australia

Opposite:
JULIE "JIGSAW" ASHCRAFT
*Stormtrooper Crossing the Alps
After David and Lucas*, 2006,
Oil on canvas,
60 x 48 inches

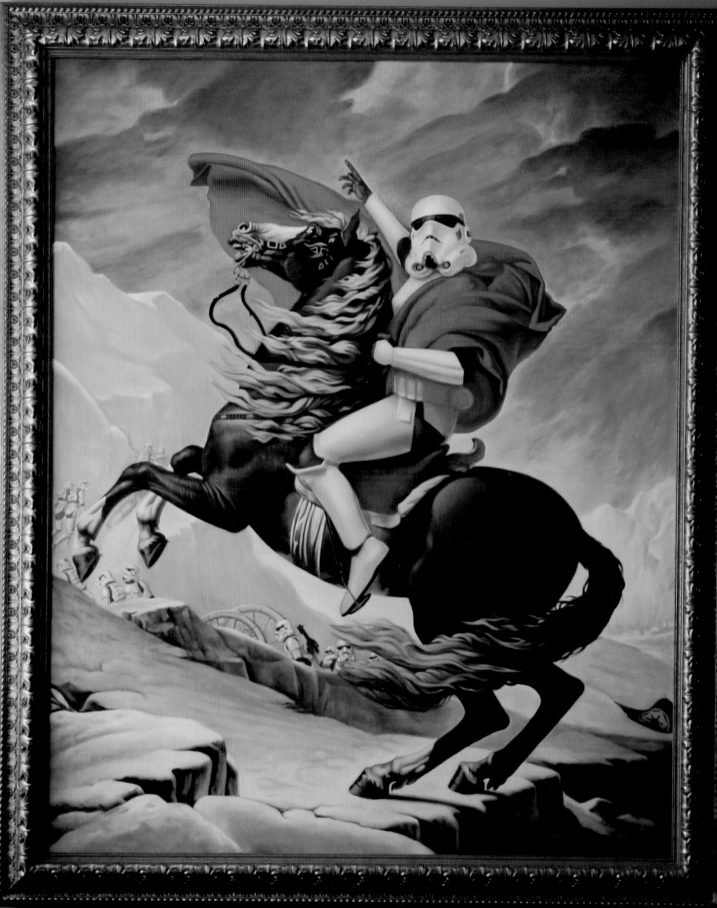

Right:
KEN SCHLES
Morning Breath At Work, 2007

Opposite:
MORNING BREATH
Untitled, 2007,
Acrylic on canvas,
48 x 48 inches

Pages 50–51, top:
MINT & SERF
Untitled, 2007,
Digital C-Print,
25 x 9 inches

Pages 50–51, bottom:
ZEPHYR
Zephyr, 1999,
Spray paint on wall,
Graffiti Hall of Fame, Harlem, USA

Above:
JEFF SOTO
The Protector, 2005,
Acrylic on wood,
19 x 15.5 inches

Right:
LAURA LEVINE
Keith Haring, 1983

Pages 54–55:
MIKE THOMPSON
Lust, 2005,
Acrylic and digital,
15 x 9 inches

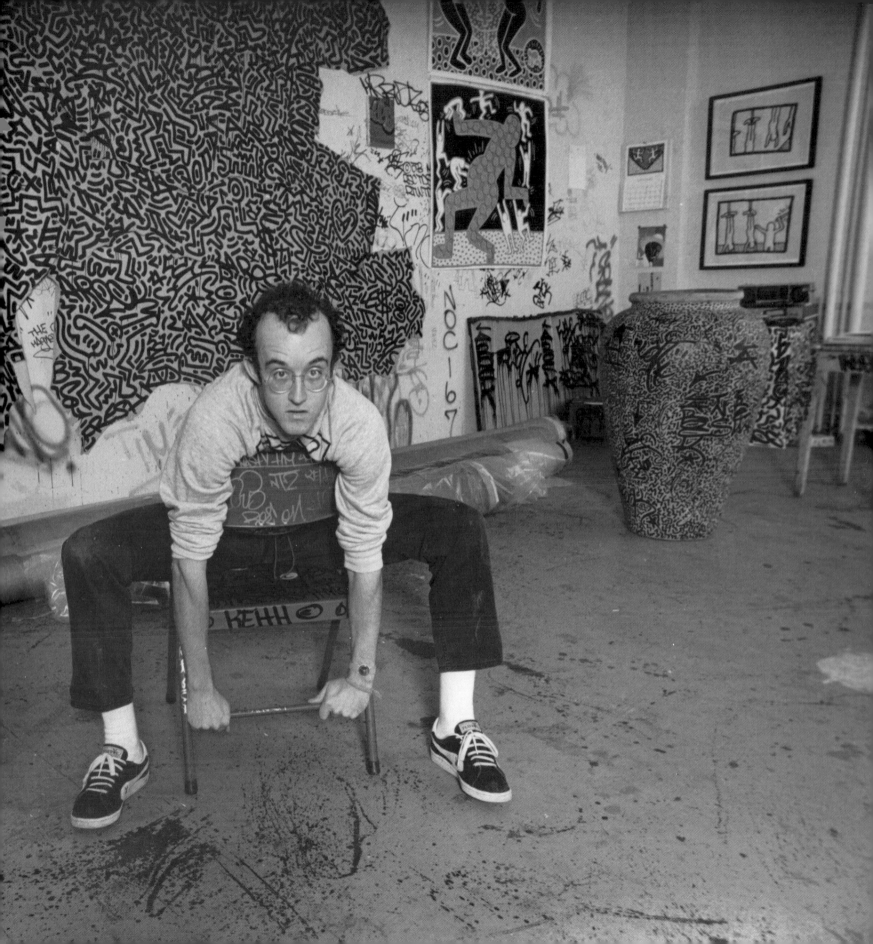

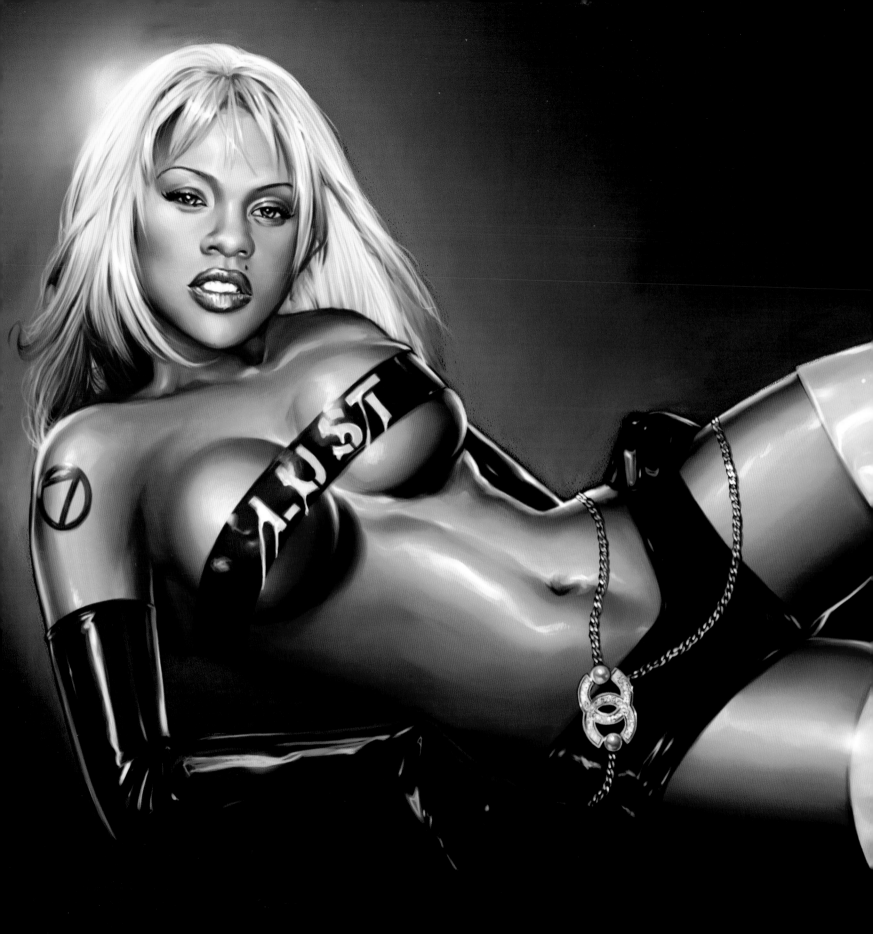

RHYTHM 'AND' DESIGN — FIGHT-FIGHT THE POWER AND THE ART OF THE COVER

BY CARLO McCORMICK

B.E. JOHNSON
Nemesis, Detail,
(*Fear of a Black Planet* album cover),
© 1990 B.E. Johnson

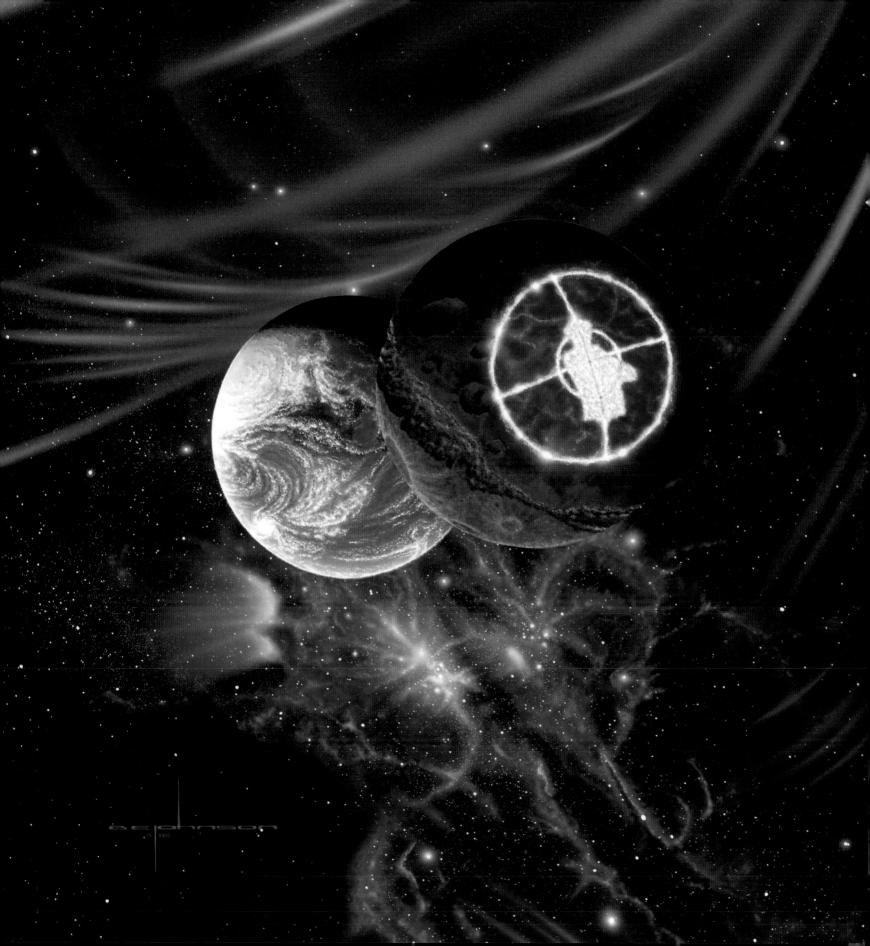

The long-playing record album, or LP, was one of the great technological marvels of mid-twentieth-century America. Not only did the album itself allow one to enjoy a full forty minutes of music with only one interruption—flip that record over, Pops—but the 12-inch-by-12-inch album *cover* was immediately seized upon as a perfectly legitimate and inviting medium for art. Not that everyone understood the possibilities, but covers like those shot by Francis Wolff and designed by Reid Miles for the Blue Note jazz label in the1950s and 1960s are still revered for their beauty today.

It took a little while longer for the rock and rollers to catch on to the importance of album art, but the Beatles certainly understood it by the mid-1960s. Looking back now, it's clear that the period from 1967 or so through the early 1980s was a golden age for rock-album cover art. Oddly, makers and lovers of black popular music at that time were largely out of luck when it came to cool album cover graphics. (There was one great exception: Pedro Bell's well-loved and widely influential Afro-psychedelic cartoon fantasies for dozens of great albums by George Clinton's Parliament-Funkadelic.) Cey Adams explains, "The labels never gave black album covers the same respect as white rock album covers. You think Marvin Gaye got as much love as Pink Floyd?"

In the early 1980s, some of the first rap recordings were graced by covers created by some of hip-hop's earliest art stars. Jean-Michel Basquiat painted the cover of Rammellzee Vs. K-Rob's "Beat Bop" for Tartown Records in 1983. Futura 2000, naturally enough, created the cover art for "The Escapades of Futura 2000," a single for Celluloid that also came out in 1983.

But even before there were rap records, pioneers like Phase 2 and Buddy Esquire were churning out eye-catching party flyers announcing live performances by popular New York deejays and emcees. In effect, Phase 2 and Esquire were hip-hop's very first graphic designers. Esquire was inspired by Phase 2, who already had a huge rep as a graffiti writer when he started making flyers.

Though Esquire possessed no formal training, he honed his craft by studying the art in comic books. He was especially inspired by the work of James Steranko, Jack Kirby, and Vaughan Bode. He also studied newspaper and magazine ads, the 1960s-era concert posters and album covers of San Francisco's Rick Griffin, and the Art Deco movement. Built around publicity photographs of the evening's featured performers, Esquire's flyers were bold and clean, distinguished by thick black Letraset and press-type lettering and Art Deco-ish abstractions. In effect, Esquire put the raw new uptown funk on a classic-looking pedestal. It was a fine fit.

"Buddy and Phase 2 were the best flyer makers," said Van Silk, the old-school party promoter quoted in Fricke and Ahearn's *Yes Yes Y'All.* "We could tell if we was gonna have a good show or a bad show by how people treated the flyer. If a person folds up a flyer and puts it in their pocket—if you don't see no flyers on the floor—you're gonna have a good show."

As hip-hop music and hip-hop album-cover graphics bum-rushed the record business in the mid-1980s, the infant art forms evolved hand in hand. Still, when Adams came of age as the creative director for Def Jam Recordings, he was on a mission, saying, "I wanted to elevate the art in contemporary black music to the level of the art in rock 'n' roll." The Drawing Board—the design studio created by Adams and his partner Steve Carr in 1986—was the first studio to devote itself exclusively to the visual expression of hip-hop music. Situated on the premises of Def Jam Recordings, but free to work for other clients, the firm was a fountainhead of groundbreaking creativity for fifteen years, and produced career-defining graphics for artists from LL Cool J, the Beastie Boys, and Public Enemy in the 1980s to Redman, Jay-Z, and DMX in the 1990s.

Of the hundreds of album covers designed by the Drawing Board, two stand out in particular: Public Enemy's *Fear of a Black Planet* and LL Cool J's *Mama Said Knock You Out*, both released in 1990. The popular success of both Public Enemy and LL Cool J earned each

act a larger-than-usual art budget, which the Drawing Board spent to hire Michel Compte and B. E. Johnson, respectively—two estimable artists who had no previous experience in the hip-hop arena. *Mama Said Knock You Out* was a landmark in large part because of Compte's striking black-and-white photograph, which featured LL's glistening torso in fighting trim. Predictably, both Def Jam and LL Cool J at first opposed using a black-and-white image, preferring tried-and-true color instead, but Adams persisted and Compte's photograph finally won them over. *Fear of a Black Planet* featured the work of B. E. Johnson, a celebrated "space artist" with the National Aeronautics and Space Administration (NASA). The cover concept was an illustration of the album's title, which was conceived by Public Enemy's Chuck D as a way of translating the social theorist Neely Fuller's "color confrontation theory" into what Chuck D called "common talk." Chuck D sketched the cover design on a napkin and gave it to the Drawing Board, then Johnson created a super-realistic sci-fi painting of Planet Earth being eclipsed by the Black Planet of the album's title, despite the fact that Johnson, who had never heard of Public Enemy prior to this, was dubious that real-world astrophysics supported Chuck D's vivid imagination. Besides these seminal covers, the Drawing Board designed key artwork and soundtrack album packaging for the popular films *Belly* (1998), *Rush Hour* (1998), *Next Friday* (2000), and *Daddy Day Care* (2003), and worked for an array of labels—Bad Boy, MCA, Universal, Warner Bros., and BMG—as well as an all-star cast of artists, including Mary J Blige, the Notorious B.I.G., Faith Evans, Ice Cube, and R. Kelly.

Affectionately called "the Motown of aspiring graphic artists" by Adams, the Drawing Board brought a group of talented artists and designers together, all united by their love for the music. Adams explains, saying, "Most of these people were fans of the music who read about what we were doing and came to New York to work with us at Def Jam. It was mind-boggling to me." Fans themselves, the Drawing Board didn't "want to speak down to the

audience, we wanted to uplift them," says Adams. "Rap graphics had a very specific and stereotypical look then, and we wanted to break that mold: brick walls, guys in a b-boy pose, graffiti, et cetera. We wanted the same creative freedom that pop artists enjoyed. If Public Enemy was selling as many records for Columbia as Mariah Carey—and they were—then we deserved an art budget on Mariah's level."

As time went on, the Drawing Board won renown not only for the high quality of their work, but also for assembling a staff of unusual ethnic diversity. "Unlike me, the people we hired weren't kids who came from the street," says Adams. "They were college-educated and they brought a whole different frame of reference to the game." Over the years, the Drawing Board cultivated the professional development of several top designers, including Kenny Gravillis, Kiku Yamaguchi, Dee DeLara, Angela Williams, Jane Morledge, Darius Wilmore, Julian Alexander, Jason Noto, and Akisia Grigsby; photographers Danny Clinch, Michael Lavine, B+, and Jonathan Mannion; and illustrators Andre Leroy Davis, Todd James, and Cbabi Bayoc. Many of these individuals have gone on to have formidable careers of their own; their most important graphic design contributions are profiled below, as selected by Adams, along with the works of some of hip-hop's greatest designers.

After getting his start at the Drawing Board, graphic designer Kenny Gravillis moved to Los Angeles to become the creative director at MCA. In 1999, he designed the package for the Roots's *Things Fall Apart*. A limited-edition release of the CD featured five different covers, each one built around a searing black-and-white documentary photo of the struggle of people of African descent. These images connected the hip-hop generation to their forebears, and illustrated exactly which kinds of history the Roots were rooted in.

Adams explains, "It's a great idea, of course. But for him [Gravillis] to have been able to *realize* it was revolutionary. Five different covers!? The only thing close to it occurred in 1986, when Profile issued Run-DMC's *Raising Hell* with two different covers. And even that was probably by accident. I imagine that the designer showed the label two separate mock-ups and the label said, 'Let's make both.'

"The point is that the biggest challenge for every designer is not creating the work, it's getting the design approved by the folks on the business side. Every day is a battle with these people. You have marketing people getting in the way, and management, and most often, the artist himself," Adams says.

"When we decided to use Albert Watson's photos of LL Cool J for the cover of *All World: Greatest Hits* in 1996, I thought the work was so amazing that I didn't want any typography on the cover. Sometimes the best thing you can do as a designer is to know when to get out of the way of the work. Of course, the execs at Def Jam disagreed with me at first, so when I finally got them to say yes, it was a real triumph."

Another Drawing Board associate, illustrator Andre Leroy Davis, a.k.a. A.L. Dre, made his design bones as the creator of "The Last Word," a timely and amusing one-page caricature of rap's biggest stars that graced every issue of *The Source* between September 1990 and January 2007. Although he thinks of himself as "the Al Hirschfeld of hip-hop," in truth Davis's work more readily recalls the riotous full-color "fold-ins" of *MAD* magazine in its glory days. Davis has provided a visual record of the world of hip-hop entertainment and its entertainers for the last twenty years. A lifelong Brooklynite, Davis says, "I am an artist, writer, journalist, manager, producer, teacher, and semi-retired emcee—it's always in the blood." Davis and his old friend Kevin Greene are partners in a design firm called Melanin, Inc.

Doug Cunningham and Jason Noto, known collectively as Morning Breath, first teamed up to design skateboards in San Francisco during the early 1990s. They formed the Morning Breath design firm in Brooklyn in 2002, after Jason served a two-year stint at the Drawing Board. They have since made their mark on the design of snowboards, sneakers, silk-screened posters, logos, video games, advertising, and clothing. Portland, Oregon's Fifty 24PDX Gallery, which hosted a show of the pair's artwork, described Morning Breath as "[fusing] portraiture, collage, and digital composition . . . to explore gritty inspiration from tats, muscle cars, pointed push-up bras, the back of comic books, bail bonds, Mexican wrestlers, and little kids." In both their fine art and their commercial art, Morning Breath's compositions tend be crowded, but balanced and clean—and as funky as an early bird with a worm in its mouth.

As design director at Sony Urban Music from 2000 to 2004, Drawing Board's Julian Alexander shared a Grammy Award with two of his colleagues for the packaging of *The Complete Jack Johnson Sessions* by Miles Davis. Now the head of SLANG Inc., his own design firm, Alexander has packaged virtually all of the G-Unit's releases, including 50 Cent's *Get Rich or Die Trying* (2003) and *The Massacre* (2005), as well as titles by Tony Yayo, Young Buck, Lloyd Banks, Mobb Deep, and the Game. SLANG Inc.'s ruling aesthetic mirrors the "smooth criminal" ideal of the artists themselves: rough, tough, and stylish all at the same time.

After starting out as the head designer for Tommy Boy Records's clothing line in 1992, D.L. Warfield moved on to Atlanta's LaFace Records in 1995. In this position, Warfield became a kind of southern equivalent of Adams at Def Jam. "D.L. took his work seriously," says Adams. "He's a hip-hop guy himself. He understood the unique personality of each of the label's recording artists, as well as what they were trying to achieve from album to album. I remember when OutKast's Andre 3000 stood up at The Source Awards in New York in 1995 and said, 'The South's got something to say.' This was when the East Coast was battling the West Coast and nobody was checking for music from the South. That kind of local pride was definitely expressed in OutKast's rhymes. And D.L. reflected it on their album covers, too."

Designer Brent Rollins is probably best known today as the graphics star affiliated with Ego Trip, the New York–based hip-hop brain trust that has churned out a series of remarkably amusing, intelligent, and good-looking magazines, books, and television shows during the last ten years. Born and raised in South Central Los Angeles, Rollins made a splash in the hip-hop world at the age of eighteen, when he designed the logo for Spike Lee's *Mo' Better Blues* (1990), well before he graduated from the design program at UCLA. A year later, he designed the logo for John Singleton's *Boyz n the Hood* (1991). While still on the left coast, Brent was the art director of *Rap Pages* magazine between 1994 and 1996, a period during which, he says, he found himself channeling the influence of George Lois, the legendary art director of *Esquire* in its heyday. Over the years, Rollins has designed many album covers, including Gang Starr's *The Ownerz* (2003), Blackalicious's *Blazing Arrow* (2004), and Dilated Peoples's *20/20* (2006).

Brent's signature style is very distinctive, usually involving mixed-media collage, the unlikely juxtaposition of "found" magazine images, and bold, flowing typography, all animated by a sense of playfulness. "It might sound a little corny, but my creative process is like 'visual deejaying,' " he said in an online 2005 interview with the Heavyweight production house. "When I can't find something specific, I might draw or photograph what I need." Although Brent's work-for-hire album-cover art is certainly representative, it is not as unfettered as his work on Ego Trip's books and television shows, which is edgy enough to invite comparison to Terry Gilliam.

Like Phase 2 and Buddy Esquire, Eric Haze was a writer and an early star of New York's downtown art scene in the early 1980s. He traded in some of his street cred to hit the books at the School of Visual Arts. Though he was teased by pals for going to the college, Haze shrugged off the ridicule, saying, "Standing at that crossroads between fine art and graphics, I began to question how the art world's elitism squared with graffiti's populism. When the choice came down to making a million-dollar painting or a million one-dollar stickers, design was a more natural progression for me."

Haze made an immediate connection between corporate branding and graffiti. "Branding is built into graffiti," he explains. "You start by doing throw ups and with constant repetition you establish familiarity." In other words, what the writer calls his tag, the corporate world calls a logo, and Haze eventually designed some of hip-hop's most memorable ones, from Public Enemy's b-boy-in-the-crosshairs logo to Delicious Vinyl's logo, a piece that radiates stylish Southern Californian mobility and neon cool. Working with photographs by Glen E. Friedman, who created indelible portraits of some of the most important rappers of the mid-1980s, Haze also designed groundbreaking album-cover art for Public Enemy's *Yo! Bum Rush the Show* and LL Cool J's *Bigger and Deffer* (both 1987), not to mention the cover for the Beastie Boys's "Hold It, Now Hit It" single in 1986. In 1992, Haze designed the Beastie's *Check Your Head*.

Looking back over the last twenty years of graphic design on the black side of the music business, Adams sees a lot of progress, both creatively and socially. Indeed, the two developments are intertwined. "CBS didn't understand the music we were making at Def Jam in the mid-1980s, nor how to make art for it. Now that more young people from the culture have the opportunity to work as professionals in the design field, the graphic art created to accompany the music does a much better job of reflecting the music than it used to. That's for sure."

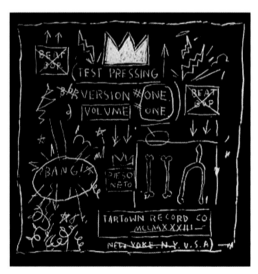

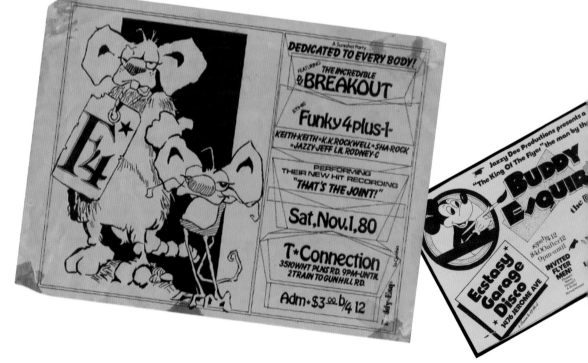

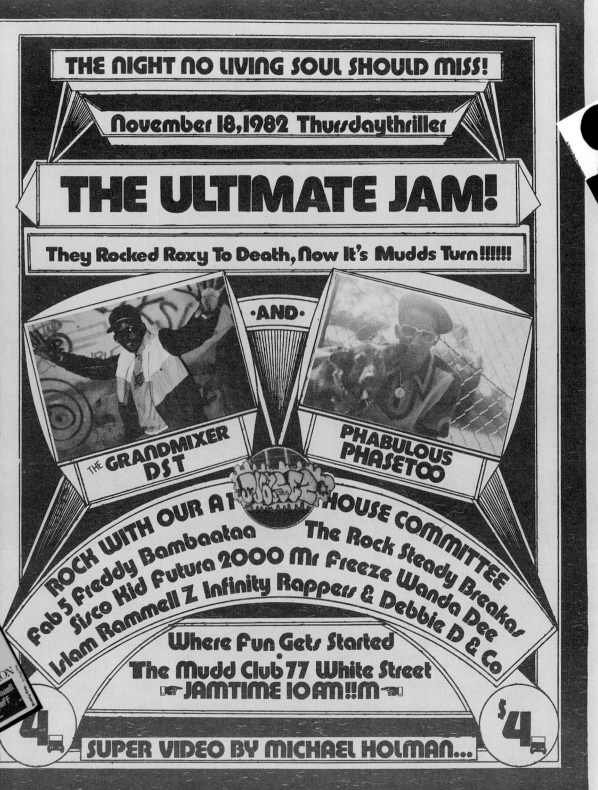

THE NIGHT NO LIVING SOUL SHOULD MISS!

November 18, 1982 Thursday thriller

THE ULTIMATE JAM!

They Rocked Roxy To Death, Now It's Mudds Turn!!!!!!

·AND·

THE GRANDMIXER DST

PHABULOUS PHASETOO

ROCK WITH OUR A1 HOUSE COMMITTEE

Fab 5 Freddy Bambaataa The Rock Steady Breakas
Sisco Kid Futura 2000 Mr Freeze Wanda Dee
Islam Rammell Z Infinity Rappers & Debbie D & Co

Where Fun Gets Started
The Mudd Club 77 White Street
JAMTIME 10 PM!!!

$4 $4

SUPER VIDEO BY MICHAEL HOLMAN...

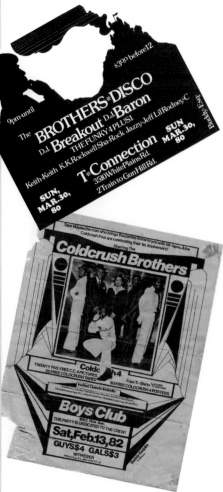

From left to right:

JEAN-MICHEL BASQUIAT
Rammellzee Vs. K-Rob, Beat Bop, 1982,
12-inch single cover

BUDDY ESQUIRE
Funky 4, 1980,
Party flyer

BUDDY ESQUIRE
Ecstasy Garage, 1980,
Party flyer,
Courtesy of the Experience Music Project

PHASE 2
Ultimate Jam, 1982,
Party flyer

BUDDY ESQUIRE
Brothers Disco, 1980,
Party flyer

BUDDY ESQUIRE
Coldcrush, 1982,
Party flyer

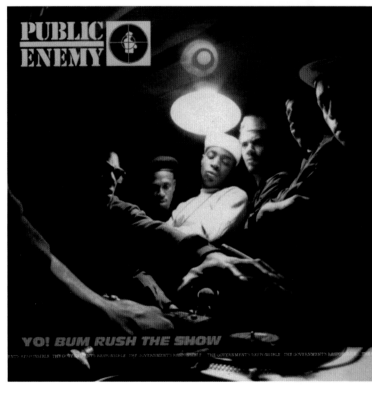

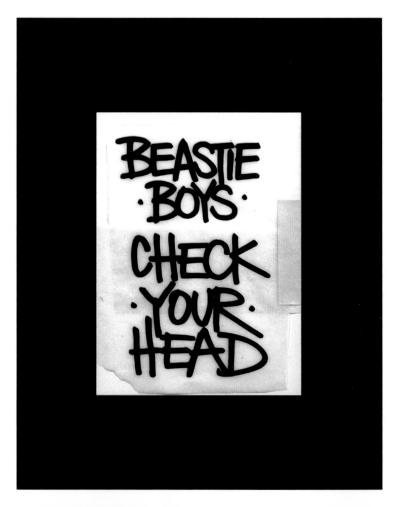

Clockwise from top:
HAZE
Tommy Boy logo redesign, 1985
Beastie Boys, *Check Your Head* album lettering, 1992
Tone Loc, *Loc-Ed After Dark*, 1989
LL Cool J, *Bigger and Deffer*, 1987
EPMD sketch for logo design, 1988
Public Enemy, *Yo! Bum Rush the Show*, 1987
LL Cool J logo design, 1987

Opposite:
Haze logo,
Circa 1970

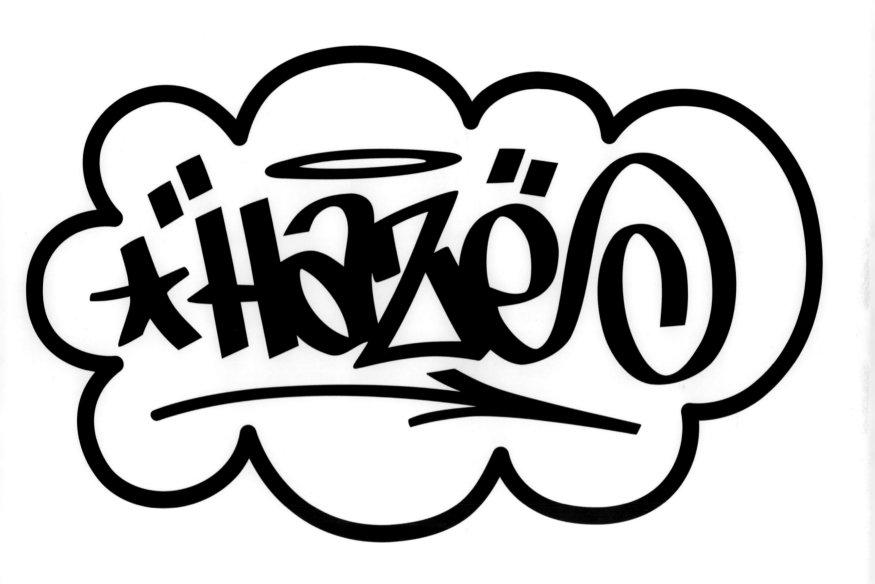

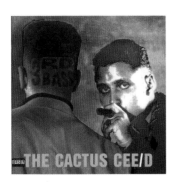
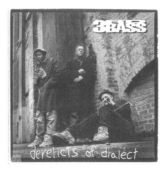
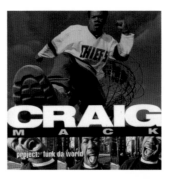
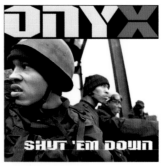
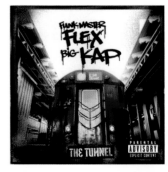

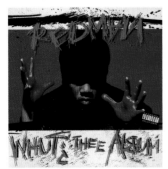
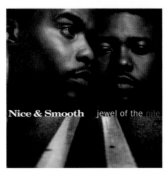
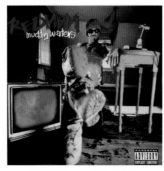
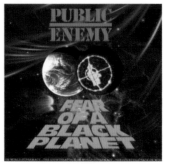
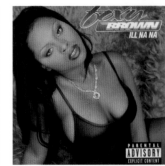

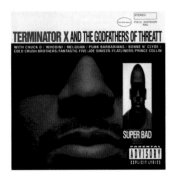
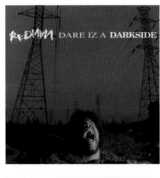
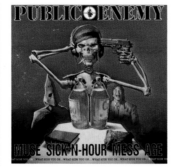
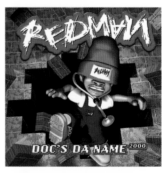
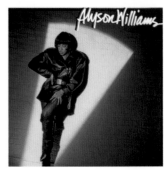

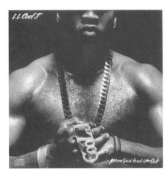
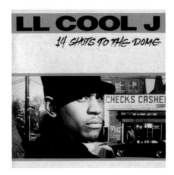

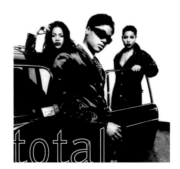
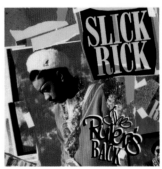

DRAWING BOARD DESIGN CEY ADAMS, STEVE CARR, JEFF CAUFIELD, BETH COLETTE, DEE DELARA, KENNY GRAVILLIS, AKISIA GRIGSBY, BILL MCMULLEN, ROSA MENKES, JANE MORLEDGE, JASON NOTO, SCOTT SANDER, HEIDI SCHUESSLER, DAWUD WEST, ANGELA WILLIAMS, DARIUS WILMORE, KIKU YAMAGUCHI, CHRIS YORMICK

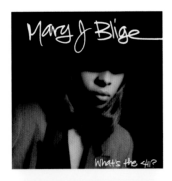 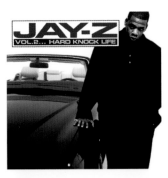 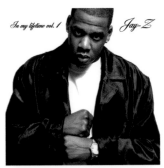 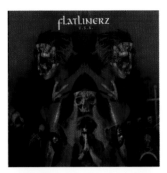 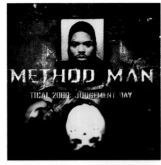

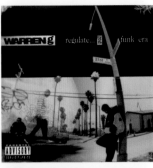

 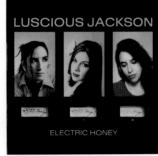

"Hip-hop is a culture. The way it looks has always been as important as the way it sounds. We relied on the Drawing Board to make our work look as official as anything coming out of the world of rock."

—Public Enemy's Chuck D, April 2008

Opposite, top row, left to right:
3rd Bass, *The Cactus Album*, 1989
3rd Bass, *Derelicts Of Dialect*, 1991
Craig Mack, *Project: Funk Da World*, 1994
Onyx, *Shut 'Em Down*, 1998
Funkmaster Flex and Big Kap, *The Tunnel*, 1999

Opposite, second row, left to right:
Redman, *Whut? Thee Album*, 1992
Redman, *Dare Iz a Darkside*, 1994
Redman, *Muddy Waters*, 1996
Redman, *Doc's Da Name*, 1998
Alyson Williams, *Alyson Williams*, 1992

Opposite, third row, left to right:
Terminator X And the Godfathers of Threatt,
Super Bad, 1994
Nice & Smooth, *Jewel of the Nile*, 1994
Public Enemy, *Muse Sick-N-Hour Mess Age*, 1994
Public Enemy, *Fear of a Black Planet*, 1990
Foxy Brown, *Ill Na Na*, 1996

Opposite, fourth row, left to right:
LL Cool J, *Mama Said Knock You Out*, 1990
LL Cool J, *14 Shots to the Dome*, 1993
LL Cool J, *All World: Greatest Hits*, 1996
Total, *Total*, 1996
Slick Rick, *The Ruler's Back*, 1991

This page, top row, left to right:
Mary J Blige, *What's the 411?*, 1992
Jay-Z, *Vol.2 Hard Knock Life*, 1998
Jay-Z, *In My Lifetime, Vol.1*, 1997
FlatLinerz, *USA*, 1994
Method Man, *Tical 2000: Judgement Day*, 1998

This page, second row, left to right:
Warren G, *Regulate…G Funk Era*, 1994
Beastie Boys, *Hello Nasty*, 1998
Luscious Jackson, *Electric Honey*, 1999
EPMD, *Business as Usual*, 1990
Lost Boys, *Legal Drug Money*, 1995

This page, third row, left to right:
DMX, *It's Dark and Hell is Hot*, 1998
DMX, *Flesh of My Flesh, Blood of My Blood*, 1998
Heavy D & the Boyz, *Blue Funk*, 1992
Montell Jordan, *More*, 1996
Geto Boys, *The Resurrection*, 1996

This page, fourth row:
Cru, *Da Dirty 30*, 1997
.

Mary J Blige

Chappelle's Show

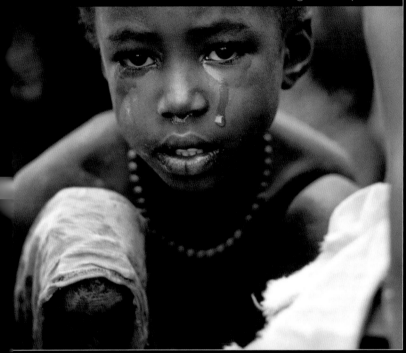

THE ROOTS
things fall apart

MCAD-11830 okay player.

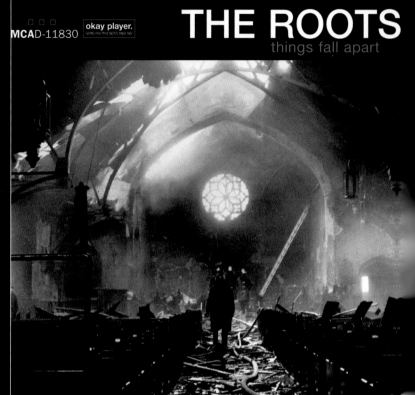

THE ROOTS
things fall apart

MCAD-11830 okay player.

THE ROOTS
things fall apart

MCAD-11830 okay player.

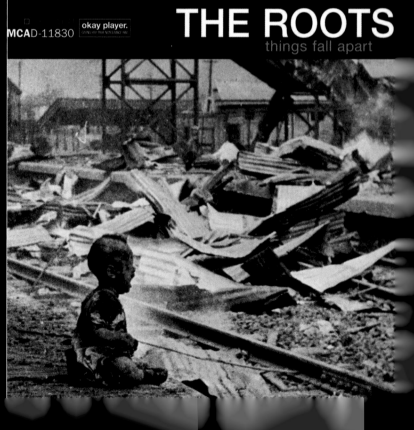

THE ROOTS
things fall apart

MCAD-11830 okay player.

MCAD-11830

okay player.
GIVING YOU TRUE NOTES SINCE 1987

THE ROOTS
things fall apart

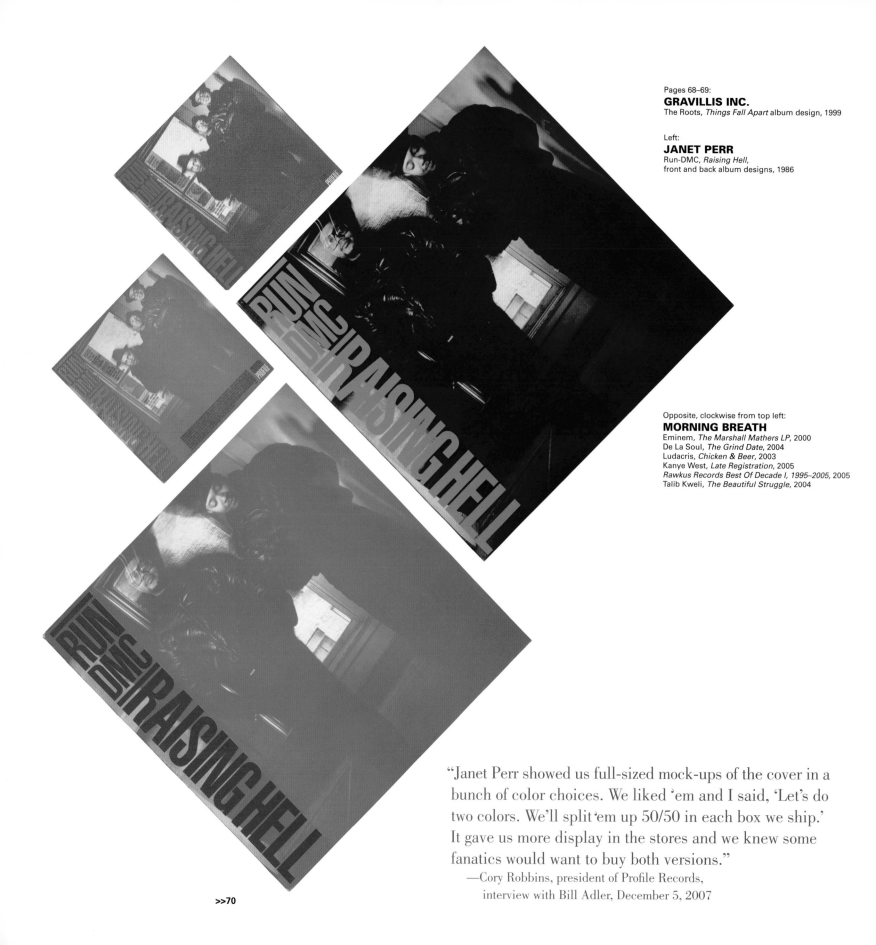

Pages 68–69:
GRAVILLIS INC.
The Roots, *Things Fall Apart* album design, 1999

Left:
JANET PERR
Run-DMC, *Raising Hell*,
front and back album designs, 1986

Opposite, clockwise from top left:
MORNING BREATH
Eminem, *The Marshall Mathers LP*, 2000
De La Soul, *The Grind Date*, 2004
Ludacris, *Chicken & Beer*, 2003
Kanye West, *Late Registration*, 2005
Rawkus Records Best Of Decade I, 1995–2005, 2005
Talib Kweli, *The Beautiful Struggle*, 2004

"Janet Perr showed us full-sized mock-ups of the cover in a bunch of color choices. We liked 'em and I said, 'Let's do two colors. We'll split 'em up 50/50 in each box we ship.' It gave us more display in the stores and we knew some fanatics would want to buy both versions."
—Cory Robbins, president of Profile Records, interview with Bill Adler, December 5, 2007

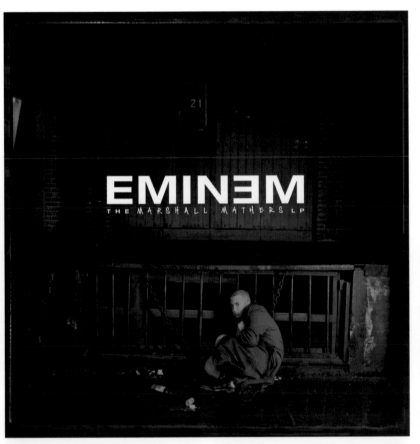

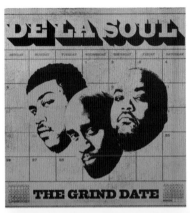

This page, clockwise from top left:

SLANG INC.
Tony Yayo logo design, 2005
50 Cent, *Get Rich or Die Tryin'*, 2003
Lloyd Banks, *The Hunger for More*, 2004
Mobb Deep, *Blood Money*, 2006
Foxy Brown logo design, 2001
Lloyd Banks, *Rotten Apple*, 2006

Opposite:

ANDRE LEROY DAVIS
KRS One Tosses Prince B (Duck Down), 1992,
Pencil, ink, and Dr. Martin's dyes

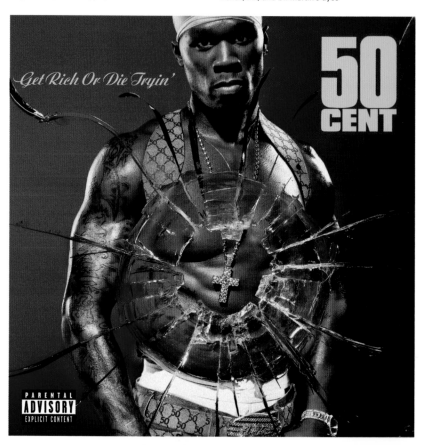

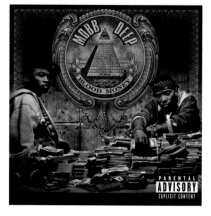

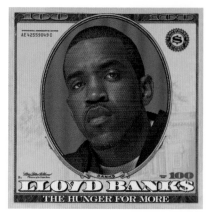

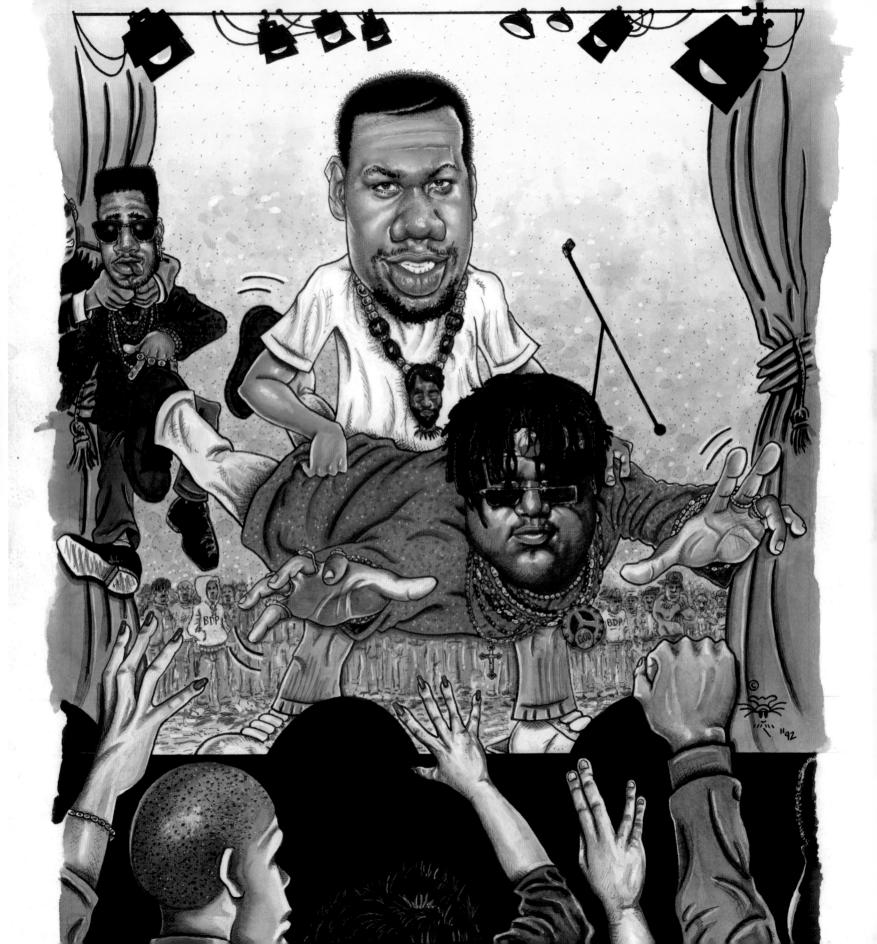

Clockwise from top left:
BLK/MRKT
DJ Spooky, *Riddim Warfare*, 1988
The New Jersey Turnpikes movie poster, 1988
DC Shoes logo design, 1994
Black Eyed Peas, *Elephunk* logo design, 2004
N.E.R.D. logo design, 2002

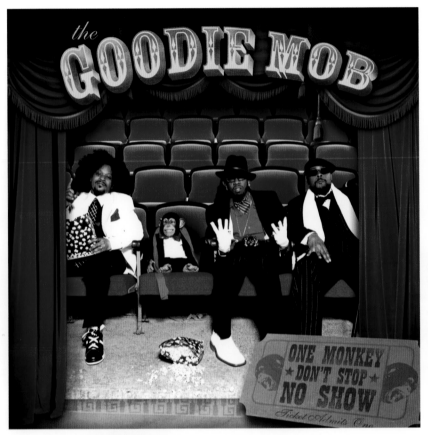

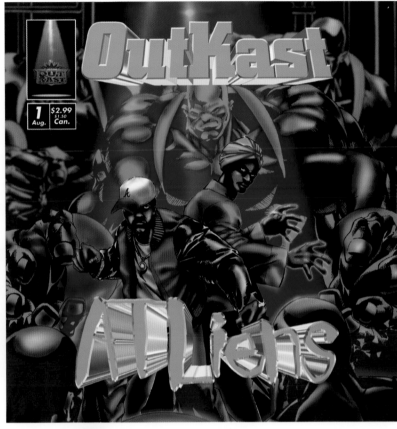

Clockwise from top left:
D.L. WARFIELD
Goodie Mob, *One Monkey Don't Stop No Show*, 2004
OutKast, *ATLiens*, 1996
Sho'Nuff logo design, 2005
Nike *Represent* logo design, 1998
OutKast logo design, 2000
Soul Chemistry logo design, 2003

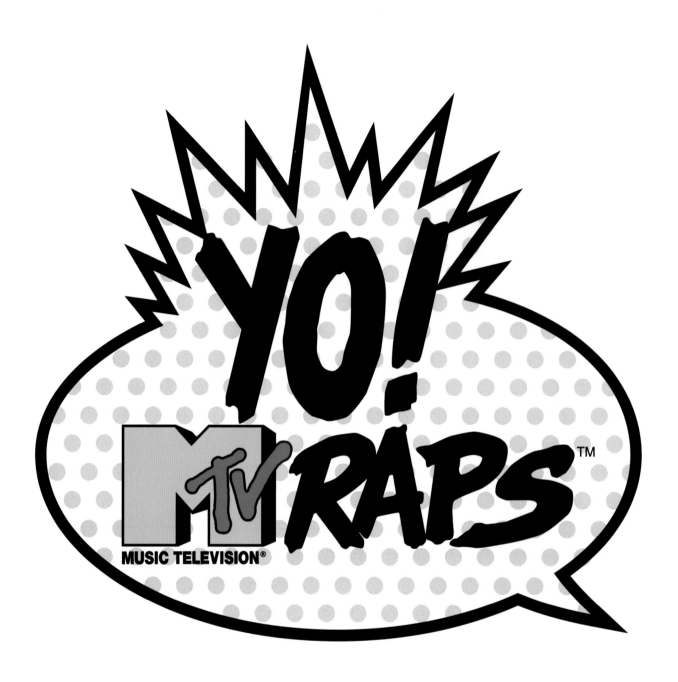

REVOLT
Yo! MTV Raps logo design, 1988

Opposite, top:
KIKU YAMAGUCHI & JANE MORLEDGE / BENTO DESIGN
Mos Def, *Black on Both Sides*, 1999

Opposite, left:
KIKU YAMAGUCHI
Hip-Hop Theater Festival '06 poster design, 2006

Opposite, middle:
KIKU YAMAGUCHI
Teardrop movie poster design, 2006

Opposite, right:
KIKU YAMAGUCHI
HardLife v.2, illustration, 2007

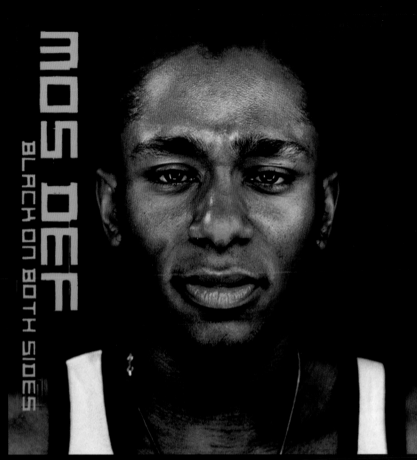

MOS DEF
BLACK ON BOTH SIDES

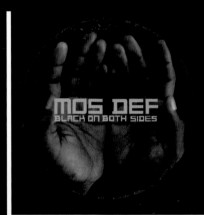

MOS DEF
BLACK ON BOTH SIDES

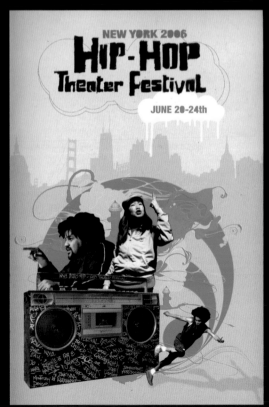

NEW YORK 2006
HIP-HOP
Theater Festival
JUNE 20-24th

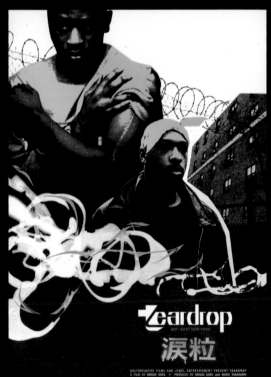

Teardrop
BPF · EAST NEW YORK
涙粒

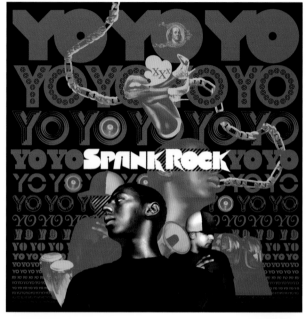
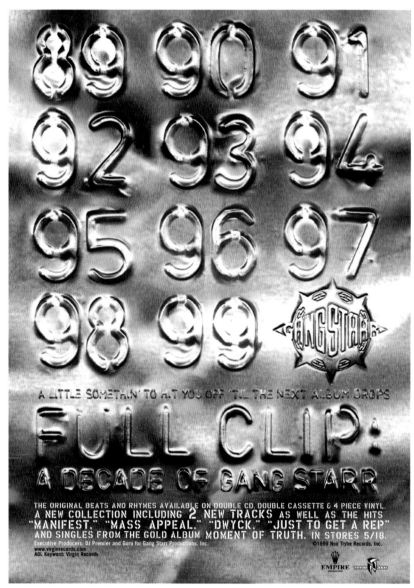
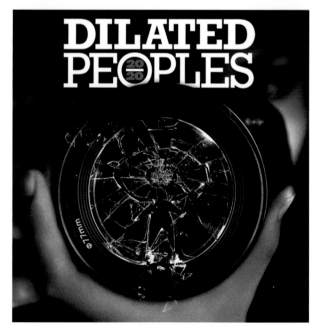

egotrip

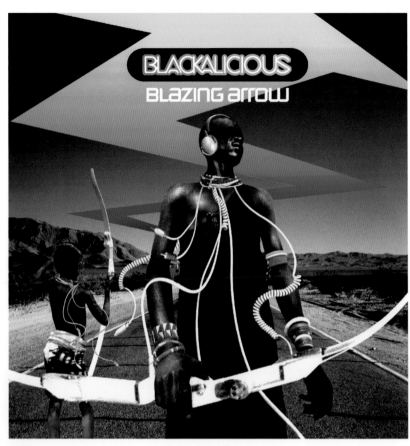

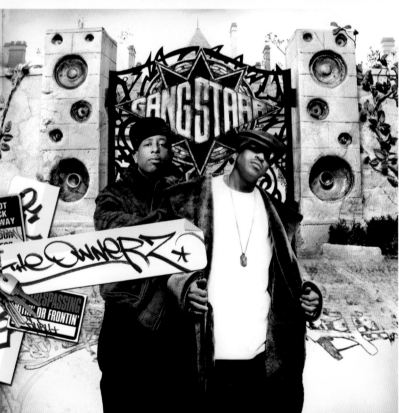

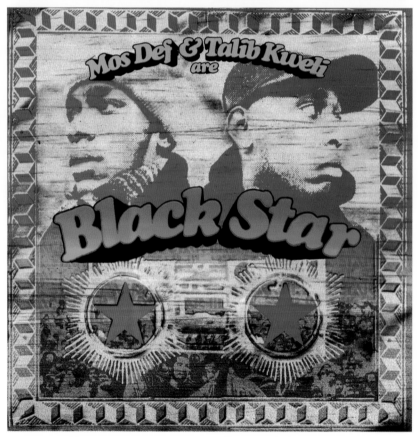

Opposite, clockwise from top left:
BRENT ROLLINS
Boyz n the Hood logo design, 1991
Grandad's Nerve Tonic logo design, 2007
Spank Rock, *Yoyoyoyoyo*, 2006
Dilated Peoples, *20/20*, 2006
Ego Trip logo design, 1997
Gang Starr, *Full Clip* advertisement, 1999

This page, clockwise from left:
BRENT ROLLINS
Blackalicious, *Blazing Arrow*, 2002

EGO TRIP
Left to right: Elliott Wilson, Gabriel Alvarez,
Sacha Jenkins, Brent Rollins, Chairman Mao,
New York, 1999

Black Star, *Mos Def & Talib Kweli are Black Star*, 1998
Gang Starr, *The Ownerz*, 2003

Clockwise from left:
MAXX 242
Real, 2006,
Created with Adobe Illustrator,
Courtesy of Real Skateboards

MAXX 242
Kastr, 2007,
Ink on paper

MAXX 242
Tribal, 2006,
Created with Adobe Photoshop,
Courtesy of Tribal Skateboards

Opposite:
MAXX 242 & FRANCISCO RIVERA
Inkhouse, 2004

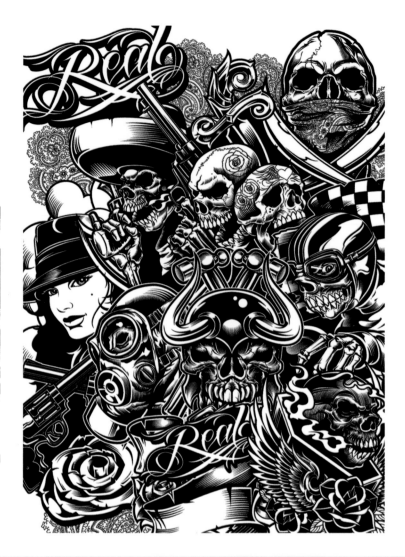

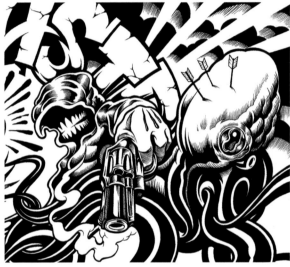

ED RENFRO
Beastie Boys,
Illustration for T-shirt design, 2004

Opposite:
BUTCH BELAIR
Notorious B.I.G., *Ready to Die,* 1994

TAGS

HIP-HOP AND ADVERTISING

FROM TO RICHES

BY TAMARA WARREN

AKISIA GRIGSBY
Sean John eyewear advertisement, 2006

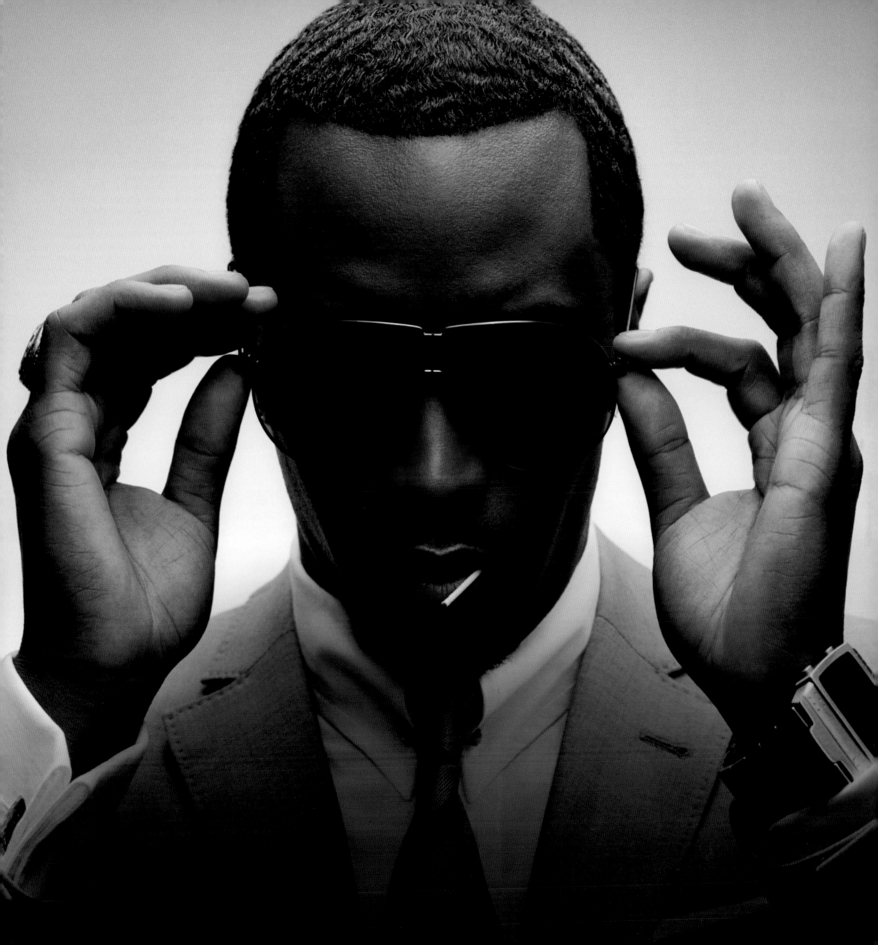

> "A female rapper with the message to send/
> Queen Latifah is a perfect specimen."
> —Queen Latifah, "Ladies First"

Perhaps Queen Latifah foresaw the future when she composed the above lyrics on her first album. Fifteen years later, she was the inspiration for a line of Cover Girl makeup called Queen Collection. The purple tagline, "Every woman is a queen," accompanied her portrait and may as well have been a quote from her own musical canon.

From the beginning of her career, Queen Latifah let it be known that she was a leader. In the 1989 video for "Ladies First," she introduced a fresh take on what hip-hop looked and sounded like. Clad in a smart white suit adorned with designer Todd Oldham's red, black, and green military bar pins, she appeared as a regal general, with her pointer focused on a map of the African continent.

"Queen Latifah had this really strong, confident personality. She was saying something new and she was saying it with a lot of authority," says Monica Lynch, who was president of Tommy Boy Records in those days. "You could really go to town with her, and we did. She wore a lot of fantastic headgear, she had an Afro-centric look, and her videos were phenomenal. *Yo! MTV Raps* and *House of Style* had just come on the air and there was some cross-pollination of those two shows. *Yo! MTV Raps* booked Queen Latifah because she was a conscious and confident rapper, while *House of Style* booked her because they liked Todd Oldham." The latter show's producers also studied *Yo! MTV Raps*, which featured an ever-changing cast of good-looking young artists with their own sense of style, for trendsetting fashion cues and quickly realized they needed to follow suit. Not every rapper merited this double exposure, but Queen Latifah did.

Despite the fact that Queen Latifah appealed to both the hip-hop and the fashion crowds, the mainstream marketing industry had difficulty accepting her as a possible spokesperson. In the late 1980s, rappers were still considered renegades, stirring up the music industry. As hip-hop has become more and more entrenched in pop culture, Queen Latifah has evolved into a movie star, a chanteuse, and a one-woman advertising powerhouse, endorsing everything from Cover Girl to Curvations to Pizza Hut.

"The biggest thing about advertising," says Keith Clinkscales, a founder of *Vibe*, "is that it tries to denote to its consumers credibility, authenticity, and urgency. There's nothing more credible, nothing more authentic, and nothing more urgent than hip-hop."

Hip-hop advertising has never been monolithic; it takes on many faces. Just like rap music, it can be tasteful, tacky, raw, refined, relevant, and frivolous. It frequently reclaims and recycles its roots, reintegrating imagery from the past into the present. It's a Cross Colours ad from the late 1980s that includes a logo for the social justice campaign Stop the Violence. It's the debonair Pharrell as the face of Louis Vuitton. It's Absolut Vodka commissioning artists to create various campaigns, like their 2007 limited-edition "bling" bottle, that tap into hip-hop's sense of style and overall coolness.

Former record executive Steve Stoute's company, Translation, connects hip-hop's top stars with America's biggest national brands. Translation paired Justin Timberlake with McDonald's for its popular "I'm lovin' it" 2003 campaign; T.I. with Chevrolet; and Jay-Z with Hewlett-Packard. Stoute explains these relationships, saying, "When you find the shared values, you execute the idea, keeping in mind those shared values. Therefore you do right by the company and by the artist." In other words, mainstream media won't climb into bed with rappers of color until the brand is convinced that the rapper in question truly represents the brand's target audience, which is mostly comprised of young, stylish, status-conscious, discriminating, and acquisitive individuals. Jay-Z's commercial for Hewlett-Packard is a perfect synthesis of artist and company branding. Stoute says, "I love the idea that you got $30 million in media running with Jay-Z, who's hanging up a sign for Roc-a-Fella that reads 'CEO of hip-hop.' That's my job: to get Hewlett-Packard to understand it's okay for him to do that; it doesn't take them out of their comfort zone."

SPREADING THE WORD

By the early 1980s, word of hip-hop's vitality had spread from the New York streets by virtue of brazen graffiti lettering. Graffiti moved from subway trains to handmade party flyers and 'zines like the *Hip-Hop Hit List*. Rap record labels developed new looks and creative concepts as artists honed their craft. The splashy, handmade-looking, orange-and-pink graffiti-styled logo on the cover of Run-DMC's first album in 1984, for example, was replaced with a more authoritative black, white, and red machine-made logo a year later.

Outlets for advertising were scant in the early days of hip-hop; hip-hop-oriented music videos, street teams, magazines, and television shows would come later. Instead, record labels relied on their own in-house talent to finesse the marketing of their artists. When Ann Carli came on board as vice president of A&R at Jive Records in 1984, more care went into all of the decisions about an artist's "packaging." Carli took control of all the art and videos for the American groups. (The label had been based in England.) Not only did Carli run all the photo shoots, but she also chose all the photos and worked with the artists on every aspect of production. She says, "I tried to create visual work that reflected not only the artist's identity, but the artist's audience."

The album covers that Carli developed for her artists—Whodini, Boogie Down Productions and KRS-One, and A Tribe Called Quest, to name a few—broadened the hip-hop aesthetic. "Up until that time most of the imagery had to do with gold chains, graffiti, and subway trains. And there's nothing wrong with that, but it was starting to seem stereotypical," she says. Whodini's *Back in Black* (1986) took the trio out of the street and into a studio, where they were posed against a neutral background, the better to see that these stylish young rappers were not Hip-Hop Everymen, but individuals repping no one but themselves. The cover of Boogie Down Productions's *By All Means Necessary* (1988) made the connection between the black nationalism of the 1960s and the conscious rap of the 1980s by re-creating the iconic photo of a wary

Malcolm X peering through a window with a gun in his hand, except this time it was KRS-One on the lookout. And A Tribe Called Quest's *The Low End Theory* (1991) featured a woman whose naked profile was decorated with red, black, and green stripes, a way of connoting sex and Afrocentrism simultaneously.

Commercial radio stations in the 1980s largely refused to play rap records. Hip-hop mix shows were devoted to rap, but these weekly shows were relatively short, leaving little time for the deejays to convey anything more than the artists' names and the record titles. Consequently, the indie rap record labels of the day were forced to figure out new and creative ways to promote their product. In 1990, Digital Underground released an album entitled *Sex Packets*, the title song of which described an imaginary aphrodisiac in pill form. Tommy Boy made them real, creating "sex packets" by putting a sugar tablet in tinfoil decorated with a photo of a sexy cover model, and then mailing them out to their press list, handing them out at live concerts, et cetera. The packets quickly became much sought-after. The label also produced promotional stickers to accompany Naughty by Nature's 1991 releases of the "OPP" video, which sparked an advertorial movement. Soon every project had to have a sticker. Tommy Boy designed lanyards—VIP credentials-holders worn around the neck—for the New Music Seminar, the large annual music business convention of the mid-1980s and early 1990s. They immediately became a coveted sign of industry status, and a fashion trend sold by street vendors. "The thing about hip-hop is that everyone wanted to be official," says Monica Lynch. "The lanyard showed that you were down, if not in the industry, then that you had a connection with the industry and were cool enough to be on a promotional list."

Though rap record sales soared in the mid-1980s, mainstream corporations remained cautious about aligning themselves with the growing hip-hop fan base. In 1986, Carli reached out to Fila to contribute tracksuits for Whodini to wear in their "One Love" video. She says, "I remember being told by the PR rep for Fila that they weren't interested in Whodini's fans wearing Fila, that that was not their market." At a time when corporate America still labored under the mistaken assumption that all rap fans were black and poor, the PR rep's comment was code: Fila was scared of attracting black customers, whom they distrusted. This tired, age-old scenario was based on racial assumptions, and was deeply reminiscent of a conversation between Bloomingdales's Marvin Traub and *New York Post*'s Rupert Murdoch in the early 1980s, in which Traub explained why the posh department store wouldn't advertise in that newspaper by saying, "Your readers are our shoplifters." Things had changed by 1993, when Fila decided it was prudent to start advertising in *The Source*.

"Today, the demographic that listens to hip-hop has broadened, and the hip-hop population has more money to spend and is being courted by corporations like Fila," says Carli. "But even Nike back in the day didn't want to have a hip-hop artist signed as a spokesperson. In the late 1980s, they would give you as many free sneakers as you wanted, but it was tough to convince them to hire our stars to endorse their products on the national stage."

THE AGE OF ADVERTISING

As the music broke through, so did the media. In 1988, a couple of Harvard students named Dave Mays and Jon Shecter launched *The Source*. Over the next decade, it grew into a glossy, well-respected monthly and was thought of as the *Rolling Stone* of hip-hop. Record labels bought the majority of the magazine's first ads. While Jive and Def Jam were well represented within the magazine, it was Tommy Boy who nailed down the back page—prime advertising real estate. Creating ads that got people's attention, Tommy Boy took the back page very seriously. One of its more memorable and amusing ads featured the New York City radio deejay Fat Man Scoop wearing very traditional and WASPy golf apparel. "It was a precursor to the Farnsworth Bentley aesthetic," Lynch says. "It wasn't a dominant look in the day, at least not in hip-hop circles. But it planted the seeds for what became an emerging [fashion] trend."

"At Def Jam they always insisted on putting the artist's image right in the middle of everything," Cey Adams says. "At labels like Tommy Boy and Jive, there was the freedom to be more conceptual." Still, Def Jam managed to occasionally push the advertising envelope, most notably when the label bought a double-page spread in *Billboard* for Public Enemy's *Fear of a Black Planet*, an ad designed by the Drawing Board and illustrated by Bill Sienkiewicz. "That was an extravagant purchase for hip-hop in 1990, and you certainly don't see much of that happening today," Adams says.

Soon film and fashion entered the picture, catching the attention of watchful hip-hop audiences. Spike Lee's films and his ads for his Brooklyn-based store, Spike's Joint, embodied an all-encompassing hip-hop lifestyle. Films like *Livin' Large, Boyz n the Hood*, and *New Jack City*, all released in 1991, featured heavily promoted rap soundtracks that were advertised in *The Source*. At the same time, lingering hand-drawn graffiti-style ads continued to appear, including a series of Bailey Broadcasting Services ads composed by Hank Ridley.

Early hip-hop-inspired clothing brands paved the way for later brands like Sean John, Rocawear, and G-Unit that continue to be forces in today's marketplace, and employ models of color and/or celebrity rappers in their advertising. Jerome Mongo teamed up with Maurice Malone to start Maurice Malone Hardware in 1984, with the memorable slogan, "Jeans for your ass." In 1989, the partners pooled the money they had made selling drugs to suburban Detroiters to take out a full-page ad in *Interview*, featuring themselves as the models. "We wanted to give the impression that our clothes were placed, as if *Interview* sought us out and took our photographs, although they didn't," Mongo said. The pair organized the photo shoot in downtown Detroit, with Stanley Kubrick's *A Clockwork Orange* as their inspiration. In 1993, the brand—by then shortened to Maurice Malone—was among the first advertisers in *Vibe*, along with designer brands Ralph Lauren and Guess, and liquor brands Dewar's and Southern Comfort.

The hip-hop clothing lines that sprang up in the early and mid-1990s—Karl Kani, FUBU, Van Grack, Dro Layer, Pelle Pelle, and Lugz—were prominently advertised in hip-hop media. Perhaps unsurprisingly, these ads featured strong masculine imagery and were often reminiscent of the album covers of the era. Soon, hip-hop fashion brands began relying on hip-hop celebrities to attract consumers. Fashion-conscious Sean "Diddy" Combs modeled for Karl Kani in an ad that appeared in *The Source* in June 1993, even before Combs's Bad Boy label took off. (Nearly two years earlier, in October 1991, he was an anonymous model in a feature story in *The Source* entitled "Fat Fashion.") But sportswear firms that were not rooted in hip-hop still kept the culture at arm's length, endorsement-wise, preferring star athletes to star rappers. Adidas ran ads in hip-hop publications featuring New York Giant Anthony Moss in June 1994. Suddenly, however, "there were Nike ads that had real crazy collaborations of athletes and hip-hop artists," recalls Keith Clinkscales. "The athlete denoted performance. The hip-hop artist denoted authenticity and credibility."

While *The Source* devoted itself to the grittier side of rap and street culture, *Vibe*—a joint venture between Quincy Jones and Time Warner—focused on a more sophisticated audience. "To differentiate ourselves from *The Source*, we went out of our way to make sure that our look and aesthetic was on a par with the finest publications out there," Clinkscales says. "It was a big risk."

Editor Jonathan Van Meter, art director Gary Koepke, and fashion director Michaela Angela Davis created the editorial content that would attract *Vibe*'s high-end advertisers. Koepke's decision to print the magazine on oversized paper was key. "He designed it like it was *Harper's Bazaar* or *Vanity Fair*," Clinkscales says. "It was based on white space and beautiful typography, very clean and very austere. He hired great photographers at the top of their game. That *Vibe* aesthetic then became the aesthetic used in videos."

While *Vibe* attracted high-end advertisers, there were times when the copy in those ads was not in tune with the magazine's mostly African-American and Latino readership. A back-cover ad for Southern Comfort in the October 1993 issue, for example, depicts a blonde couple at the beach. The blithe copy reads: "Life is not work. It can't be. It better not be." Even earlier, some brands appeared to be laughably unaware that their product had been adopted by the young subculturists. An ad for Kangol hats that ran in *Rolling Stone* in March 1988 features three models, all of them over thirty years old and not one with an atom of hip-hop flavor . . . and this was after four straight years of Run-DMC and LL Cool J (not to mention UTFO's Kangol Kid) sporting Kangols everywhere.

DAVID LACHAPELLE
Kimora Lee Simmons for Baby Phat advertisement, 2004

Eventually, the more traditional brands began to take their creative cues from the hip-hop brands. A 1999 Tommy Hilfiger ad in *The Source* showing Q-Tip at the keyboard was reminiscent of a very popular FUBU campaign that had run two years earlier, featuring LL Cool J in a recording studio.

Mainstream beverage brands began to employ hip-hop vernacular. Think of Coca-Cola's 1995 slogans "Always Phat" and "Get Ur Chill On." Crown Royal, ringing a change on record industry slang, created an ad with a photo of both a large and a small bottle of the high-end liquor. The copy? "Went gold. Went platinum."

Dave Kinsey, who began his art career designing skateboards and writing graffiti, conducts his commercial design work under the banner of Blk/Mrkt Communications. When Blk/Mrkt undertook the assignment of "rejuvenating" the Hawaiian Punch brand, they did so by resorting to classic graffiti forms (bubbles and cityscapes) and street art techniques (the subtle way one color fades into another). The firm's billboard campaign for Heineken in 2004/2005 was built around a one-word slogan redolent of hip-hop: respect. The illustration was of an emcee, a deejay, and a drummer, with a Heineken bottle displayed prominently. Adams notes that it's a sign of the times that Blk/Mrkt was even awarded the account. It would not have gone to a firm run by an artist with Kinsey's c.v. ten years earlier.

As a certain segment of the hip-hop nation was indeed going platinum, the imagery of ad campaigns for hip-hop brands grew increasingly luxurious. While early ads for Russell Simmons's Phat Farm were casual, the brand was featuring models playing with pets in a spacious country home setting by 2001. But these were nothing compared to the lavishness of the ads for Baby Phat, a joint venture of Simmons and his wife Kimora Lee Simmons, the former supermodel. Kimora herself was the face—and the body—of the brand. Top fashion photographers shot her in superplush settings, under twinkling chandeliers, as an icon of elegance, wealth, and power. The message was irrefutable—the sky was the limit for the successful hip-hop mogul. It was the fulfillment of the *Vibe* aesthetic.

MAINSTREAM AMERICA

In pop culture, trends tend to move in generational cycles, and they frequently borrow from the past. Patrick Courrielche, creative director of Inform Ventures, a company that has developed much of Scion's hip-hop-oriented campaigns, looks to early hip-hop for his commercial themes. "I'm more inspired by the glory days and the old-school hip-hop images. When we're working with a brand, the old school tends to align more with the brand's virtue," he says. He confesses that advertisers shy away from many contemporary rap stars, who can be volatile and controversial. By contrast, old-school hip-hop seems straightforward and virtuous. This is not a little ironic. What corporate American once considered too edgy is now nostalgic and safe.

Even so, that old-school flavor retains its potency. Kevin Stone, creative director of Global Hue, a multicultural ad agency, worked on a recent television spot that traced Jeep's history in parallel to hip-hop history. The spot opens with a break-beat sample, a graffiti-splashed wall, and bold text that reads, "We ran the streets and became legendary." The shadow of a b-boy is projected onto the wall and a subway train speeds alongside a Jeep. The spot closes with the image of old-school icon Grandmaster Flash and the text, "More room to move the crowd."

While hip-hop has become second nature to today's younger generation, it hasn't permeated all levels of the advertising business. "The creative directors grew up in the culture, but there is still an older generation of decision makers who were not part of the culture because they were already in their forties when hip-hop became a mainstream phenomenon," Stoute explains.

For some, hip-hop's present-day advertising opportunities are all about cashing in on credit where credit is due. Successful artists are no longer simply the face of the brand; they are also the owners of the brand. Think of Jay-Z and 50 Cent, who took ownership of their Reebok shoe brands. "As much as Run-DMC did back in the day to put Adidas in the hearts and souls of the culture, I don't think they truly got what they deserved," Stoute says. "At the time, the industry and the movement weren't mature enough to demand certain things. But today, twenty-five years later, I'm really proud that guys like Jay and Fifty have their own sneaker company with a major publicly held company."

"When we first started out, it was a completely blank slate," Lynch says. "Today it's hard to conceive of a time when there wasn't *XXL*, *The Source*, or hip-hop clothing lines. Fifteen and twenty years ago there just weren't a lot of places to get your images placed. But it was actually kind of cool. At the very least, we had a lot of fun because we didn't think most people were paying attention." With all eyes set on an entire generation raised on hip-hop, it's anyone's guess where to look next.

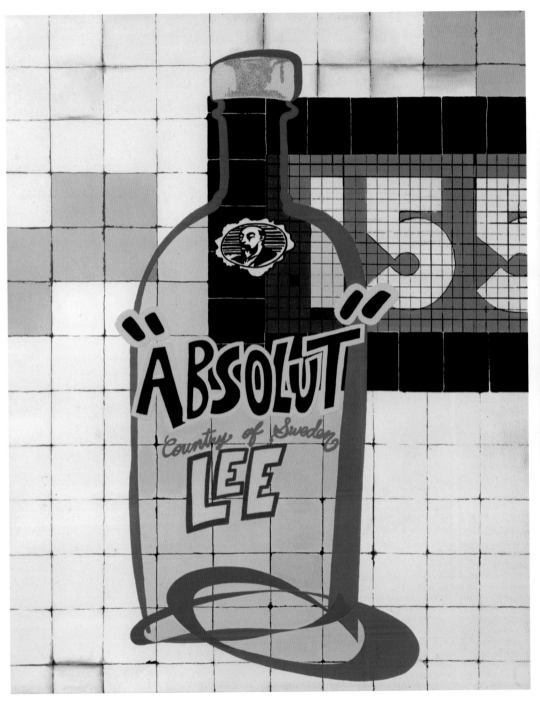

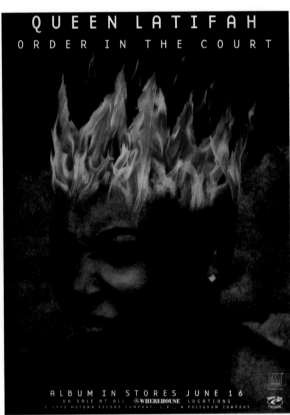

Left:
LEE QUIÑONES
Absolut Lee Absolut Vodka advertisement, 1994

Above:
MATT MAHURIN
Illustration for Queen Latifah's *Order in the Court* advertisement, 1998

Graffiti artist **Faust** really crushed this little campaign, which was limited to the neighborhood in Brooklyn where **Chris Rock** grew up. They hired Faust to spray paint right on the billboard. That's the cool thing about graffiti; It's a one-shot deal with no room for fuck-ups. It's guerrilla marketing for real!

Opposite and above:
FAUST
Everybody Hates Chris billboards, 2006

Opposite, clockwise from top left:

ZULU WILLIAMS
PNB Nation logo design, 1994

JANE MORLEDGE
Sean John logo design, 1998

BLK/MRKT
Mountain Dew package redesign, 1998

This page:

BLK/MRKT
Hawaiian Punch package redesign, 2001

AVAILABLE AT MACYS AND SEAN JOHN FIFTH AVENUE
www.seanjohn.com

AKISIA GRIGSBY
Sean John kidswear advertisement, 2007

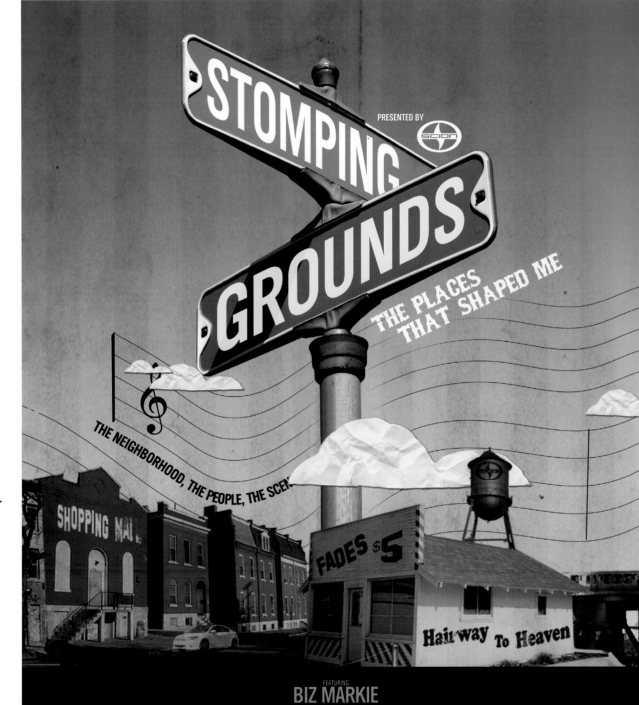

DRAWING BOARD DESIGN
Def Jam Heroes comic book, 1997,
Illustration Michael Bair and Buzz Parker

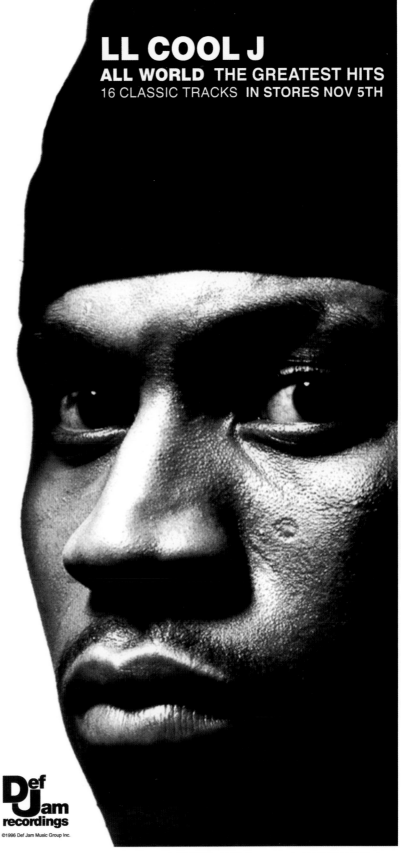

LL COOL J
ALL WORLD THE GREATEST HITS
16 CLASSIC TRACKS IN STORES NOV 5TH

Def Jam recordings

©1996 Def Jam Music Group Inc.

DRAWING BOARD DESIGN
LL Cool J, *All World: The Greatest Hits*
advertisement, 1996

HIP-HOP & THE AMERICAN MOVING IMAGE

BY ARMOND WHITE

DAVID LEE
Spike Lee as Mookie
on the set of *Do the Right Thing*, 1989

The emergence of hip-hop was one of the best things to happen to film and television in the 1980s. Hip-hop artists exemplified the paradox of a society's marginal citizens staking out the entire country's—and the world's—imagination. A groundswell of the dispossessed and the pissed-off found voices and images to express their condition. Pop-art legitimacy not only furthered their discontent, but also confirmed its reality in a society where "racism" and "homophobia" are disruptive words.

The American film and television industries couldn't stop hip-hop's bum-rush. Even television producers couldn't have predicted that this new musical culture would change the small screen's complexion. The history of visual media became revolutionary with the interplay that occurred between hip-hop music culture and the movies, television (including commercials), and the music video, a medium that came into being more or less at the same moment that rap music started to be recorded.

Hip-hop busted out of the ghetto of restricted radio playlists and narrow television and movie genres. MTV's popular *Yo! MTV Raps* (which debuted toward the end of 1988 and was hosted by Fab 5 Freddy, Doctor Dre, and Ed Lover) was a major change in MTV's predominantly white and rock-oriented video playlist. At a time when big-ticket rock was defined by parody and bombast,

Yo! MTV Raps's programming and its hosts delivered an ethnic authenticity that refreshed and redefined the entire channel.

In short, the rise of hip-hop is also a history of popular culture's expansion, especially through the 1980s, when the faces of non-white Americans became a regular element of American visual culture. All these years later, it's evident that culture has expanded into a widespread, all-encompassing, multiracial American form. The chronological list that follows is my personal collection of the seminal milestones in video, film, and television that have helped define the look of hip-hop, from its early days in the 1980s to the 2000s.

VISUAL RAPTURE

From the late 1970s onward, hip-hop found an immediate and natural expression in the visual media associated with the record industry. In 1981, hip-hop hit an important cultural milestone with Blondie's video for "Rapture." The video featured a backdrop of New York graffiti art and Fab 5 Freddy. The video was a perfect pop-culture hybrid that proved that hip-hop was firmly on the map. Above all else, though, hip-hop was now being heard, seen, and embraced by an audience larger than it had addressed originally. Blondie's low-budget video commemorated graffiti culture as well as break dancing and rap. It looked grassroots, but its depiction of street

life was an affectionate Fab(5)rication. (Fab recruited his pals, graffiti-style painters Jean-Michel Basquiat and Lee Quiñones, for cameos in the piece.) Ushered in by Blondie, a New York new wave/punk group, the "Rapture" video proved a kinship between hip-hop and punk. (Singer Debbie Harry even namechecks Fab and Grandmaster Flash in the song's lyrics.) The video was a nearly underground, not quite mainstream example of how hip-hop graphics came off the city's walls and subway cars; it danced and broke beats. What's more, it commanded the wider world's attention—all that, via the graphic image.

THE REEL DEAL

In 1983, New York indie filmmaker Charlie Ahearn wanted to capture real-life, local hip-hop culture on film. Influenced by Fab 5 Freddy's participation in New York's downtown art scene, Ahearn sought to film and dramatize the new wave of youthful creativity in urban America. Fab introduced Ahearn to kids in the Bronx who expressed themselves through tagging walls and subway cars as well as rapping and deejaying. Ahearn realized that this underground art was the twin innovation of record-scratching deejays and the rhythmic emcees who rocked neighborhood parties. Both forms showed the same originality and audacity. A documentary simply wouldn't adequately convey its spirit. Ahearn cast the culture's real-life movers and shakers, including graffiti masters

Lee Quiñones, Sandra "Pink" Fabara, Dondi, Zephyr, Daze, the rappers Busy Bee and the Cold Crush Brothers, and Fab 5 Freddy, to define and celebrate themselves in a theatrical drama. The filmed result was *Wild Style*.

All the iconography was there: the city, the kids, and the rebellion. What Ahearn initiated was respect for the art impulse. *Wild Style* didn't scrutinize a sociological quirk within the impoverished masses; Ahearn understood how the passion of living includes the drive to create. His characters leapt out of their social-worker, ghetto-clichéd backdrops and into the thrill and anguish of making art, becoming larger than themselves through their personal expression. The film was the purest understanding of hip-hop in the purest visual terms. Its subplot, which dealt with the encroachment of the established, moneyed downtown art world, was prophetic.

TOKEN

Immediately following the breakthrough success of Spike Lee's feature-length film debut, *She's Gotta Have It*, in the summer of 1986, Lee spun off one of that film's characters, Brooklyn b-boy Mars Blackmon (played by Lee himself), into a commercial pitchman. With hip-hop's popularity on the increase, Lee made Mars Blackmon into a spokesperson for Nike sneakers, appearing in print advertisements and a series of television commercials that he wrote and directed. His catchphrase—"Is it the shoes?"—referred to the mystifying greatness of his costar in the commercial, Chicago Bulls basketball player Michael Jordan. Lee also sparked the buying habits of hip-hop youth—and the rest of materialistic 1980s America—tantalizing them all with capitalism's promise of power through consumerism.

With his flipped-lid baseball cap and hip-nerd eyeglasses, Mars Blackmon was perhaps the first hip-hop icon who wasn't simply taken from the streets. He was a modification of street style, turning the urban youth profile into a friendly, nonthreatening emblem. Mars Blackmon was a commercial token, then, but also a token of esteem. He was a symbol of African-American youth to whom all youth could relate and to whom corporations could market. Even the name "Mars Blackmon" speaks to the mainstream: He's alien, ethnic, and masculine. For mid-1980s marketers, these were the perfect demographic signs.

It was the simplicity of Mars Blackmon's character that made him an effective, sharp, and memorable graphic image, perhaps even more so than Michael Jordan. Along with Adidas's hiring of Run-DMC as sneakers spokesmen, the Mars Blackmon spots confirmed that youthful urban style, even in athletic wear, was going to be determined by young hip-hoppers from then on.

NETWORKING

Music videos are basically commercials made to sell records, but director Lionel Martin broke those boundaries when he and record producer Hank Shocklee conceived of the video for "Night of the Living Baseheads" for Public Enemy in 1988. Running a couple minutes longer than the album track itself, the music video was modeled after a television news broadcast. On the imaginary PETV Network, news reports and commercials were broadcast while following the adventures of the rap group as they recounted black history and the contemporary crack epidemic.

"Night of the Living Baseheads" demonstrated the most sophisticated understanding of hip-hop iconography. While featuring group members in split-second dramatic scenarios, the video was also a who's who of significant hip-hop cultural figures—from deejays Red Alert and Afrika Bambaataa to Public Enemy's background stepping troupe, the S1Ws. Martin utilized familiar filming techniques—such as having the reporters directly address the camera or taking frequent commercial breaks—and blended them into the group's mythology as newsmakers and cultural and political revolutionaries. The language of hip-hop graphics was never smarter, funnier, or better timed to the syncopations of beats and rhymes. Going forward, the culture's various components—landmark locations, neighborhood celebrities, even social crises ripped from the headlines—could be employed

Page 104:
CHARLIE AHEARN
Jean-Michel Basquiat (in the doorway),
Debbie Harry, and Fab 5 Freddie, 1981,
on the set of the music video for "Rapture"

Page 105:
CHARLIE AHEARN
Debbie Harry and Blondie on the move,
with Lee Quiñones and Fab 5 Freddie
painting in the background

for unlimited expression. The very essence of hip-hop and the moving image is its ability to transform real-world elements into media symbols.

MASKS

Although Run-DMC—with their black fedoras, hip-length black leather jackets, and Adidas sneakers—were the simplest, most readily identifiable icons of any pop music group since the mop-top Beatles, it took a feature-length film to convey the full extent of their character. *Tougher Than Leather* took the group beyond the indie-records arena seen in a film like *Krush Groove* (1985) and showcased the group's inner life.

Tougher Than Leather is the hip-hop equivalent of the Beatles' second film, *Help!* Although it was released in 1988, just as the American independent film movement was heating up, the movie never became a popular hit. The scenario of Run-DMC expressing their thoughts and fears and relaying their various setbacks and crack-ups might have been too intimate. Nonetheless, *Tougher Than Leather* remains a fascinating demonstration of how resilient Run-DMC's individual styles—and the codes of hip-hop culture—could be. The film's visual/graphic style varies according to the story's needs: Verite scenes of Run-DMC in the 'hood complemented more stylized images of them performing onstage. Director Rick Rubin and screenwriter Ric Menello presented the rap world as a place where city boys' dreams collide with real-world challenges. Run-DMC both masked and unmasked themselves—and the hip-hop industry, too.

PRIME TIME

By the time the television series *In Living Color* premiered on the Fox Broadcasting Corporation in 1989, hip-hop was way past being an underground art form. It was ready for prime time in the same way that

Saturday Night Live had made college improv humor an American institution fifteen years earlier. *In Living Color* became the home base of New York's Wayans family, a group of mercurially talented sibling comedians headed by Keenan Ivory Wayans, the actor-writer-director known from Robert Townsend's *Hollywood Shuffle* (1987) and *I'm Gonna Git You Sucka* (1988).

The Wayans' weekly half hour of skits gave recognizable faces to the comic sensibility of hip-hop culture. It took "the dozens"—the verbal cutting contests played for sport by young black kids—and expanded it to mainstream cultural commentary. Many of the spoofs—whether of politicians, housewives, b-boys, or drag queens—inspired spontaneous laughs and fresh, sometimes shocked, recognition from viewers. The show represented modern American life filtered through the attitudes of a new generation who took pride in their wit, arrogance, and musical taste (courtesy of the show's featured dancers—the Fly Girls—and musical performers). *In Living Color*'s performers provided funny images that convey how the hip-hop generation thought about the world. It was a weekly parade of hip-hop caricatures and wit.

ON FIRE

Public Enemy's song "Fight the Power" jolts Spike Lee's *Do the Right Thing* (1989) from the very beginning. The inspired opening features dancer-actress Rosie Perez in a choreographic and pantomime performance like no other. A veteran of *In Living Color*'s dance troupe, Perez becomes Lee's embodiment of hip-hop energy, sass, and physicalized intelligence. She moves to Public Enemy's rhythms and ideas as if electrified by the potential of pop art with serious political and personal meaning. No editorial cartoon was ever so vivid.

Do the Right Thing combines folklore, fable, sermon, poetry, and sex. From the three elders sitting in front of a fire-red wall to Radio Raheem's soliloquy to the radio deejay Mister Señor Love Daddy (played by Samuel L. Jackson) cooling out the city's angry tempers, the spectrum of hip-hop-era attitudes is made graphically unforgettable. Every facet of hip-hop culture is preserved here.

Lee also directed the music video of Public Enemy's "Fight the Power." Straight political provocation, it aired on television simultaneously with the film's theatrical release—an MTV first!

SOUL FOOD

While hip-hop is well known for the fervor of its vocal protests and, vice versa, its sense of good cheer, it has never confined itself to political or happy images. The soulful side of hip-hop was made visual with the 1991 film *Boyz n the Hood*. This debut feature by writer-director John Singleton brought the gang war experience to nationwide attention in a different way than the recordings of gangsta rappers like N.W.A. or Schooly D. Singleton dramatized the aspirations of young men caught in the limited opportunities of life in the 'hood. The film's full-out dramatization had more amplitude than such contemporary films as *Juice* and *Colors*, partly due to its emotionally affecting cast— Ice Cube, Cuba Gooding, Jr., Morris Chestnut, Nia Long, Laurence Fishburne, Angela Bassett, and Tyra Ferrell.

The value placed on "hardness" in hip-hop's usual image of young black males was challenged by Singleton's emphasis on the emotional lives of his characters. With scenes of personal bonding that communicate the pain shared between friends and family, the film gives soul to the hip-hop way

of life. The scene between the grief-stricken Tré Styles, played by Cuba Gooding, Jr., embracing his father, played by Laurence Fishburne, makes this the first compassionate hip-hop movie.

MEMORIAL

After making his big screen debut as Doughboy in *Boyz n the Hood* (1991), Ice Cube brought his post-N.W.A. "Wrong Nigga to Fuck Wit" sneer to such dramas as *Trespass* (1992), *The Glass Shield* (1994), and *The Players Club* (1998). (He was also beginning to craft a different persona in the *Friday* and *Barbershop* comedy franchises, the first of which was launched in 1995; the second in 2002.) The images of young black male attitude in these films were surprisingly heartfelt. But it was in "Dead Homiez," his 1992 music video, that he most memorably etched the pain of ghetto ambition. This was an elegy for the lives of brothers who fell victim to the tragedy of life in the 'hood. Cube mourned their passing through a montage of headstones, obituary photos, and grief-filled funeral services. The video's black-and-white images rebuked the confetti-colored pathologies being praised in films like *Menace II Society* (1993) and *Dead Presidents* (1995). Cube's video memorial showed audiences the flipside of being a badass.

FURIOUS STYLES

Hip-hop films and music videos excel at representing the camaraderie of black American life, and none was more amusing than the 1993 RuPaul video "Back to My Roots." A drag performer specializing in dance music, RuPaul took a cue from the street-knowledge principle of hip-hop, not least perhaps because she recorded for Tommy Boy, a label that mostly specialized in hip-hop. Always more a rhythmic rapper than a singer, RuPaul's story of the customers who seek out her mother's Atlanta beauty shop for different hairstyles and nail sculptures was pure hip-hop. With the lyric, "Back, back, black to my roots," RuPaul displayed the same down-home principles as a Goodie Mob video, the same principled cultural authenticity as a De La Soul or TLC video.

RuPaul also showed that the hip-hop's virtues were not limited to a particular demographic. "Back to My Roots" showcased the cosmetics culture seen in videos by female rappers Miss Melodie and Lady of Rage, but made it cross-gender and cross-generational. RuPaul's response to hip-hop celebrated the many ways and different styles of being black.

ESSENCE

It's not just realistic images of street life that define hip-hop music videos and movies. Ice Cube and RuPaul's stylized pieces express the observable reality of black experience.

This blend of the actual and the imagined lifestyles is the essence—the hallmark—of director Hype Williams's most striking videos. One of the best examples of his work is his 1993 "Flava in Ya Ear" for Craig Mack.

Music videos sell records, but their artistic purpose is to define the recording artist's personality, to create a visual iconography by which one can recognize the musician and understand his/her personality and themes. In order to capture the essence of the "Flava in Ya Ear" song, Williams focused his attention (and camera) on Mack's face, making the video an iconographic sourcebook for understanding 1990s rap. Seeing it years later, audiences know what the face of 1990s rap looked like.

The video's series of black-and-white close-ups suggests a photo shoot for the cover of a fashion magazine. It's all about style and culture. As Mack cavorts with LL Cool J and Sean "Diddy" Combs, Williams steers hip-hop away from the ghetto and into the sleek world of high fashion and high art. In this way he helped rappers to define themselves visually as they never had before. Williams's close-ups—in themselves a revolutionary, nonsatirical use of the fish-eye lens—brings the viewers closer to the artists' personalities. It's a modern way of conferring Hollywood glamour on hip-hop's newest stars. His later work as the director of some iconic Gap television commercials as well as feature films has contributed to mainstream media's acceptance of hip-hop.

RUNNING MAN

Dance, an important part of hip-hop, achieved its greatest expression in the music videos by MC Hammer. From the phenomenally popular "U Can't Touch This" (1990), to the spectacular "Too Legit to Quit" (1991), to the pared-down "Pumps and a Bump" (1994), with its clearly defined yet complex elastic movements, Hammer used dance to express the exuberance of hip-hop life. Hammer created the most vigorous example of hip-hop dance culture since that opening scene in Spike Lee's *Do the Right Thing*. Only a couple of years earlier there had been robust male dance duos and trios in the videos behind Big Daddy Kane and Heavy D & the Boyz, carrying on the tradition of break dancing that was a fundamental element of hip-hop's origin. (The movies *Breakin'* and *Breakin' 2*, both released in 1984, captured that fact.) But Hammer further legitimized dancing as a hip-hop necessity; in fact, he redefined an artist's necessity to bust a move. It was something a brother could do and be great at. Hammer extended the ingenuity of break dancing, adding the elegance of stand-up movement, and revealed a whole new dance language. "U Can't Touch This" not only showcased Hammer's prowess, but was also a rousing hip-hop anthem. It was a visual demonstration of bravado, grace, and power.

BROTHERHOOD

Beer wasn't the only product being sold in the popular Budweiser commercial that first aired in late 1999. Conceived and directed by Charles Stone III—who directed the video for Public Enemy's "911 Is a Joke" (1990) and the feature films *Paid in Full* (2002), *Drumline* (2002), and *Mr. 3000* (2004)—the commercial immortalized the saying "Whassup?," an exuberant greeting shared by five young black men. The television spot was incredibly popular and is considered the most significant hip-hop ad campaign since Spike Lee's Mars Blackmon campaign for Nike.

Commercials provide an opportunity for businesses to target black consumers, but shrewd directors can use advertising to define the popular image and public profile of a social group that is little understood or usually negatively shown. Stone's "Whassup?" commercial didn't feature young black men doing stereotypical "black" things—shooting hoops or running from cops—but instead showed them being themselves. Stone went beyond the product to highlight a lifestyle. His vision of brothers who high-five each other over the phone became an idealized portrait of community. It's the same theme heard in Public Enemy's "Brothers Gonna Work It Out" from *Fear of a Black Planet*, but here, sponsored by an international manufacturer and sent around the world, it's a triumph of medium and message.

DREAMS

After years of music videos turning hip-hop artists into memorable icons, the Atlanta group OutKast collaborated with director Bryan Barber in 2003 on two music videos that took the medium to a new level. In Big Boi's "The Way You Move" and Andre 3000's "Hey Ya," Barber explored the fantasy lives of hip-hop artists, showing their imaginary sense of themselves. Through images of couples dancing, Big Boi revealed his sexual desires in "The Way You Move," while Andre 3000 revealed his hopes for celebrity status and fame in "Hey Ya." Both men's dreams illustrated the full range of the music video and its potential for communicating the ultimate hip-hop fantasies.

Barber's fondness for crowding the screen with numerous figures—dancing couples, screaming fans, and children huddled around television sets—expresses surreal, comic appreciation of hip-hop's twenty-first-century stature as a big-time media sensation.

BUSTING CLICHÉS

Video director Mark Romanek was a sworn enemy of the clichés of hip-hop music videos by the time he directed his first video, De La Soul's "Ring, Ring, Ring (Hey, Hey, Hey)" in 1991. But it is in the video for Jay-Z's "99 Problems," filmed in 2004, that Romanek made the genre comment on itself while also transcending the form. This black-and-white day-in-the-life litany of urban troubles has all the provocative elements that had become standard in hip-hop videos—booty-shaking women, threatening men, shoot-outs, and drive-by tours of the projects. But every shot and edit creates a rising tide of sorrow and tragedy through varied rhythms and recognizable street imagery.

Jay-Z's narration as an embattled observer of his 'hood's demise pleads for escape, but there is none. He's caught in the sights of a social miasma that Romanek's images make indelible. These harsh, poignant images of conflict, exploitation, and strangeness are perfectly matched to the wit and verisimilitude of Jay-Z's lyrics. It's like a Sam Peckinpah movie, where the treachery of the Wild West is put directly in your grill. Romanek's documentary style finds real-life examples of the street life that music videos have typically treated casually, whether the world of gangbangers, convicts, strippers, or victims of drive-by shootings (as portrayed by Jay-Z himself). Romanek photographs them to be undeniably grave and makes them unforgettably stark—the opposite of rapture.

BACK TO THE FUTURE

Not merely a concert movie, the Beastie Boys's *Awesome: I Fuckin' Shot That* uses hip-hop images to make sense of the cultural revolution of hip-hop. Twenty years after their cameo performances in *Tougher Than Leather*, it shows the Beastie Boys headlining at Madison Square Garden as captured by fifty fans who were given digital cameras.

Awesome: I Fuckin' Shot That was the most radical music film experiment of 2006. Adam Yauch assembled the different points-of-view from each of the fifty audience members. Through edits and special effects, he created a feature-length cinematic collage. This style was true to the sampling and scratching technique that originated on a deejay's turntable, only here the crucial device is a video-editing console. The result is a revelation: Showcasing the images of the Beastie Boys chosen by select fans during the euphoria of the concert experience, Yauch relays multiple views of the event while always capturing the thrill of hip-hop as a personal experience, a cultural happening, a public exchange of art and affection, show business and emotion. Hip-hop graphics are put back in the hands of the people. The culture redefines itself.

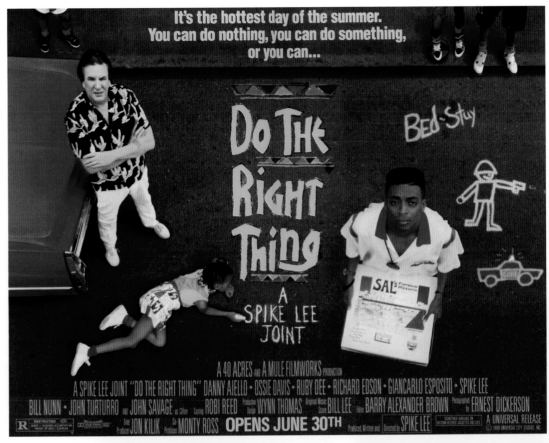

Clockwise from top:
SPIKE LEE
Do the Right Thing movie poster, 1989

DAVID LEE
John Turturro, Danny Aiello,
and Richard Edson on the set of *Do the Right Thing*, 1989

DAVID LEE
Rosie Perez on the set of *Do the Right Thing*, 1989

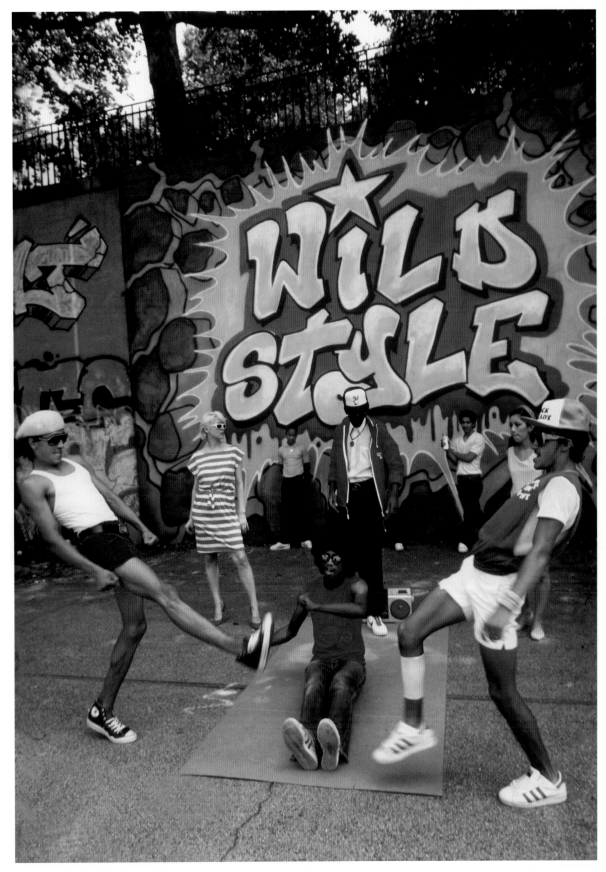

Opposite:
MICHAEL BENABIB
MC Hammer, New York, 1988

Right:
MARTHA COOPER
Wild Style, 1982

Patti Astor, Fab 5 Freddie, Lady Pink,
and members of the Rock Steady Crew
(Doze, Frosty Freeze, and Ken Swift),
Little Crazy Legs and Sharp in background,
Wild Style logo by Zephyr and Revolt

DAVID LEE
On the set of Spike Lee's "Fight the Power"
video for Public Enemy, 1989

DAVID LEE
Michael Jordan and Spike Lee (as Mars Blackmon)
on the set of a Nike TV commercial, 1986

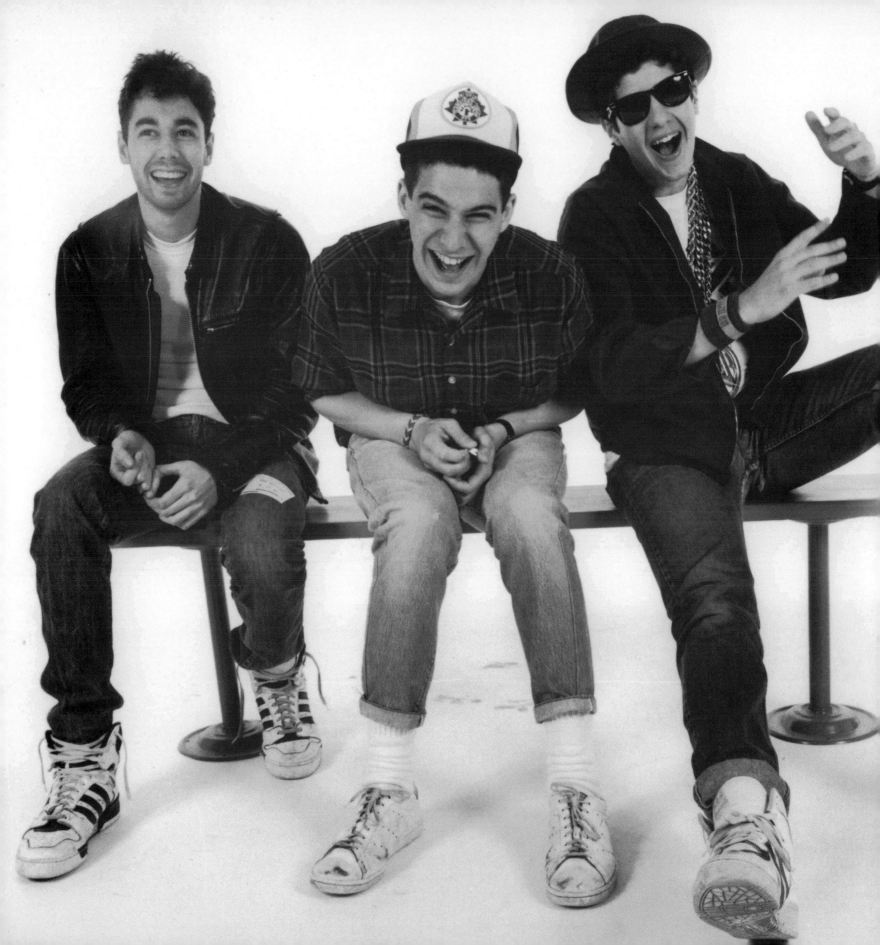

...FINALLY, HÖRNBLOWER IS TAKING BACK WHAT'S HIS

THINKFILM IN ASSOCIATION WITH OSCILLOSCOPE LABORATORIES PRESENT

BEASTIE BOYS STARRING IN

AWESOME: I... SHOT THAT!

 WINNER
AUDIENCE AWARD
Katajikistan Film Festival

 WINNER
GRAND JURY PRIZE
Shibuya Film Consortium

 WINNER
BEST DIRECTOR
Appenzell Cine Fest

 2nd PLACE
BEST DRESSED
LeFrak City Movie Contest

THINKFILM Presents an OSCILLOSCOPE LABORATORIES Production of
A NATHANIAL HÖRNBLOWER Film AWESOME; I... SHOT THAT! (An Authorized Bootleg) Starring MIKE D ADROCK MCA as the BEASTIE BOYS
Also Starring MIX MASTER MIKE KEYBOARD MONEY MARK And Introducing ALFREDO ORTIZ Special Guest Appearance by DOUG E FRESH
Shot by A BUNCH OF PEOPLE Edited By NEAL USATIN Executive Producers JEFF SACKMAN MARK URMAN RANDY MANIS DANIEL KATZ
Produced By JON DORAN Produced And Directed By NATHANIAL HÖRNBLOWER

 OSCILLOSCOPE
oscilloscope.net beastieboys.com

IN THEATERS MARCH 31, 2006

TH!NKFilm
thinkfilmcompany.com hollywoodandvine.com

awesomeishotthat.com

 R RESTRICTED
UNDER 17 REQUIRES ACCOMPANYING
PARENT OR ADULT GUARDIAN
FOR LANGUAGE.

myspace.com

These are my boys. Over the years we've shared so many great moments. "cey"

LAURA LEVINE
Beastie Boys, 1987

Right:
BEASTIE BOYS
Awesome: I Fuckin' Shot That movie poster, 2006,
Courtesy of Oscilloscope Laboratories

THE BEATING DRUM

CARS AND HIP-HOP

BY CHEO HODARI COKER

GREGORY BOJORQUEZ
Missy Elliott with her
Rolls Royce Phantom, 2005

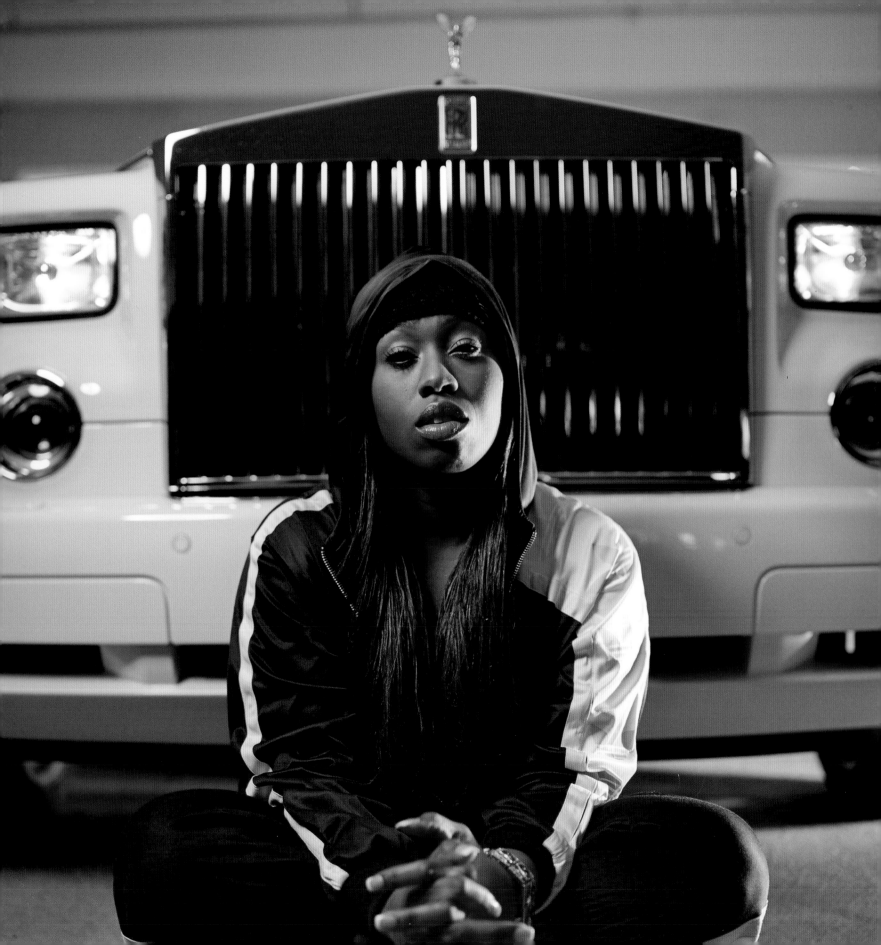

"I got a big long Caddy, not like a Seville/
And written right on the side it reads
'Dressed To Kill . . .'"
—Run-DMC, "Sucker MCs," 1983

Back when the Model-T Ford was virtually the only car a person could buy, Henry Ford himself quipped, "You can have one in any color you want as long as that color is black." In a word, cars then were strictly about *function*.

Come the middle of the twentieth century, Harley Earl, the father of the Chevrolet Corvette, described his lifelong mission as a designer by saying, "My primary purpose has been to lengthen and lower the American automobile. Why? Because my sense of proportion tells me that oblongs are more attractive than squares, just as a greyhound is more graceful than an English bulldog." In short: *form and function*.

In 2007, Mad Mike Martin, of L.A.'s Galpin Auto Sports and MTV's *Pimp My Ride*, described the inclination of some of his customers to put 28-inch and 30-inch rims on the tires of their cars, saying, "They don't give a fuck if the wheel don't turn. They say, 'That shit looks dope, right?'" In short: *all form, no function*.

This last anecdote is a prime example of what happens when a hip-hopper gets to customize a car, or, to put it in hip-hop terms, to pimp a ride. Admittedly, it's an extreme example, and perhaps even a knuckleheaded one. But it's certainly not unrepresentative. Consider Snoop Dogg. He hired his old friend Big Slice —who'd deejayed for Above the

Law earlier in his career—to transform a $4,500 school bus into a $90,000 media room on wheels for the youth football team coached by Snoop. Smoothed out in silver and black—the team's colors—the ride's exterior boasts a gigantic airbrushed likeness of Snoop holding a football. Inside there's an X box, two DVD players, screens in the headrests of every seat, and over seventy speakers. Form and function, to be sure, but Snoop's creation is slightly heavier on the form.

This hip-hopified sense of style is what drives today's auto accessories business. Once a niche market, it has gone mainstream in recent years, generating nearly $29 billion in 2004, according to the *New York Times*. Rick Caplan, owner of Roslyn, New York's Power Motorcar Company, frequently does auto bodywork for Sean "Diddy" Combs and Busta Rhymes, among others. "We've put more than $100,000 into brand-new cars," he says. "You can spend $75,000 just on tires, rims, sound system, and a body kit. Then it's another $50,000 to $75,000 in bulletproofing."

Of course, Mad Mike has seen it all. Born in Compton, California, the home of N.W.A., Mad Mike had been customizing cars for nearly twenty years when he was cast in 2004 as the "car cus-

tomization specialist" on MTV's *Pimp My Ride*, alongside the rapper Xzibit, the show's host.

Despite having been privy to most of the trendiest car design fads, Mad Mike can't help being flabbergasted by the industry's baroque-like excesses. "Today?" he says. "People want TVs outside their cars and 42-inch plasmas on their tailgates. You go on Sunset [Boulevard], you might see someone with TVs in all four of their windows, pointing outwards, or spinners with words beamed on them electronically. Everyone is getting into this tricky gadget shit on their cars. They ain't really worried about the paint job."

Mad Mike says this with disdain, as if he's a samurai sword maker in a world dominated by gun-toting kids. He is old enough to remember a time when "the booming system" came before everything. To have a hip-hop car, you had to be heard for miles around, even before you were seen. "Black people like to beat their drum," he says. "There's a Compton in every state, but in my Compton guys knew how to beat their drums really, really good. We was making some ground-pounding stuff."

In fact, Mad Mike's interest in creating a booming sound system is what initially attracted him to the car customizing industry. At heart, he's an audio specialist, nicknamed the Wizard of Wires by those

in the know. He started out in the 1980s making speaker boxes in a small shop on Central Avenue and Rosencranz. His customers craved a huge bass sound, but there were very few specialized woofer suppliers back then. So Mad Mike customized stock speakers by adding woofers of his own. "Back then there was no real science for this stuff," he explains. "We was creating a way."

This sentiment is echoed by Big Slice when he talks about lowriders—cars customized by Southern California's Latinos and blacks to ride low to the ground. Lowriders usually contain a hydraulic setup for adjusting ride height, a fantastic candy paint job, chrome features, and customized upholstery. Lowriders came into being in the late 1940s and 1950s. According to Denise Sandoval of Los Angeles's Petersen Automotive Museum:

> As the demand for new cars increased when automobile manufacturing resumed after WWII, a large number of used cars became readily available to anyone with limited means—WWII veterans, youth, the working class, and minorities. These second-hand cars provided Motorists with an avenue to transcend the limits of territory, like the barrio or Ghetto, through the mobility of their cars—and the postwar car culture exploded.

Broadly, the customizers broke into two groups: hot-rodders and lowriders. But where hot-rodders customized their cars by raising them off the ground and enhancing their speed, "lowriders lowered their vehicles and cruised as slowly as possible," according to Sandoval. (Indeed, *low and slow* encapsulate the whole aesthetic.) Veterans of the era recall being able to buy a used car in the 1950s for fifteen dollars. "It was easy to put dual pipes on—you know, lower it—and if you messed that up, you'd go get another car," said Los Angeles's Ernie Ruelas in the 1997 documentary *Low and Slow*.

The 1970s were another golden period for car customizers: The Chevy Impalas of the 1960s, with their superstrong chassis, along with the boatlike Cadillacs of the 1970s, were being put up on blocks in the wake of the oil crisis, recession, and inflation. But just as hip-hop's deejays dusted off old records to make thrilling new music, Los Angeles's young people of color dusted off old cars and found gold. Kids lowered the suspension on these rides and experimented with hydraulics, which either made the cars bounce or tilted the car's frame to one side while the car was cruising, producing what was dubbed "three-wheel motion." Inspired by the style of the pimps of their youth, local hustlers began to "pimp their rides," experimenting with glossy paint and exotic tire rims. Mexican-American youth, influenced by their culture's great muralists, were among the foremost innovators when it came to elaborate, almost photorealistic paint jobs. African-American youth, Mad Mike among them, became obsessed with booming sound systems. "We made something out of nothing," says Big Slice. "You take everybody else's junk and make it shine."

And just as every hip-hop locale produces its own brand of hip-hop music, so hip-hop car customizing varies according to one's travels. Funkmaster Flex, the New York hip-hop radio legend who's also a heavyweight in the customized car game, expounded on this regionalism for the *New York Times* in 2002, saying, "I went to Orlando and I was surprised that people were hooking up 1977 LeSabres and 1979 Delta 88s. Then I went to St. Louis. I thought it was strange that Nelly had an old Cutlass—it's painted blue and gold, because he's such a big Rams fan—but everyone out there has a Cutlass or a Monte Carlo. The Midwest cats are into two-door midsize cars."

Interviewed by *Rides* magazine in 2007, Q-Tip, formerly of A Tribe Called Quest, recalled the car that used to make a Queens rapper's heart beat a little faster back in the 1980s. "Everybody in the 'hood wanted the Volkswagen Jetta sittin' on chrome 17s. And you had to have the dark tint then, too—every window

had to be blacked out. But people would rock Nissans, Mazda MPVs—those were the working man's cars that were still acceptable to be seen in. Once you had the extra paper, that's when you'd go get the Jetta or a Saab. Above that, you'd move to something like a Mercedes 190E. That's when you were really doing something, when you got that Benz."

Of course, it would only be a matter of time before hip-hop's customizers and Detroit's auto titans started eyeing each other. There was a lot of talk in 2002 about Cadillac teaming up with Snoop Dogg to create a limited-edition "Snoop DeVille." Sadly, it never happened. Rather, Snoop bought a "base" DeVille from a Cadillac dealer in Memphis and customized it to his specifications. Indeed, the rapper, a self-described "Caddy man," has apparently created more than one Snoop DeVille. Dustin "Volo" Pedder, interviewing Snoop at home for *Lowrider* magazine, noted that Snoop had a blue model parked right next to the candy red one that launched the line. "Yeah," confirmed Snoop. "We had to step up the game and give it different flavors like LifeSavers." Fast-forward to the spring of 2007, when the Ford Motor Company announced the coming release of the 2008 Ford Expedition Funkmaster Flex edition, "a vehicle created by hip-hop deejay Funkmaster Flex into a limited-production, short wheelbase SUV." The venerable brand's Web site described the rare ride with no little relish:

The Expedition FMF will sport a two-tone Colorado red-and-black paint scheme with orange pinstriping and special chrome badging, a custom front fascia with integrated fog lamps, side skirts, rear fascia and 20-inch chrome-clad aluminum wheels. Inside, a matching Colorado Red instrument panel, console bezel, shifter and switch bezels blend with four leather captains chairs with red stitching, FMF red logo headrests and a red-stitched steering wheel. Rounding out the package is Sirius satellite radio and an exclusive numbered dash plaque signed by Funkmaster Flex. The Expedition FMF Edition also sports a 340-watt Audiophile Sound System, MP3 player audio jack, Powerfold third-row seating, heated and cooled front seats and an optional navigation system, power liftgate and rear-seat DVD entertainment system.

Street trends are merging with automotive trends at an unprecedented rate. Today, many car makers include options like television sets in the headrest, expanded color and upholstery offerings, expansive audio options, and imbedded GPS systems.

And that's not even touching on the effect that hip-hop auto styling has had on television. Can't get enough of *Pimp My Ride*? Tune into *Trick My Truck, Monster Garage, Unique Whips, Overhaulin', American Chopper,* or *Ride with Funkmaster Flex*. In the Netherlands you can enjoy *Pimp My Room*; in Germany, *Pimp My Fahrrad*; in Quebec, *Roxenette My Brete*; and New Zealand's Maori Television boasts *Meke My Waka*.

In 2005, Snoop Dogg pulled his Rowland Raiders youth football team from the Orange County Junior All-American Football Conference and formed his own league. In short order, Snoop Dogg's league was thriving and the old league was shrinking. According to blackathlete.net, parents and coaches from the old league groused that Snoop was "a modern-day Pied Piper luring football players with his song 'Drop It Like It's Hot' blasting from a school bus pimped out with enough bass, television screens, and gadgetry to persuade any kid to sell out the old for the new." Exactly.

But for all of Snoop's seductiveness, it was Sean "Diddy" Combs who really brought the bling. In the spring of 2005, Combs's Sean John fashion brand entered into a fifty-fifty partnership with Weld Wheel Industries "to produce a new line of custom, precision-forged aluminum rims for sports trucks, luxury SUVs, and high-end American and German automobiles."

"Wheels have become a fashion statement—a badge of taste and style," Combs told the Associated Press. "We see an opportunity to bring excitement to the wheel category by delivering the Sean John sophisticated design with the best quality production."

> "It has about six years of my mural work on it, plus a plasma screen, 20 speakers, 10 TVs."
>
> —Mr. Cartoon

Right:
DEREK GARDNER
Mr. Cartoon's 1963 candy tangerine ice-cream truck,
Petersen Motor Museum, Hollywood, 2007

Below:
MICHAEL BENABIB
Rakim and His Benzeeto,
Bleecker Street, New York, 1988

Greg Weld, a former racecar driver and founder of the Kansas City–based Weld Wheel, also saw an opportunity. "[Combs] is an icon in the urban market, and the urban market is huge—the single biggest segment of the wheel business," he said. At the time, Weld Wheel was described as "the country's largest premium aftermarket wheel manufacturer."

Unfortunately, a year later Weld Wheel filed for bankruptcy. The 2005 Sean John rims were the only ones that ever saw the light of day. Still, they were beauts—seven truly elegant examples of bling. The individual rims bore names like Apollo, Hermes, Poseidon, Eros, and Chaos. "The way we've designed spokes, holes, the features, it looks like it's aggressively moving when it's not even moving," Weld said with pride. The rims retailed between $700 and $3,000 each.

But Busta Rhymes went Diddy one better. Casting a cold eye on his rims one day, Busta decided they looked naked without paint. "I'm the dude who invented the color of your car on the wheel," he bragged to *Dub*, an automotive lifestyles magazine. "My rim became a navy blue with chrome rim, which you were unable to buy anywhere because that wasn't a thing they were doing in 1995." Not content to stop there, Busta tinted his front windshield "so when it was nighttime, people would think that the car was driving itself." The owner of a fleet of about a dozen cars, the rapper suggests that the creativity that goes into customizing cars is "like the creative genius that we put into making these records. From clothing to vehicles to films to television, it's all art and it's all creative in one form or fashion."

At the end of the day, one begins to suspect that hip-hop auto customizing is as much a state of mind as it is a hot art form. Big Slice, Snoop Dogg's customizer, notes that a given job "can run anywhere from ten grand to $250,000. The price depends how fast a customer wants it and what he wants. It's the I-need-it-now price or the take-your-time price."

"People say I'm expensive," he concludes. "I'm not expensive; I'm a luxury"— a small but telling distinction that separates hip-hop's wannabes from those who have already arrived.

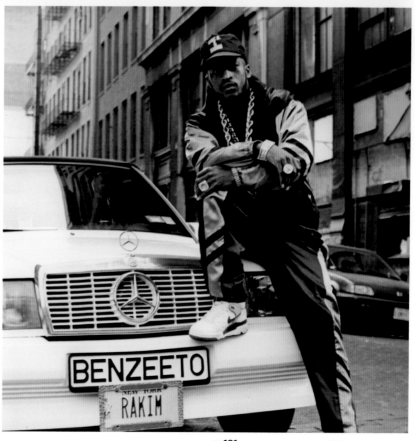

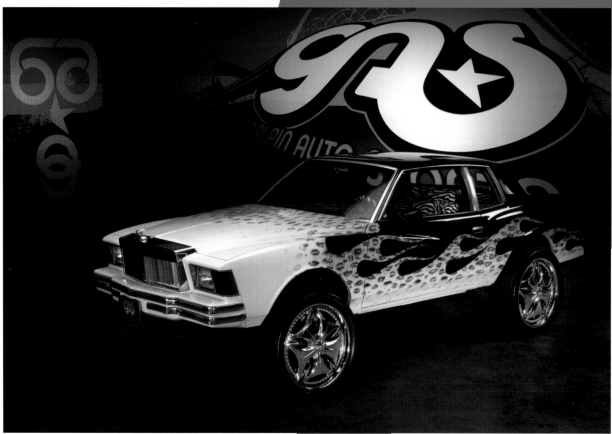

Clockwise from top left:
JOEY JULIUS for Galpin Auto Sports LLC
Beau Boeckmann, 2006
Tire rim detail from *The Box*
"Mad Mike" Martin, 2006
The Box (1978 Chevy Monte Carlo)

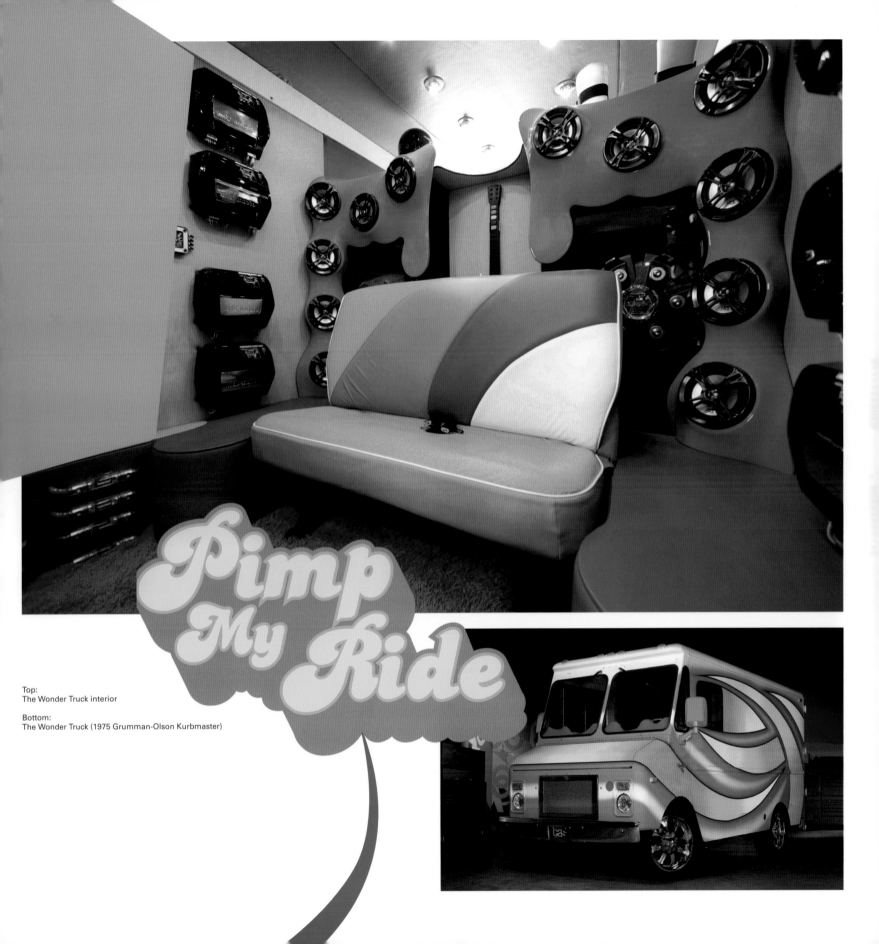

Pimp My Ride

Top:
The Wonder Truck interior

Bottom:
The Wonder Truck (1975 Grumman-Olson Kurbmaster)

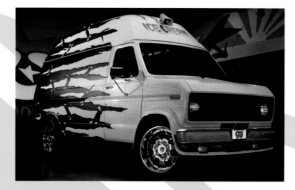

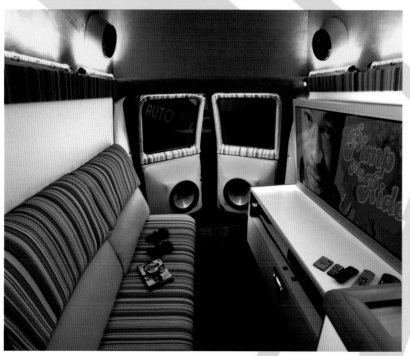

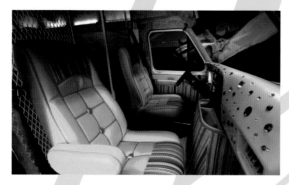

JOEY JULIUS for Galpin Auto Sports
Ice Cream (1976 Ford Econoline Van)

"Ice Cream shouldn't be the only thing chillin' in
this ride, so GAS installed a State-of-the-art ordering
system with a touch-screen menu, a slammin'
motorized door, and a robotic arm that dispenses
ice cream at kid-level."
—GAS

Top:
The Tearor (Ford Focus SVT)

"With a unique green-and-orange torn interior, a lighted orange neon dash, and a bumpin' custom sound system . . . this Focus will surely make you the buzz of the boulevard!"
—GAS

Bottom:
The Lincoln Navigator Lux

"Elegant Rau maple burl wood throughout, custom shearling floor mats, chrome accents, and Image Dynamic speakers . . . give the Lux its modern appeal while preserving the craftsmanship and elegance that is so traditionally Lincoln!"
—GAS

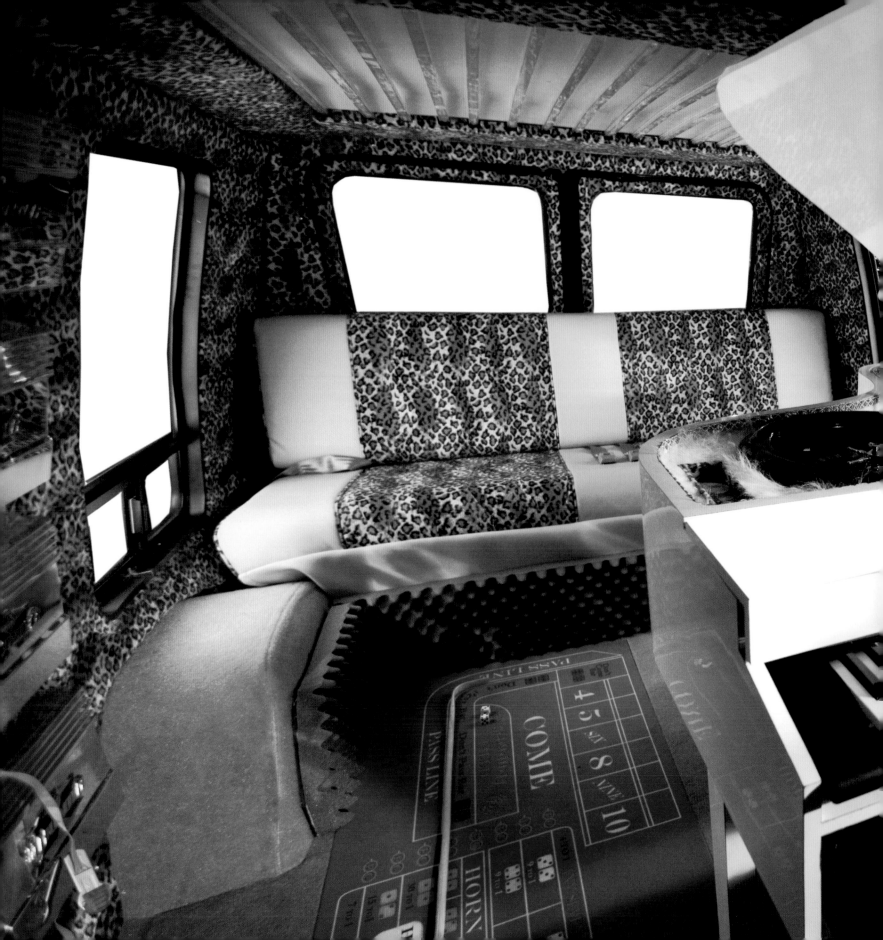

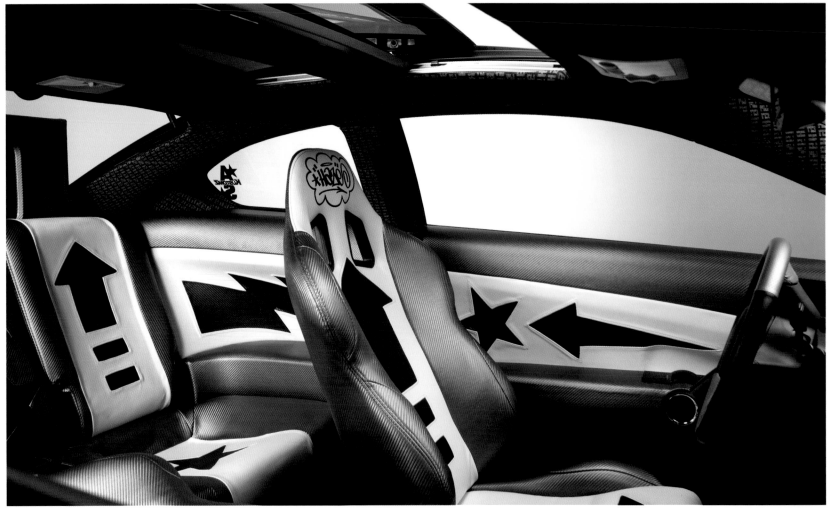

Pages 126–127:
JOEY JULIUS for Galpin Auto Sports LLC
Lucky SeVan (1984 Chevy G20 Van)

Opposite:
HAZE
Custom design for Scion, 2006

Below:
HAZE
Custom design for Honda motorcyle, 2006.

"Haze shows that given the opportunity we're capable of *flippin' the script* on anything."

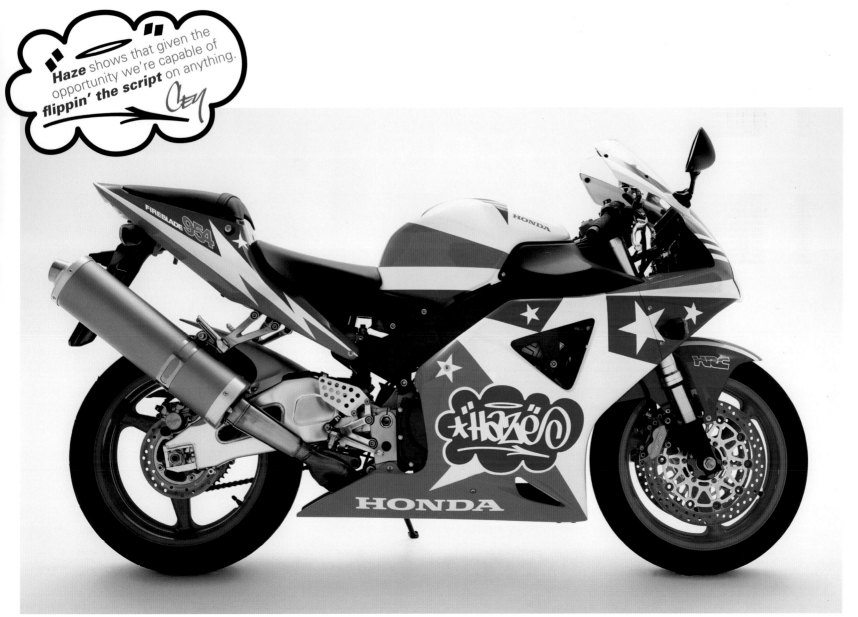

GREGORY BOJORQUEZ
Floor mat in Big Boi's 2002 Bentley Azure

Opposite:
Diamond-covered Flying Lady hood ornament
on Rolls Royce owned by Nigo of Bathing Ape

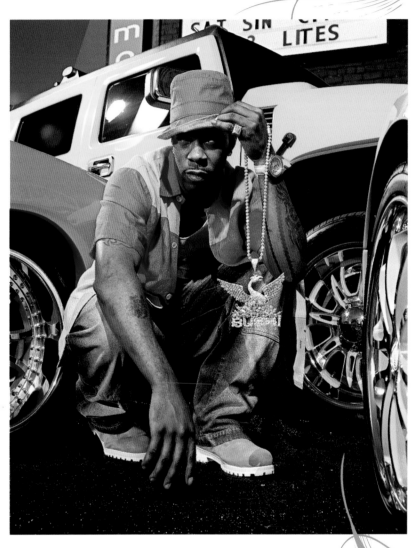

Top:
GREGORY BOJORQUEZ
Detail of rims

Left:
GREGORY BOJORQUEZ
Busta Rhymes with his yellow 2002 H2 Hummer

Below:
A.J. MUELLER
Funkmaster Flex with
the Ford Expedition FMF, 2007

Opposite:
GREGORY BOJORQUEZ
Ice-T and Coco with his 2004 Mercedes SL55, 2005

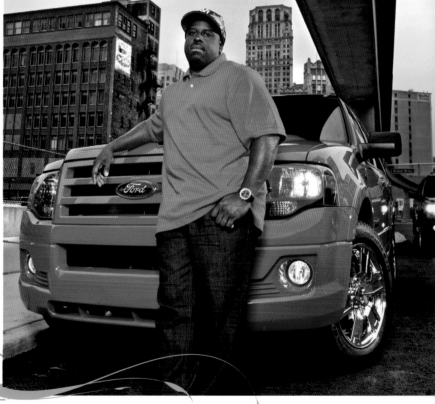

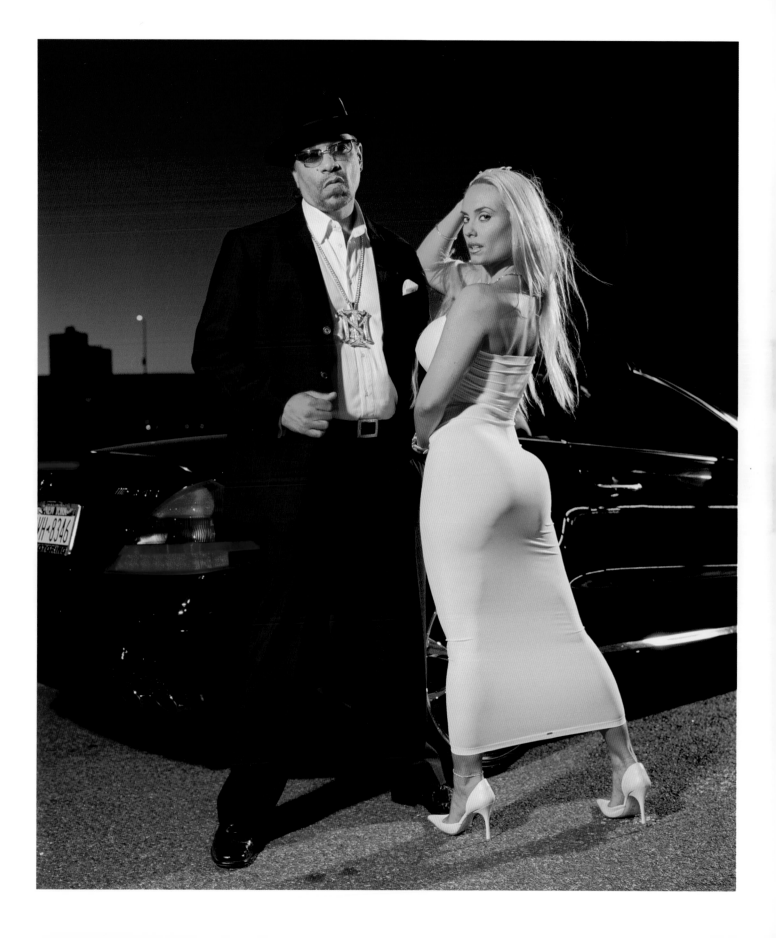

Above:
RICHARD DREW
Sean "Diddy" Combs with Sean John rims, 2005

Opposite:
GREGORY BOJORQUEZ
Lil Kim with her 2002 Mercedes G500
Cabriolet Wagon, 2003

HIP-HOP KICKS & SNEAKERS

BY MICHAEL A. GONZALES

Adidas Brougham JMJ Edition, 2007

Walking home from school, my friends and I often stopped in front of the rusty gates of a Harlem basketball court at 153rd Street and Amsterdam Avenue called the Battle-grounds. Be it a nippy winter evening or a blazing summer afternoon, the tarred park would be full of lanky b-boys shooting hoops and getting their groove on. Emulating the fierce moves of their favorite 1973/1974 Knicks (when cats like Willis Reed and Walt Frazier were pounding the pill on the hardwood floors of Madison Square Garden), the uptown ballers mostly wore either hi-top or low-top canvas Pro-Keds.

While I had always been more geek than athlete, at ten years old I was conscious of the rumblings of a style revolution. Available in a variety of colors, Pro-Keds recruited professional hoop-men Kareem Abdul-Jabbar, Nate "Tiny" Archibald, and the Harlem Globetrotters to hawk their product. (The Harlem Globetrotters were my favorite of these three because they had their own Saturday morning cartoon.)

The Pro-Keds ad campaign worked its marketing mojo even off the courts. Whether dudes were trooping to school, swinging stickball bats on the block, playing pin-ball at the Jesus Candy Store, graf-bombing subway cars at the 145th layup, or shooting skellzies in the middle of the street, it seemed that everyone was rocking Pro-Keds by the spring of 1974.

Everyone, that is, except me.

For years, Mom bought tennis shoes for my baby brother and me from Robbin's Discount store. The king of irregular merchandise, the store sold underwear, sweat suits, and sneakers. But after being surrounded by a posse of friends pointing at my sneakers and chanting, "Skips, they make your feet feel fine / Skips, they cost a dollar ninety-nine," I knew that I'd have to use my prepubescent powers of persuasion for something other than soul records and comic books.

Without a doubt, I was on a mission to be down.

Though it took months of begging and a few tears, Mom finally broke down. Seriously, nothing that year (except the release of the Jackson 5's hypnotic single "Dancing Machine") made me happier than bopping out of the Buster Brown store wearing those thick-soled kicks with the trademarked red-and-blue stripe on the side of the heel. I literally felt like a different kid. Simply having those Pro-Keds on my feet made me feel as though I looked cooler and could sprint faster and jump higher than ever before.

My baby brother and I ran the six blocks back home. I couldn't wait to style and profile those Keds for the other kids. "Those are the joint," my homeboy Stanley said as we stood in front of our building. "It's 'bout time your ass was in style." Older than me by four years, Stan's approval meant I had finally arrived.

During the birth of the hip-hop culture in 1970s New York City, everybody cared intensely about sneakers. Kool

Herc was wearing fresh kicks as he dragged his speakers from his Bronx building, Crazy Legs was sporting Pumas when he first began spinning on his head, and countless writers slipped on a pair of old sneakers as they bombed the subway system.

Even today, the right kind of sneaker can have a powerful impact. The sneaker designer Carlton "C.L." Lester has declared, "No matter what 'hood you're from or what you do, if you're not wearing the right kicks, you're gonna get clowned." His statement is just as true now as it was when I was a kid.

In fact, from the very beginning of the hip-hop movement, there was a subculture within the subculture comprised of creative young people who cared so much about the right kicks that they customized the available models. Some of these kids glamorized and improved their old shoes because they lacked the dough to buy new ones. Others created new kicks on their own because models weren't coming out quickly enough. Whenever anyone scored truly fresh kicks, he was besieged by a bunch of kids, friends, and strangers, who'd point at his feet and ask, "Where'd you get those?" (Author Bobbito Garcia fittingly employed this question as the title of his essential bible for sneaker fiends.) This DIY impulse is at the heart of hip-hop: Not enough slammin' beats at the party or on the radio? I'll create my own. Not enough dazzling kicks? No problem. I'll make my own.

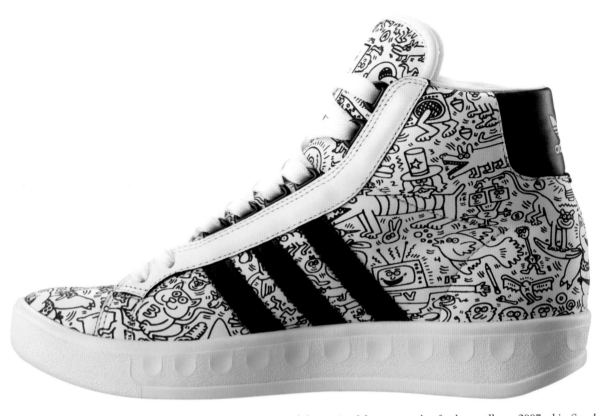

KEITH HARING & JEREMY SCOTT
Adicolor black series, 2006

Run-DMC was hip-hop's first high-profile group of sneaker freaks. In 1986, the Queens trio recorded "My Adidas," a heartfelt ode to their shell-toed Superstars. Run says that the concept was Russell's, but it was nonetheless a subject about which Run-DMC could write about with deep conviction. They certainly didn't do it as an endorsement for Adidas—at that time, no sportswear manufacturer had ever thought to hire someone who wasn't an athlete to be a company spokesperson. But in the fall of that year, Russell Simmons invited representatives from the German sports apparel company to a Run-DMC concert at Madison Square Garden to demonstrate the connection between hip-hop and footwear—and the marketing power of a heavyweight rap group. Seeing 20,000 kids holding their Superstars in the air at Run's command sealed the deal for Adidas, who gave Run-DMC a million dollars for their endorsement.

Four models of the Superstar were designed, and each was assigned a suitably grandiose name: Fleetwood, Eldorado, Broughham, and Ultrastar. Apparently, however, Adidas was a little ambivalent. Cey Adams says, "If you actually look at the Run-DMC model sneakers, you'll notice that none of them have the group's name on the shoe. It was on the hang-tag instead. That way, if the shoe didn't sell, Adidas could remove the tag and attempt to sell it generically."

The vogue for shell toes and for sneaker customizing progressed throughout the 1980s. Then it seemed to peter out. In the early years of the new century, the limited-edition sneaker took over in terms of popularity. It was a pop-culture phenomenon that recalled Andy Warhol's quote: "There is an inherent beauty in soup cans that Michelangelo could not have imagined existed." This kind of thinking led to the creation of the "collector's sneaker market," in which sneaker fans from all over the globe fiend to acquire shoes limited to editions of no more than a thousand pairs. Typically, these shoes cost from $195 to $295, although a 2005 *Forbes* article profiled the most expensive men's sneakers and found an extremely limited-edition run of Nike Air Force Ones—less than forty pairs were produced—selling for $1,000 to $1,500 per pair. But perhaps nothing

communicates the mania of the true sneaker freak as well as a 2007 ad in *Sneaker Freaker* magazine. In the ad, a roomful of young sneaker fetishists are on their knees, as if in worship, in front of a wall display of dozens of pairs of the Nike Dunk Lo Supreme, which is lit up from behind like the godhead itself. Manufactured in an edition of only 150 pairs, the Dunk Lo Supreme was a skateboarding shoe featuring a small orange-footed pigeon embroidered on the heel. According to a story in the *New York Times*, they sold for $2,500 a pair at a New York City sneaker specialty store called Flight Club in April 2006.

Who designs these exquisite sneakers? An elite corps of hip-hop vets. The decision to hire these impresarios is a measure of top sneaker manufacturers' deepening understanding of the hip-hop nation's eternal love affair with footwear. For example, the Nike Dunk Lo Supreme, a.k.a. the Pigeon Dunk, was designed by Jeff Staple. Born Jeff Ng, he formed Staple Design "by accident" while silk-screening T-shirts as a twenty-two-year-old student at the Parsons School of Design in 1997. Dubbed "your favorite designer's favorite designer" by the Tastemaker Society in 2007, Staple is best known for his street wear and sneaker designs. Eric Haze, Cey Adams, and Dave Kinsey are a few of the former bombers who have also been persuaded to use the sneaker as their canvas. Haze, a seasoned vet rooted in late-1970s graffiti, designed his first limited-edition sneaker in 2002. A custom version of the Nike Dunk in black, white, and smoky gray, Haze's shoe appears to have been spray-painted while the Nike logo was masked off so that the swoosh gleams against the aerosol background. He sees the design as a successful latter-day test of one of the key articles of faith of the street artist: "If a throwup doesn't work in black and white, it doesn't work at all." His shoe was among the first to inspire the market for collector's sneakers. "Somebody told me that my shoe was the first to blow open the doors," Haze says.

Cey Adams finds that designing sneakers is "a lot like being on the side of a train with a spray can. The surface of the shoe, like the surface of a train, isn't smooth or flat, and that presents its own set of challenges."

Adams was one of thirty-six artists commissioned to create a shoe for the Adidas Adicolor campaign in 2006. A salute to the original Adicolor sneaker launched in 1983, each purchase included a pure white model and a set of specially created quick-drying waterproof pens, which allowed every buyer to paint his sneakers as he wished. The original Stan Smith Adicolor featured three portraits of Disney's Goofy character outlined in black ink, waiting to be colored in. Adams's 2006 version was, he says, "a celebration of the four-elements of hip-hop culture: graffiti, break dancing, deejaying, and emcee-ing," while the shoe's bright blue color represented "that golden age when hip-hop was still innocent, and it was all about peace, love, and unity."

In 2006, Adidas hired Dave Kinsey to design the San Diego shoe as part of the manufacturer's City Series. Although he's now based in Los Angeles, Kinsey used to live in San Diego; it was there that he established his reputation working and designing for brands like DC Shoes, Droors, Ezekiel, Expedition One, and Dub. "My only criterion for Adidas was to keep a San Diego theme in mind," he recalls. "I utilized a palm tree pattern and the Charger's colors—blue and yellow—to hold true to that."

Not all of today's custom sneaker designers come from a background in painting and graphic design. Carlton "C.L." Lester, for example, had never picked up a brush or a can of spray paint in his life before he started messing with sneakers. As a young man in his twenties who had just returned from a stint in the U.S. Army, the Philadelphia native decided that contemporary sneaker design was lackluster.

Convinced that he could create cooler shoes, C.L. began applying the skills he'd learned while working for his father's carpet company to the redesign of his own sneakers. "I learned to trim and tuck by watching my dad cut and install carpets," said C.L., whose first design was made from a cut-up T-shirt. "I understood how to put things on top of things and make it all look perfect." His evolution as a designer went into overdrive thanks to a gift from his uncle of one thousand dollars, which C.L. promptly sank into the purchase of fifteen pairs of sneakers. He worked out of a messy room in his grandmother's house. "The entire place was filled with pieces of leather, suede, and swatches," he said.

Although C.L. claims never to have thought about taking his hobby to a professional level, he changed his mind after a chance meeting with Russell Simmons. Wearing a pair of reconstructed Rev Run sneakers, C.L. trooped into the after-party for Simmons's Hip-Hop Summit Action Network event in Philadelphia in 2003. The crowd went crazy over C.L.'s kicks, a leather-and-suede overhaul of a pair of Rev Ones in orange, blue, and red. "When Russell saw my sneakers, his mouth flew open. He grabbed my foot and just stared at my sneakers while I held onto his shoulder," C.L. recalled. A few months later, C.L. was working in Phat Farm's custom footwear department.

Perhaps the biggest misconception about sneaker culture is that it is solely a man's world. According to Imani Brown, the multitalented designer behind Artistic Sole, the ladies in the house like to stomp around in fresh kicks, too. "Some guys think that if women are into sneakers, they must be super-tomboys or gay, but that just isn't true," says the Washington, D.C., native. "There are a lot of us around. It's just that most of the bigger companies aren't really geared toward females."

Though Brown has been a sneaker head since she was a teenager, it wasn't until post-graduation from Clark Atlanta University that she designed her first set of kicks. "I was curating an art show that was going up in October 2006," she remembers. "I was supposed to show photographs, but just didn't have the time to get it together." Instead, the trained photographer/tattooist/painter retreated to her bedroom, where she blared Common, the Roots, and Mos Def, and began constructing a wide range of sneakers. A few had the appeal of a Roy Lichtenstein, while others were shout-outs to Bratz dolls and the *Aqua Teen Hunger Force* cartoon characters.

Looking back on her work, Brown says that one of her favorite designs is *Thug Life*, which features tear-riddled, crimson-hued skeletons and bouquets of black roses. "I did that shoe for a friend who is far from thug, but I wanted the art to be ironic and funny," she says. "These days, working on a very limited scale, I try to 'get' the customer before designing the shoe. That way the shoe becomes more personal for them."

For all of the glories of custom sneaker design, designer Jor One feels the trend has gone too far. "I know a ton of people who've grown disenchanted with collection sneakers because of all the wack hype," he told sneaker e-zine *Dead Stock* in 2005. "I'm talking about kids who had hundreds of shoes and just said, 'Fuck it! This shit is retarded.' They sold their kicks and these days just buy sneakers for more functional purposes. They seem much happier now."

A Brooklynite transplanted from the Bay Area, the former graf artist is best known for sneakers featuring graphics of doughnuts, dollar signs . . . and shit. "It seems like any shoe that gets stamped with the words 'exclusive,' 'premium,' or 'limited' is all of a sudden worth sleeping in front of a shoe store for—no matter how shitty the quality," he explains from his studio in Carroll Gardens. "The irony of 'limited-edition sneakers' is that Nike and Adidas can easily make 5 or 500,000 of them. The 'exclusiveness' is artificially created. For me, painting cans of limited-edition shit was my way of bringing this issue to light."

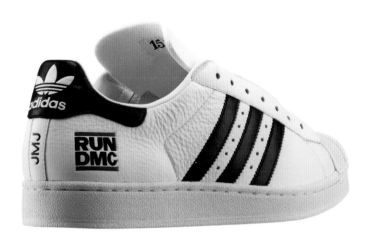

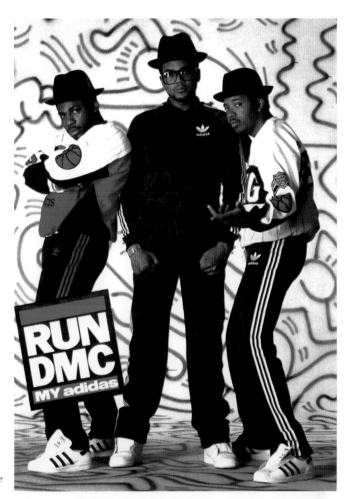

Chef of GourmetKickz is a designer who neatly combines the mass market and the handmade. A sole proprietor and one-man band who sells his sneakers on his Web site, eBay, and on consignment in shoe stores throughout his hometown of New Haven, Connecticut, Chef customizes the Nike Air Force One any way he pleases. "I think purists love cleanliness and precision. That's the beauty of a Nike shoe," he says. "But when you get a GourmetKickz sneaker, it's the same precision and even more attention to detail. I isolate stitching and paint the edges of the leather. This is stuff Nike either doesn't always do or has still not done."

Chef's passion for sneakers goes back to his youth. "Back then I was king of the laces, putting my own little spin on that aspect of [the sneaker]." Though he used pencil and ink during his high-school days, it wasn't until he started customizing shoes that he began experimenting with paint. He discovered the joys of working with fabrics around the same time. "My favorite shoes of my own design are called *Enter the Dragon* and *The Emperor's Robe*," he says. "I put my love for Asian culture, kung-fu films, and footwear together, and created something I'm extremely proud of."

In 2004, Adidas celebrated the thirty-fifth birthday of the Adidas shell toe (designed by the firm's founder, Adi Dassler) by commissioning thirty-five celebrity artists to design limited-edition tribute shoes. The celebration was a salute to the company's glory days in the mid-1980s, when Adidas had Run-DMC and hip-hop to themselves. But the firm failed to follow up. Nike swooped into the vacuum and established itself as the top brand by making great-looking and great-performing shoes for athletes, a one-two punch that couldn't help but impress hip-hoppers. Determined to win back their fan base, Adidas recruited a roster of hip-hop legends and fellow travelers for their shell-toe birthday blowout: legendary graffiti artist Lee Quiñones, who wore dusty Pumas in *Wild Style*; rapper and sneaker goddess Missy Elliott, who dreamt up a beautiful black-and-orange joint with a small icon of her face on the back; rockers the Red Hot Chili Peppers, who created a cool black shoe with red stripes; Bobbito Garcia, who created a shell toe called Project Playground that boasted yellow-and-light-blue suede on the side; and Run-DMC, who created a Jam Master Jay tribute model that featured both the Run-DMC logo and Jay's name prominently on the shoe itself.

Today, the DIY hip-hop spirit is the same as it ever was: the right kicks and nobody getting clowned.

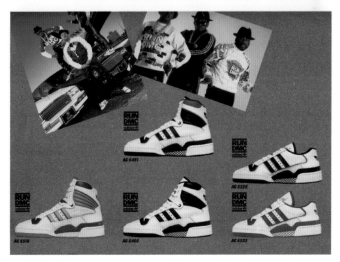

Clockwise from top left:
RUN-DMC
Superstar 35th anniversary series, 2005
Adidas promotional postcard for Run-DMC sneaker line, 1986
Adidas catalog featuring Run-DMC sneaker line, 1986

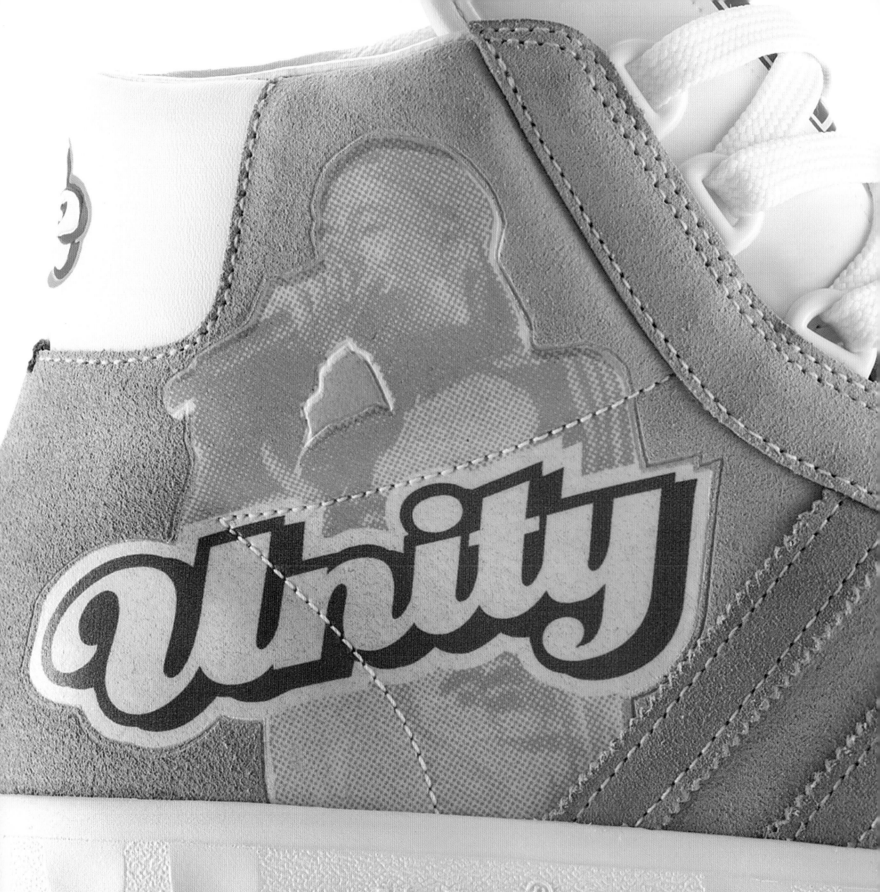

Pages 142–143:
CEY ADAMS
Adicolor blue series, 2006

Opposite:
HAZE
Nike Dunk Lo and Hi, 2003

Below, left to right:
Adidas Superstar 35th anniversary series, 2005:
NEIGHBORHOOD
NEW YORK
UNDEFEATED

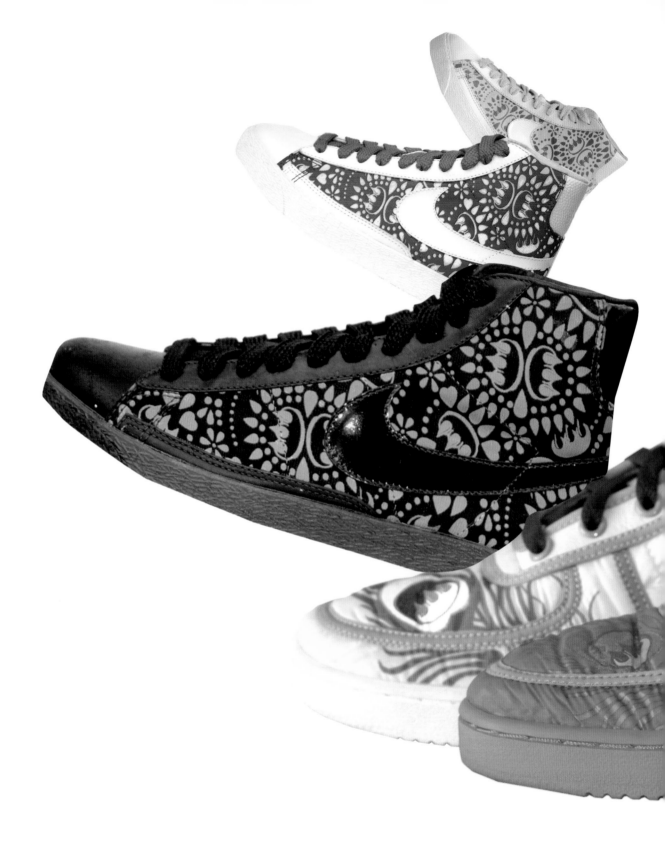

Left to right:
CLAW MONEY

Nike Blazer Series 2007:
Red and Yellow
Red and Light Green
Black

Nike Vandal Series 2007:
Peacock White
Peacock Blue
Peacock Black

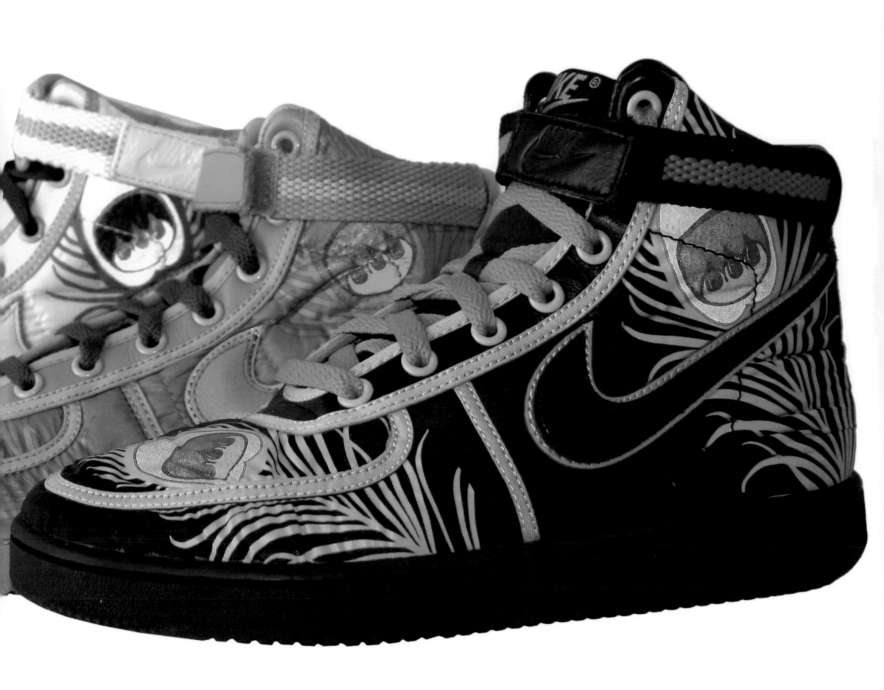

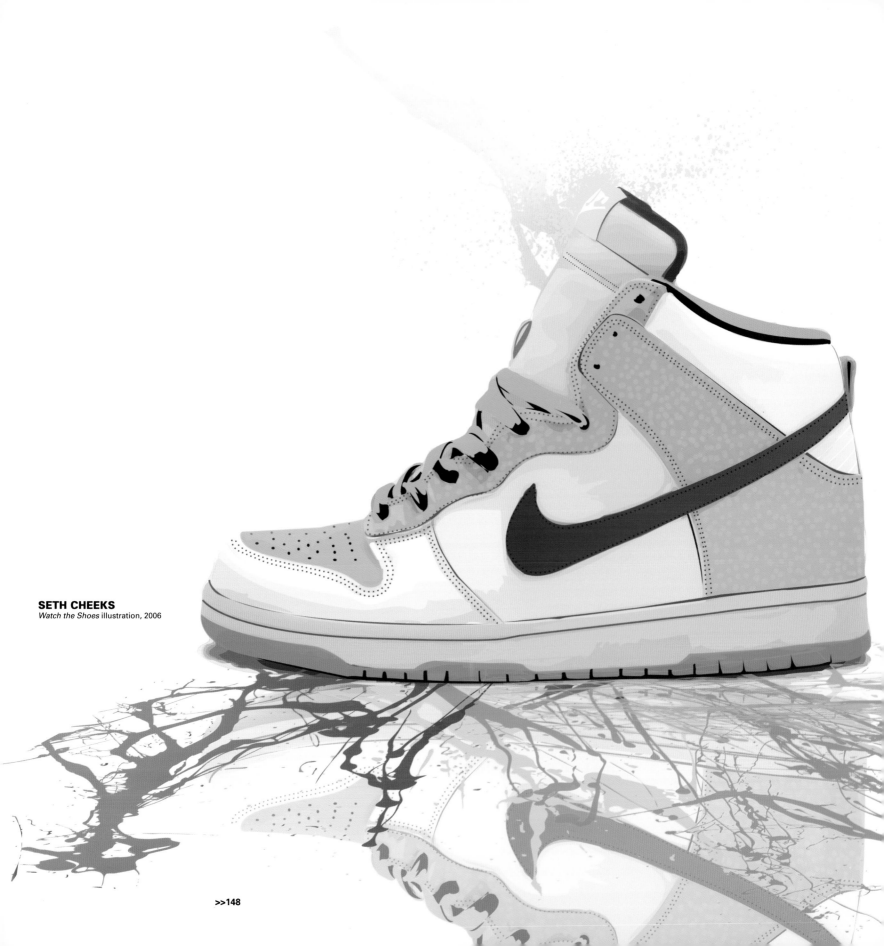

SETH CHEEKS
Watch the Shoes illustration, 2006

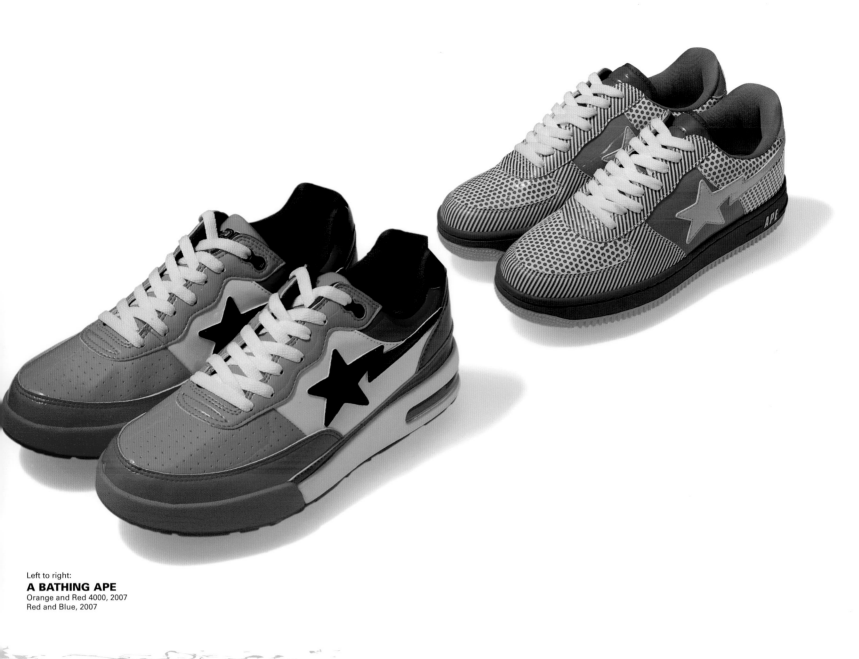

Left to right:
A BATHING APE
Orange and Red 4000, 2007
Red and Blue, 2007

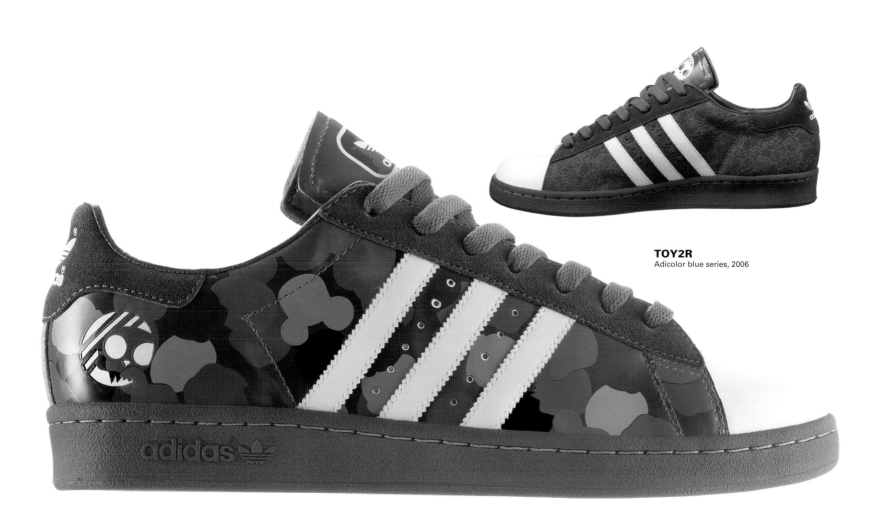

TOY2R
Adicolor blue series, 2006

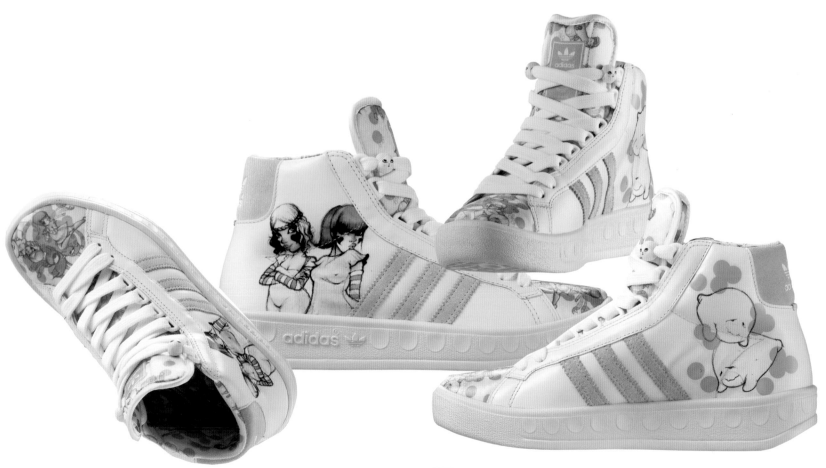

FAFI
Adicolor pink series, 2006

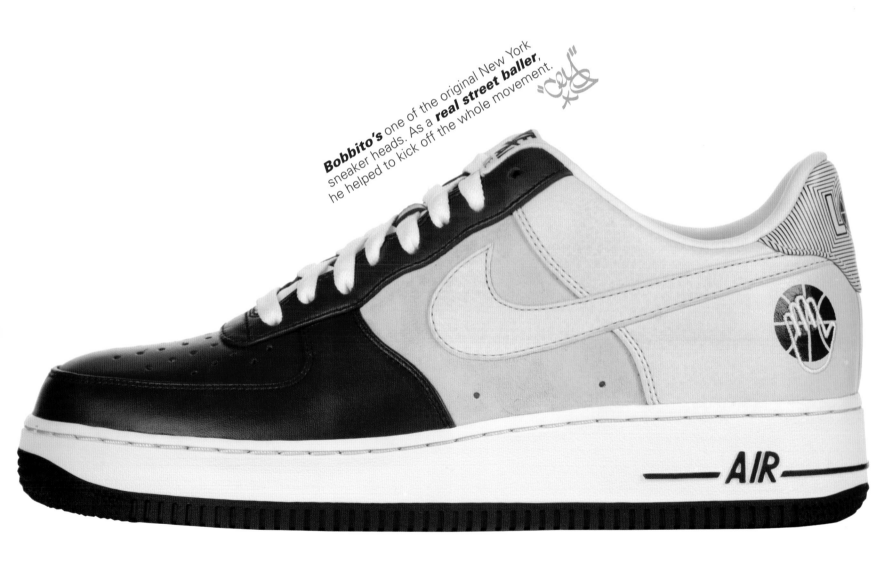

Bobbito's one of the original New York sneaker heads. As a **real street baller**, he helped to kick off the whole movement.

BOBBITO GARCIA
Nike AF1 Bobbito, 2007

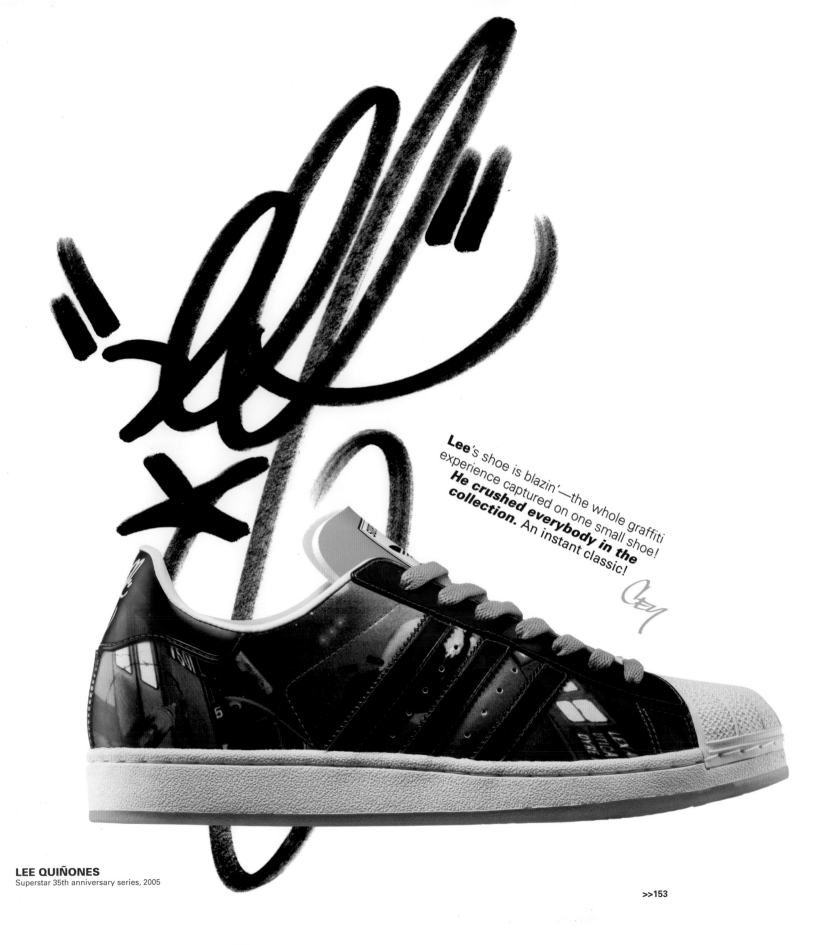

Lee's shoe is blazin'—the whole graffiti experience captured on one small shoe! **He crushed everybody in the collection. An instant classic!**

LEE QUIÑONES
Superstar 35th anniversary series, 2005

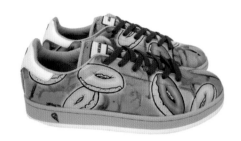

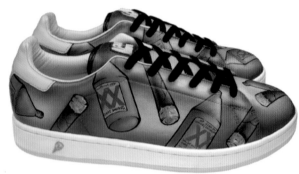

"My dream customer visualizes my kicks sitting in the MoMA some day soon."

—Jor One, 2004

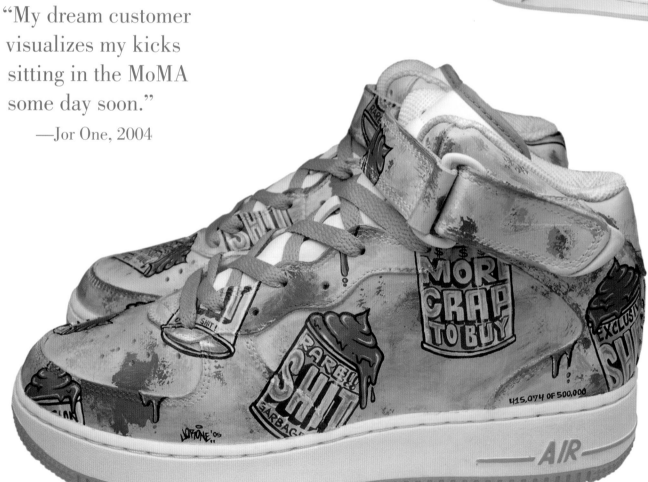

Top to bottom:
JOR ONE
Coffee and Donuts, 2005
40s and Blunts, 2005
Limited Edition Cans of Shit, 2005

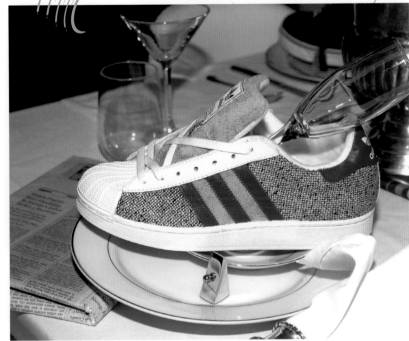

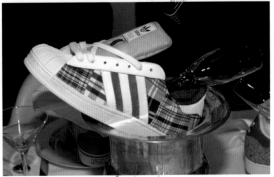

Clockwise from top:
CARLTON LESTER
Country Club Sport, Phat Farm Footwear, 2006
Gallery Prep, Phat Farm Footwear, 2006
Don't Get Madras, Get Even, Adidas, 2006
Country Club LE, Phat Farm Footwear, 2006
The Paperboy, Adidas, 2006

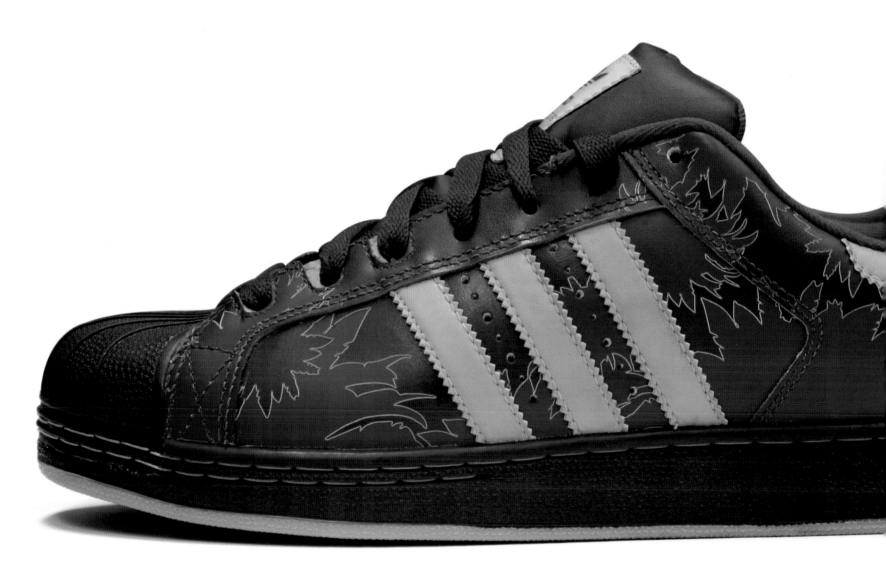

KINSEY
Adidas Superstar Skate San Diego edition, 2006

Opposite:
KINSEY
Limited edition Adidas screen-print, 2006

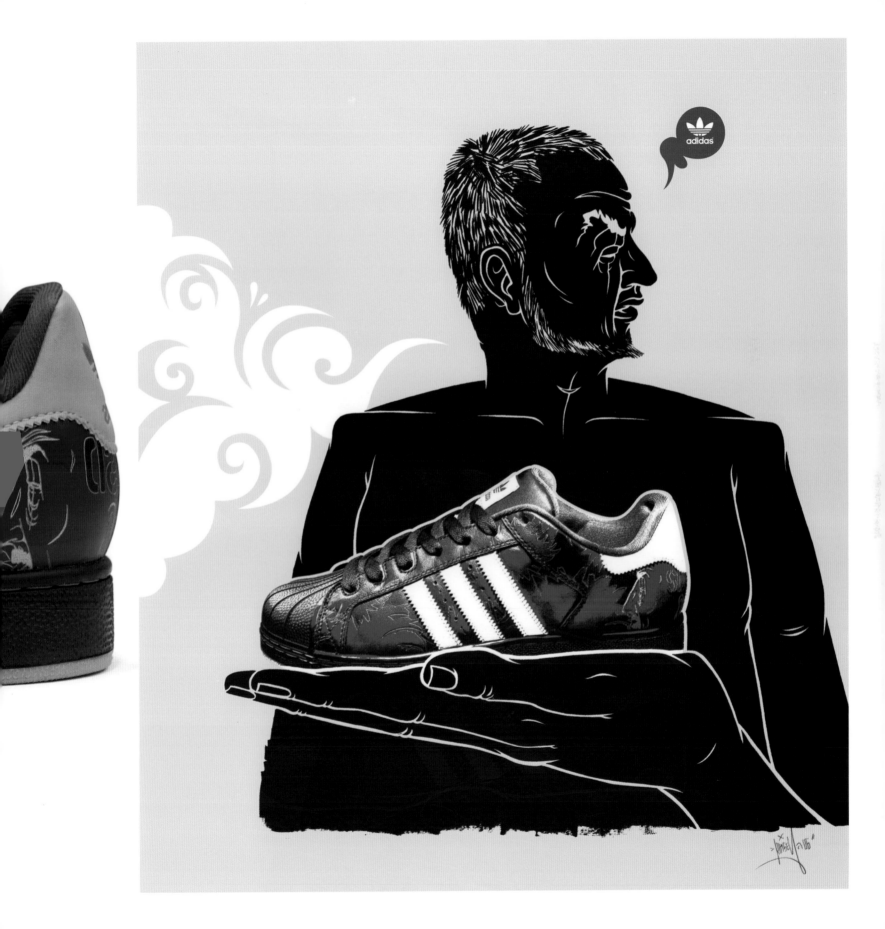

FRESH FRESH AND SO CLEAN

BY RAQUEL CEPEDA

HIP-HOP

AND FASHION

SARAH J. EDWARDS
OutKast, 2006

Hip-hop's eye for fashion has always been as original and influential as its ear for music. Twenty years before Sean John and Rocawear, hip-hop's fashion pioneers created a blueprint for virtually everything else that followed. Now that hip-hop style has gone global, the world—or at least the world of fashion—is a looser, more colorful, and more amusing place than ever before.

Well before anyone in the culture made a nickel, hip-hop's devotees were fashion-forward. A hip-hopper always knew what the cool hat was in any given season. He kept his sneakers superclean and he customized his T-shirts and belt buckles with his name. Rocking this gear with just the right street bravado is what made one fresh. And while the culture's vernacular has certainly changed throughout the years, the underlying tenet still applies today: You must come correct. That is, either choose your gear with flair or don't bother to step out of the crib.

In 1984, the artist Richard Lee Sisco created four pages of illustrations for Steven Hager's book, *Hip-Hop: The Illustrated History of Break Dancing, Rap Music, and Graffiti* that depicted how the main citizens of the hip-hop nation—gangster, b-boy, writer, deejay, and emcee—were meant to represent themselves and the culture, at least from 1970 to 1983. Each character's ensemble delivered both form and function. The writer, circa 1979, was togged out as follows: "Tight black shirt, tight straight-leg jeans, duffle bag for paint cans, and good-traction sneakers."

On the West Coast, during the same period, street wear was inspired by gang and prison culture. In his book, *The Ice Opinion: Who Gives a Fuck?*, Ice-T writes:

Gangbanger clothes are all based on the cheapest shit in the stores. Bandanas. Shoe-laces. The Mexican kids wear pressed T-shirts; they even iron a crease in them. They wear khakis and corduroy house shoes that cost five or ten dollars. They wear Pendleton shirts that

last forever. The entire dress code consists of inexpensive items, but they press them and turn their dress into something that's honorable 'cause this is all they got.

But these examples describe fashion in hip-hop's infancy, when it was all still very local. It wasn't until rappers became pop stars that hip-hop fashion impacted how people rocked their gear all over the world. As one of the first bands to reach pop-star status, Run-DMC was responsible for three separate fashion landmarks in 1984: the album cover of *Run-DMC*, their eponymous first album; the music video for "Rock Box"; and their first national tour. All showcased not just how hip-hop sounded, but how it *looked.* Russell Simmons, the group's manager, wasn't going to allow his rappers to dress like their predecessors—that is, like the cowboys and spacemen and other fantasy figures left over from the disco and funk eras.

Instead, he directed Run-DMC to dress like deejay Jam Master Jay, who'd been sporting a homegrown street hustler's look since he was a junior-high schooler in Queens. As Jay told Bill Adler in *Tougher Than Leather: The Rise of Run-DMC,* "Even then I had my black velour, Stetson with a feather in it, my black-and-white Adidas with the shell toe, and my Lee jeans . . . and I thought about how my colors had to be coordinated."

Later in the decade, the rappers Slick Rick and Public Enemy's Flavor Flav succeeded Run-DMC as hip-hop fashion icons. "Slick Rick the Ruler," as he called himself, adopted a majestically jeweled style that not only recalled the plush gear of the blaxploitation film heroes of the 1970s, but the extravagance of the English royals. (Interestingly, the Bronx emcee was born and lived in England until he was eleven years old.) In "La Di Da Di," his debut hit from 1985, Slick Rick describes his extravagant morning grooming rituals—brushing his gold teeth, taking a bubble bath, and splashing on Oil of Olay,

Johnson's Baby Powder, and Polo cologne—and preference for dressing in "brand-new Gucci underwear," Bally shoes, "fly green socks," and a Kangol hat. By 1989, Slick Rick was actually wearing a crown onstage, along with half-a-dozen thick gold "ropes" around his neck, a ring on every finger, and diamonds in his teeth, making him unquestionably one of the godfathers of bling.

Public Enemy's Flavor Flav was another original. Determined to make sure that everyone knew what time it was, politically speaking, Flavor Flav was likely the first person in human history to wear a swinging clock the size of a dinner plate around his neck. Absurd? Sure. But he often counterbalanced the clock by crowning himself with an elegant black silk top hat straight out of the 1930s, while sporting superfuturistic Italian sunglasses. It's a tribute to Flavor Flav's fashion genius that he made these wildly disparate pieces come together in one outfit.

Throughout the late 1980s and early 1990s, rappers continued to exert their influence on hip-hop fashion. N.W.A. made wearing all-black clothing trendy in the hip-hop community. The Native Tongues Posse, including De La Soul, A Tribe Called Quest, and especially the Jungle Brothers, became known for their khaki-colored fisherman vests and hats, and their extra-large Marithé & François Girbaud jeans.

Monie Love and Queen Latifah made traditional African garb fashion-forward, while KRS-One, X-Clan, Public Enemy, and the aptly named Afrika Bambaataa made *anything* Afrocentric all the rage. The hit-making Kwame adopted polka dots as his signature style. It was a period when hip-hop fashion and hip-hop music were equally creative and eclectic, and there appeared to be something for everyone.

Suddenly, established fashion brands like Tommy Hilfiger and Ralph Lauren began introducing what they called "street wear" or "urban wear" lines, a token of their recognition of the buying power of the hip-hop

community. Hilfiger was awakened to hip-hop's stylish flair by his brother Andy, who had taken to partying at night with Russell Simmons and his friends. (For his part, Simmons's interest in the fashion business was predated by his interest in fashion models.) Ralph Lauren's interest in hip-hop was sparked after he was "threatened by Hilfiger in a market [Lauren] had profited from but never embraced," according to Marc Spiegler in a November 1996 article for *American Demographics*. Of course, by the summer of 1992, when Grand Puba's guest rap on Mary J Blige's "What's the 411?" included a salute to the Hilfiger brand, it was impossible for the mainstream fashion world to continue to ignore hip-hop, not least because such shout-outs invariably produced a marked spike in sales.

But even earlier, a battalion of urban wear designers with roots in the "urban" or black community had begun to establish their own enterprises. Among the very first was the mysterious Mr. Dapper Dan, who was himself already a brand name, at least in hip-hop circles, by the mid-1980s. Working out of a street-level shop on 125th Street in Harlem, Dan catered to his clients' lust for European name brands by creating custom garments out of bootlegged swatches of material on which high-end logos—Louis Vuitton and Gucci were particular favorites—were endlessly repeated. What was the source of this bootlegged fabric? Dan bought name-brand luxury garment bags and tailored them as required. The feisty female rapper Sparky D recalls paying $1,200 for a "Fendi" outfit, $1,400 for "Louis Vuitton," and $1,500 for "Gucci."

The hip-hop couturier's other celebrity clients included the Fat Boys, Eric B. & Rakim, Big Daddy Kane, Roxanne Shanté, Salt-N-Pepa—as well as the prizefighters Mike Tyson and Mitch "Blood" Green, who famously got into a fistfight in front of Dan's shop in 1988. (Dan was enough of a celebrity to have been namechecked on recordings by Kool G Rap, Yukmouth, and Jay-Z, among others.) Dan never acquired a license to use these swanky logos, but his illegal pieces more often helped a company's trademark—in terms of its exposure and newfound street cred—than hurt it. Author Susan Scafidi writes, "In the right hands, street fashion can make established labels newly trendy by association." Dapper Dan had the right hands.

Inspired by Dan's example, the Brooklyn-based designer April Walker opened her first store, Fashion in Effect, in 1988. Four years later, she launched Walker Wear, a men's clothing line. The brand's rough and rugged denim jeans, oversized T-shirts, and branding style resonated with the hip-hop community. Walker made sure her designs had the proper fit, and this proved crucial to the line's success. "Many guys who wanted to wear jeans, which were getting baggier by the year, needed to size up and then have the pants tailored to fit," she explains. "I wanted to create something that would fit men's hips, take care of their rise [the measurement from the crotch to the top of the waistband], and still be baggy." While working as a stylist for Run-DMC, Walker was clued into the importance of a good fit by Jam Master Jay; it was a lesson she never forgot.

Established on Manhattan's Lower East Side by designer Camella Ehlke in 1989, Triple 5 Soul is a sterling example of the interdependence of music, art, and fashion in hip-hop. Ehlke sold original hand-sewn hoodies and velour jumpsuits featuring a "555" logo designed by the iconic skateboarding graffiti artist Alyasha Jibril Owerka-Moore, who several years later became one-half of the original design team at Russell Simmons's Phat Farm. (The line's name was inspired by a slate of late-1980s phone sex advertisements, which invited New Yorkers to dial easy-to-remember numbers, like 555-HOTT.) Triple 5 Soul became very popular very quickly thanks to celebrity patrons like KRS-One, Main Source, De La Soul, Brand Nubian, and Fab 5 Freddy, who visited the store in 1990 for a feature on *Yo! MTV Raps.*

Like Triple 5 Soul, PNB Nation, which placed their first pieces in the Triple 5 Soul store, had roots in graffiti. Comprised of highly respected aerosol artists Isaac "West" Rubinstein, James "Bluster" Alicea, "Zulu" Williams, "Serge One" Williams, Sung Choi, Roger "Brue" McHayle, and Shara McHayle, PNB Nation took the skills required to get up in New York City and redirected them into an apparel company. "We went from trains to clothes because trains died in the late 1980s," says Williams. "And for a [graffiti] writer it's all about fame . . . so clothes became our new way to get up."

The letters PNB were said to stand for many things, including Proud Nubian Brothers. In one of their most popular T-shirt designs, PNB's company acronym replaced the NBA logo. While the NBA logo features a color scheme based on the American flag (a white silhouette of Jerry West, a white player, rests against a background of red and blue), PNB's version was based on Marcus Garvey's pan-African black Liberation flag, and featured a black silhouette of a ballplayer wearing an Afro against a background of red and green. PNB excelled at delivering powerful statements with simple design treatments, one of the most indelible being a line of plain ready-made T-shirts and sweatshirts with the words Justice, Wisdom, Divine, Supreme, and Knowledge stitched onto them. The words' message evoked the self-empowering ideology of the Nation of Gods and Earths, and the design was cool. Their line of "Hello My Name Is . . ." T-shirts featured the names of victims of police brutality, like Michael Stewart, Eleanor Bumpurs, and Phillip Pannel.

Of course, the world of hip-hop fashion was hardly confined to New York City. In 1990, Los Angeles bum-rushed the game in the form of Cross Colours. Founded by designers Carl Jones and Thomas Walker and devoted to "clothes without prejudice," Cross Colours enjoyed much success. The rap duo Kriss Kross wore superbaggy Cross Colours gear backward in their video "Jump" (1992). On almost any given night, *Yo! MTV Raps* welcomed a hip-hop star who wore the Cross Colours logo onto the show. Teenagers wearing Cross Colours T-shirts with slogans like "Stop D Violence" and

"Educate 2 Elevate" were spotted on dance shows like *The Grind* (an MTV show that was not especially about hip-hop) and on popular urban sitcoms, like *The Fresh Prince of Bel-Air* and *A Different World*.

Cross Colours had been steaming along for a couple of years when it hooked up with an ambitious young designer calling himself Karl Kani. Born Carl Williams in 1968 and raised in East New York in Brooklyn, Kani began designing his own clothes as a teenager and was soon persuaded to perform the same service for his friends. According to an interview with *Vibe*, he moved to Los Angeles, after "people who were close to me started getting killed." In 1989, Williams gave himself the hopeful nom de guerre Karl Kani (pronounced "Can I?") and opened a store on Crenshaw Boulevard called Seasons Sportswear. A couple of years later, he introduced himself to Carl Jones at a Cross Colours fashion show, and the two began working together. Their partnership was very successful. Where PNB and Triple 5 Soul spoke to a set of globally conscious intellectuals who hung out at cafés and multicultural spots like lower Manhattan's Washington Square Park, Karl Kani's clientele were straight out of Brooklyn, Harlem, and Los Angeles's Echo Park. Indeed, people all over the world who wanted to look like rappers dug Kani's cool visage, and soon everyone started buying his brightly colored, superbaggy ensembles, including denim-colored coordinates, "bulletproof" fleece suits, and chunky sweatshirts with metal nameplates. Business conflicts with Cross Colours persuaded Kani to step out on his own in 1994. Although he could boast that Tupac and Snoop Dogg were sporting his threads, the designer ultimately wanted, he said, "to clothe the guys on Wall Street."

As an independent designer, Kani was so popular that his clothes were wildly counterfeited. In defense, he directed his manufacturers to start fastening a signature plate made of metal and leather to the brand's jeans. The manufacturers thought Kani was nuts, worrying that the plates would tear up the seats of a customer's car. "These turned out to be our best-selling jeans ever," Kani claimed. "Then, of course, they started counterfeiting that."

Design aside, Kani was not shy about promoting himself as the spokesman of his own brand. The metal-and-leather patch of his popular jeans bore a printed message from the designer that typified his brashness. It read: "Karl Kani, the young African-American designer of Karl Kani Jeans, encourages you to follow your dreams and accomplish your goals. . . . Recognize the signature that symbolizes African-American unity and pride." Personalizing his brand in this way was routine for rappers and for

established fashion designers, but it was an innovation in the world of hip-hop fashion.

Just as Cross Colours begat Karl Kani, Karl Kani begat FUBU. Daymond John, one of the brand's four founders, told *Vibe*, "Before seeing Karl, it never dawned on me that young African-Americans could control and create fashion." That sense of race pride and new opportunity was built right into the brand's name, an acronym for "For Us By Us." Established in John's home in Hollis, Queens, FUBU started as a line of hats, but quickly evolved into a full-fledged men's collection comprised of oversized silhouettes plastered with the kind of big bold logos that identified most popular hip-hop fashion brands, from PNB to Karl Kani.

The hip-hop community supported FUBU's designers, who looked like them and who, by all accounts, hired many African-Americans to work for them. LL Cool J, a Queens native like John and FUBU's first celebrity endorser, famously managed to slip a shout-out to FUBU into a national television commercial for the Gap.

Like the best rappers, the FUBU crew was defined as much by their self-confidence and ambition as by their creativity. Before them, hip-hop fashions were mainly confined to the urban community. FUBU's audacious dream was to take on the likes of Nike head-to-head in every suburban mall in America. And it largely succeeded. As an article in *American Demographics* noted in 1996: "Hordes of suburban kids—both black and white—have followed their inner-city idols in adopting everything from music to clothing to language. The . . . evidence is at suburban shopping malls across the country: licensed sports apparel, baseball caps, oversized jeans, and gangster rap music." FUBU, however, apparently overdid it. Its meteoric drive for mass appeal cost it some of its flava. Nonetheless, the brand is still carried in many department stores across the country. It is also wildly popular in countries like South Africa, Saudi Arabia, and Australia—just a few of the foreign lands newly receptive to hip-hop culture in its various forms.

And then, inevitably, came Russell Simmons's Phat Farm. In retrospect, one imagines that the only reason it took Simmons until 1992 to launch his own fashion brand is that he was preoccupied by his other hip-hop businesses, primarily Def Jam. Interestingly, the Phat Farm aesthetic was much more conservative than Def Jam's. At the same moment that the record label was enjoying its first gangsta rap hit (Onyx's "Throw Ya Gunz"), Russell was introducing a fashion line comprised of preppy buttoned-down chambray and Oxford shirts, chinos, and hoodies, all done up in argyle patterns and a palette of pastels. The clothes were oversized, to be sure, but otherwise the look was very Ralph Lauren. And why not? If white kids could

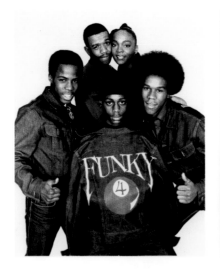

dress "black," why couldn't black kids dress "white"? Throughout the early 1980s, Russell himself wore exactly that kind of gear, accessorized in hip-hop style. Phat Farm, he declared, embodied Classic American Flava—a sentiment that became the brand's tagline. The phrase allows the brand to have it all ways: The gear is at once timelessly tasteful, a token of native accomplishment, and authentically hip-hop. More pointedly, Phat Farm announced to the world that hip-hop wasn't as alien-looking as people outside the community might have imagined.

Within the hip-hop community, Phat Farm wasn't nearly as trendy as, say, Karl Kani. But over the years, Phat Farm is the brand that's lasted. Of course, it didn't hurt that Russ employed his future bride, the stunning Afro-Asian Kimora Lee, as the face of his brand. Kimora's undeniable beauty forced one to reconsider the meaning of Classic American Flava. A decade earlier, the phrase might have conjured images of Christie Brinkley. That era was over.

Echo Unlimited jumped off in the summer of 1993. (The "h" in "Echo" was replaced by a "k" in 1997.) Named after Marc "Ecko" Milecofsky, who released a popular line of six T-shirts, the brand's first full collection debuted in 1996. It married street wear with a political point of view and skateboarder chic. It also boasted a cool-looking rhinoceros logo. In effect, the line possessed not only the intellect of PNB and Triple 5 Soul, but also the crossover appeal of FUBU and Phat Farm. This winning combination managed to appeal to all of the constituents addressed separately by previous hip-hop brands. Somehow Ecko was simultaneously bohemian, street, and preppy.

Taking stock of the hip-hop fashion scene for the *New York Times* in the fall of 1996, journalist Constance White noted that the underwear-revealing jeans and busy logo tops of yesteryear were giving way to "a toned down, more preppy look and to active-year-driven-styles. There are wide, straight-leg jeans that sit on the waist or hips; pastels or sophisticated bright colors, and nylon puff jackets, some trimmed with fur . . . reflect[ing] an emerging strain of luxe spurred by images of entertainers buying and rapping about Versace clothes, diamonds, and Cristal Champagne."

This "strain of luxe" was expressed in different ways by different camps. The first camp, relatively upscale and sophisticated, was personified by Sean "Diddy" Combs. A restless multitalented producer and entrepreneur who modeled himself on his mentor, Russell Simmons, Combs most likely conceived of his Sean John brand the minute he learned that Russell had launched Phat Farm. The line, however, didn't get rolling until 1998, but when it emerged, it was fully formed in the image of Combs himself: Beautifully tailored and heavily be-diamonded, it presented the CEO as pop star. "When Puffy wears a suit, it's hipper than [how] any other businessman would wear [it], and it's more expensive," Tommy Hilfiger wrote admiringly in *Rock Style*. "It's a suit that makes a point: Puffy is taking care of business, but on his own terms." Like Dapper Dan, but with no need to bootleg his materials, Combs was selling *aspiration*. Sean John simply translated its namesake's lifestyle into a line of clothing. In 2004, when Combs beat out Ralph Lauren and Michael Kors to win a Council of Fashion Designers of America award for menswear, he declared that the victory confirmed for him that he was "living the American dream."

Glitzy as he is, Combs is a model of WASPy restraint compared to the denizens of the second luxe camp: the devotees of bling. A brilliant cartoon evocation of the imaginary sound generated by something gleaming and expensive (like diamonds, gold, or platinum), the word has come to stand for the wildly ostentatious display of wealth in the forms of everything from finely detailed clothing to gem-encrusted watches to the diamond "fronts" for one's teeth known as "grillz." Bling came into general usage thanks to a song entitled "Bling Bling," which was a hit in 1999 for the New Orleans rapper named B.G. and his pals in the Cash Money Millionaires. A product of southern hip-hop, the word quickly passed into the bloodstream of the hip-hop nation everywhere.

In recent years, hip-hop fashion has welcomed design contributions from women, like Fafi and Claw. Fafi, a worldwide art star who emerged out of the graf and fine arts scene in her hometown of Toulose, France, contributed a signature tracksuit to Adidas's Adicolor campaign in 2006. Like so much of her art in other media, the suit is bedecked with several of her original cartoon characters, including the Hello Kitty–like Fafinettes and the shmoo-like Hmilos.

Claw's two-toned and three-toned Claw Paw has been her trademark since the early 1990s. According to Claw, the icon "maintains a fun, fabulous, and feminine allure despite the grit and grime that makes graffiti a man's world." A dropout from New York's Fashion Institute of Technology, she launched her Claw Money clothing line in 2002. Images of big bear-claw prints and fluorescent colors dominate her designs. Her aesthetic is, according to Cey Adams, "a cross between 1970s Studio 54 and 1980s

downtown b-girl."

The highly popular rapper Missy Elliott first jumped into the fashion game in 2004, with her Respect M.E. line, a collaboration with Adidas. The line of T-shirts, tracksuits, boots, and bags is an elaboration of Elliott's personal style as displayed in her music videos—casual, colorful, unisexual, and playful. The deal was Adidas's first with an entertainment icon since it had hooked up with Run-DMC in 1986. Indeed, as Adidas itself pointed out in a company press release, "The Respect M.E. collection looks back at Adidas's old-school street credibility while simultaneously contemporizing the Trefoil for hip-hop's newer generation." The Trefoil was the shoe immortalized by Run-DMC.

To a certain extent, hip-hop fashion in the twenty-first century has become a victim of its own success. Dedicated shoppers turn up their noses at the culture's mass-produced goods in favor of hard-to-find lines like A Bathing Ape. Founded by Tomoaki Nagao as a hole-in-the-wall T-shirt store in Tokyo in 1993, A Bathing Ape quickly attracted a global coterie of hip-hop hipsters. Jay-Z, Kanye West, and producer/performer Pharrell were all on hand when the brand opened its retail outlet in New York's SoHo in 2005. The line is a well-tailored mix of skater chic and street wear (two stylish subcultures that have been influencing each other for decades), but what makes it truly sexy is its scarcity. It takes time, effort, and taste to get your hands on a garment.

But, now as ever, it's worth it to those in pursuit of what's truly fresh.

KEITH HARING & JEREMY SCOTT
Adicolor black series, tracksuit, 2006

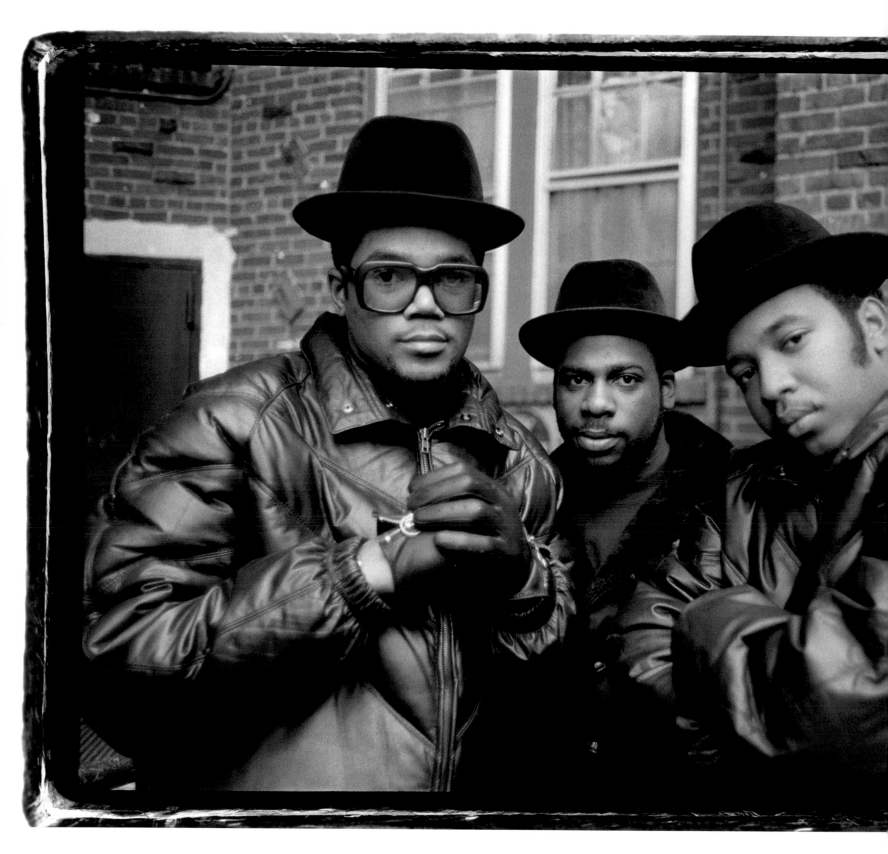

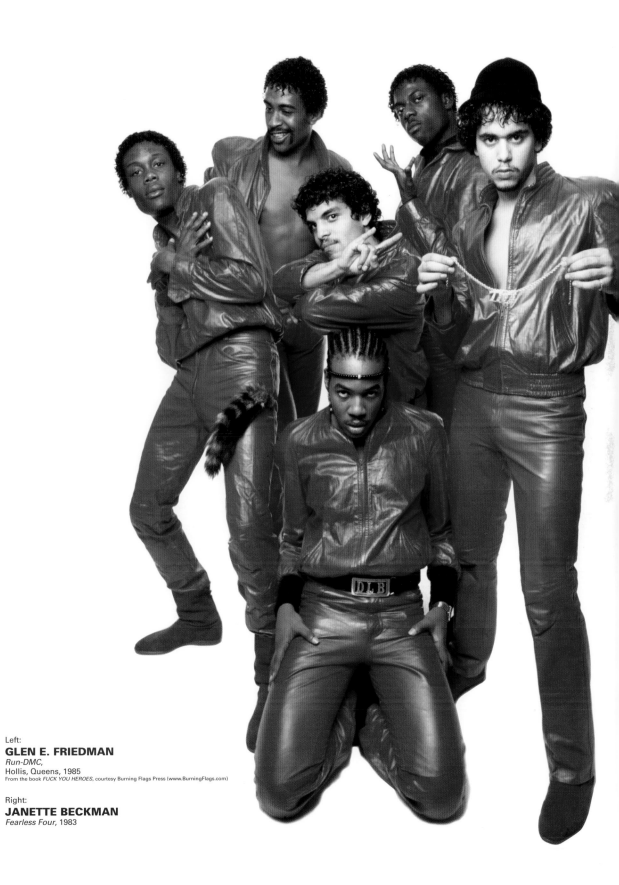

Left:

GLEN E. FRIEDMAN
Run-DMC,
Hollis, Queens, 1985
From the book *FUCK YOU HEROES*, courtesy Burning Flags Press (www.BurningFlags.com)

Right:

JANETTE BECKMAN
Fearless Four, 1983

modern classics

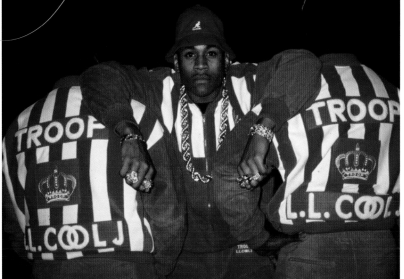

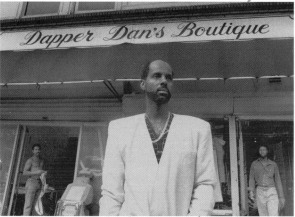

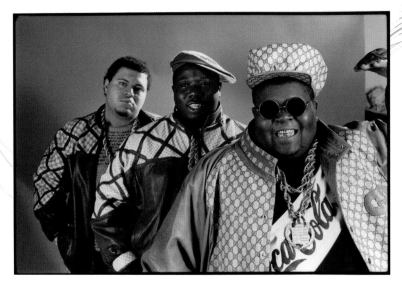

Clockwise from top:
Kangol® Koolers advertisement, 1988
Kangol® Modern Classics advertisement, 1988

DAPPER DAN
At his boutique, Harlem, 1988.
This was two days after Mike Tyson
came to pick up a custom-made
white leather jacket and got into a
fight with boxer Mitch Green.

MICHAEL BENABIB
Fat Boys, 1987,
Gucci suits by Dapper Dan

RICKY POWELL
LL Cool J, wearing Troop tracksuit, Los Angeles, 1988

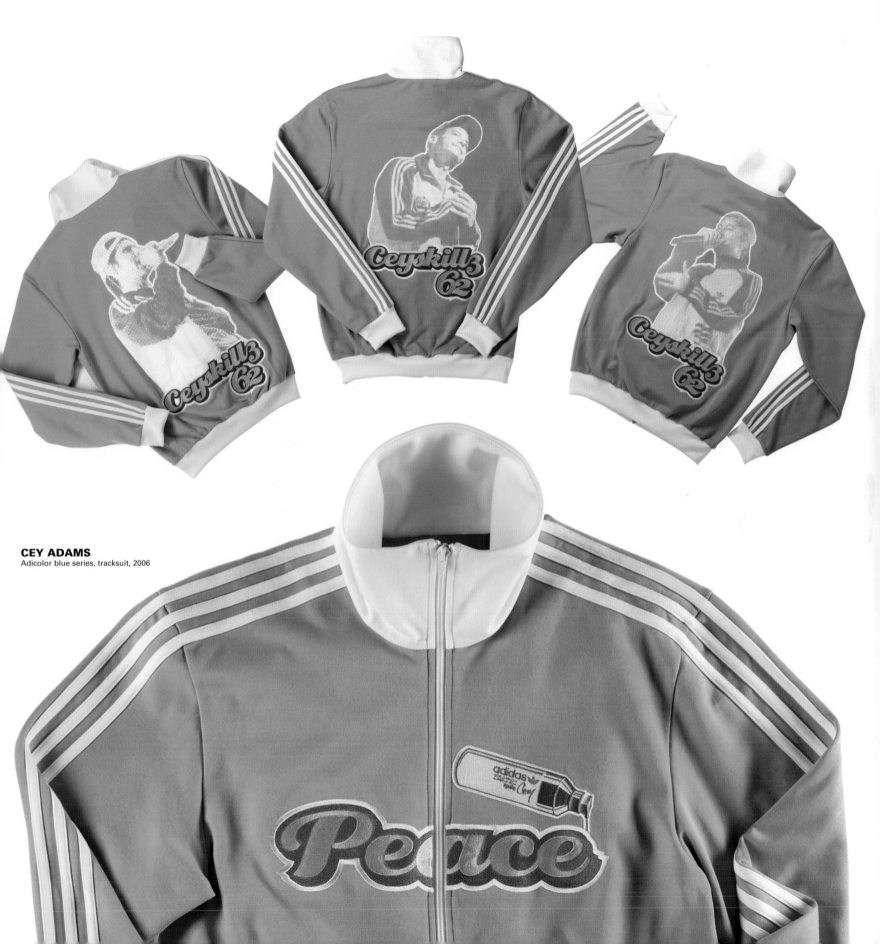

CEY ADAMS
Adicolor blue series, tracksuit, 2006

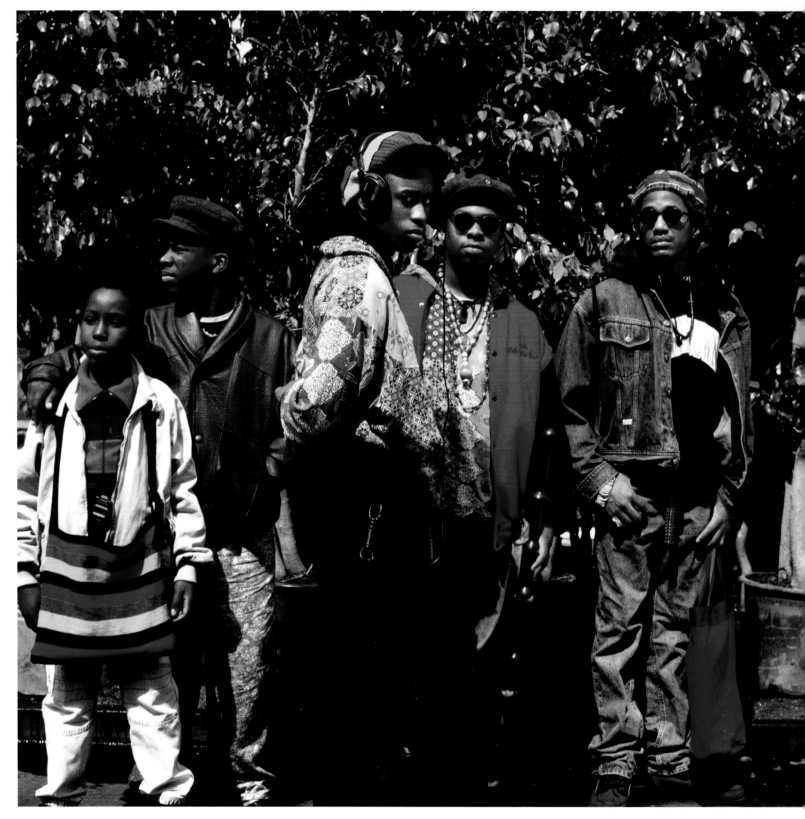

JANETTE BECKMAN
A Tribe Called Quest
at the height of Afrocentrism, 1990

Opposite:
MICHAEL BENABIB
Naughty by Nature, 1991

Around this time everyone was sporting *Spike's Joint* gear. Spike used plenty of red, black & green in his designs, which was a measure of his commitment to **black power** and **black pride.**

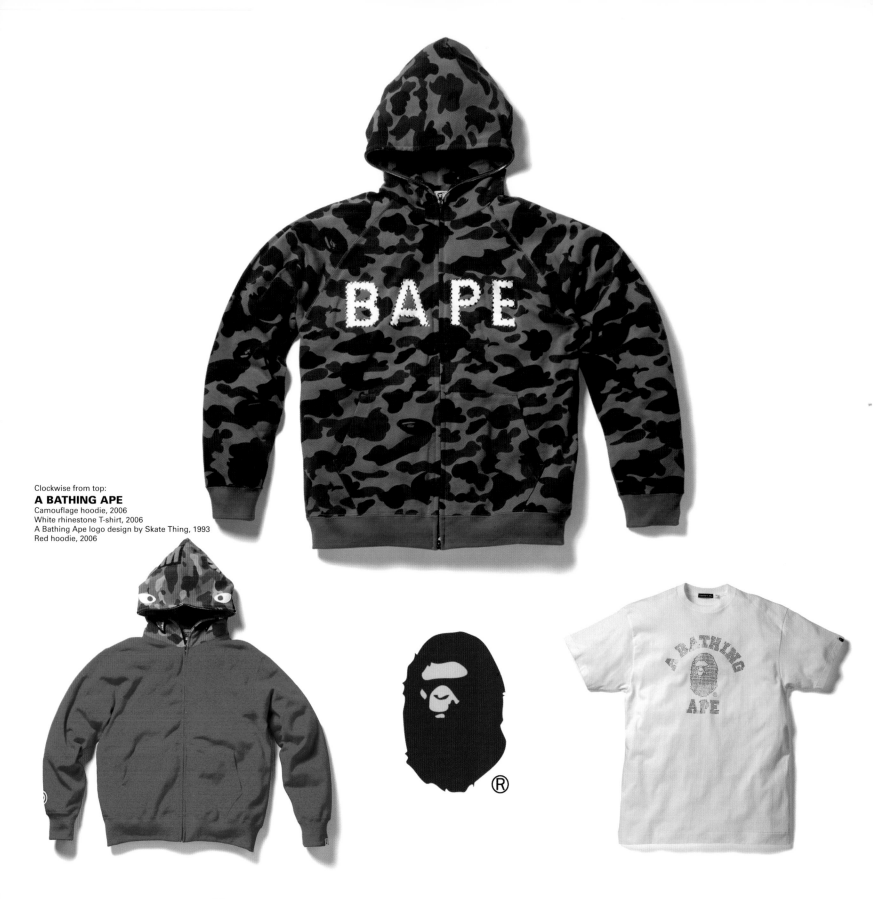

Clockwise from top:
A BATHING APE
Camouflage hoodie, 2006
White rhinestone T-shirt, 2006
A Bathing Ape logo design by Skate Thing, 1993
Red hoodie, 2006

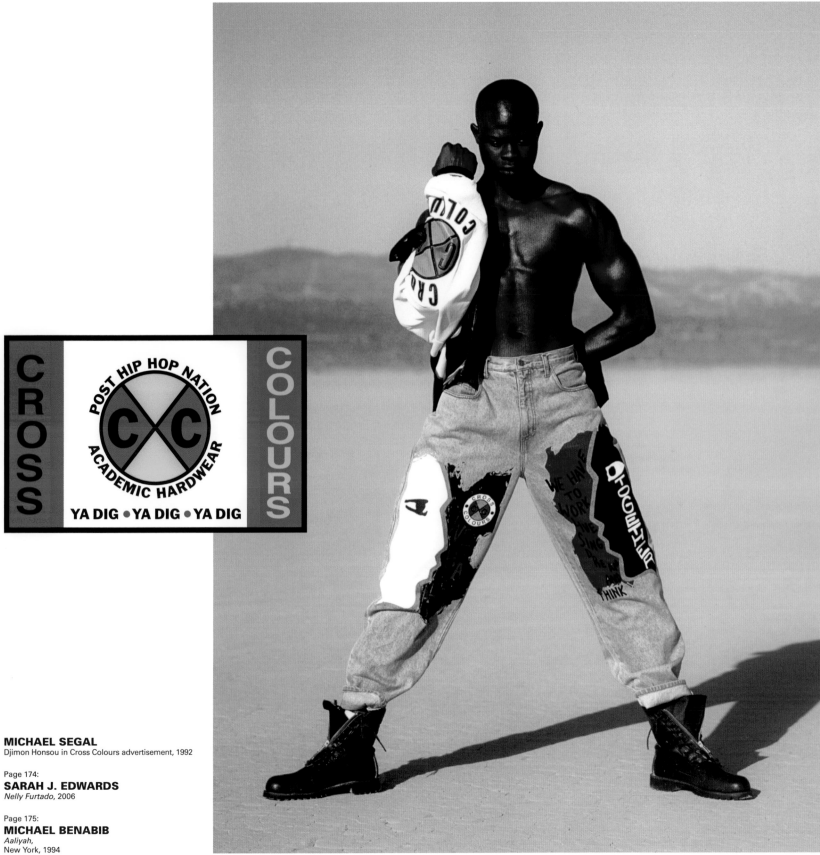

MICHAEL SEGAL
Djimon Honsou in Cross Colours advertisement, 1992

Page 174:
SARAH J. EDWARDS
Nelly Furtado, 2006

Page 175:
MICHAEL BENABIB
Aaliyah,
New York, 1994

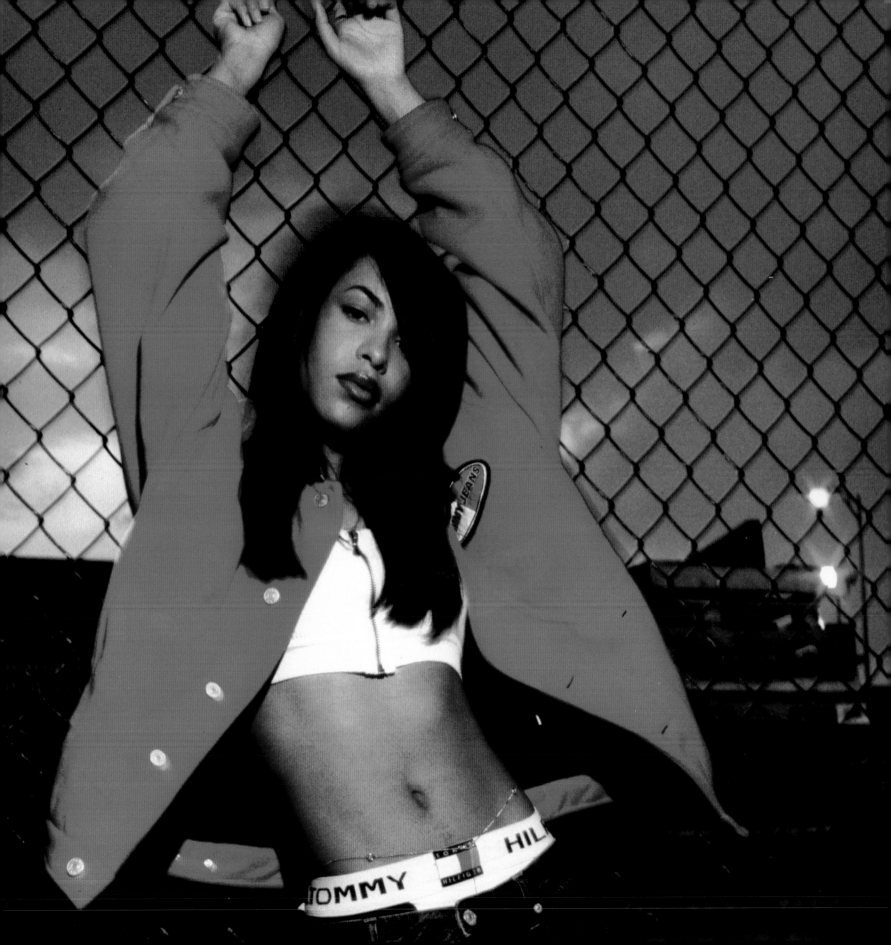

ANGELA BOATWRIGHT
Amel Larrieux,
New York, 2000

Opposite:
WILLIAM RICHARDS
Public Enemy wearing BAMN! NATION clothing, 1995

Page 178:
MICHAEL BENABIB
Sean "Diddy" Combs for Sean John, 1999

Page 179:
GLEN E. FRIEDMAN
*Kimora Lee Simmons for Phat Farm,*1992
From the book *FUCK YOU HEROES*, courtesy Burning Flags Press (www.BurningFlags.com)

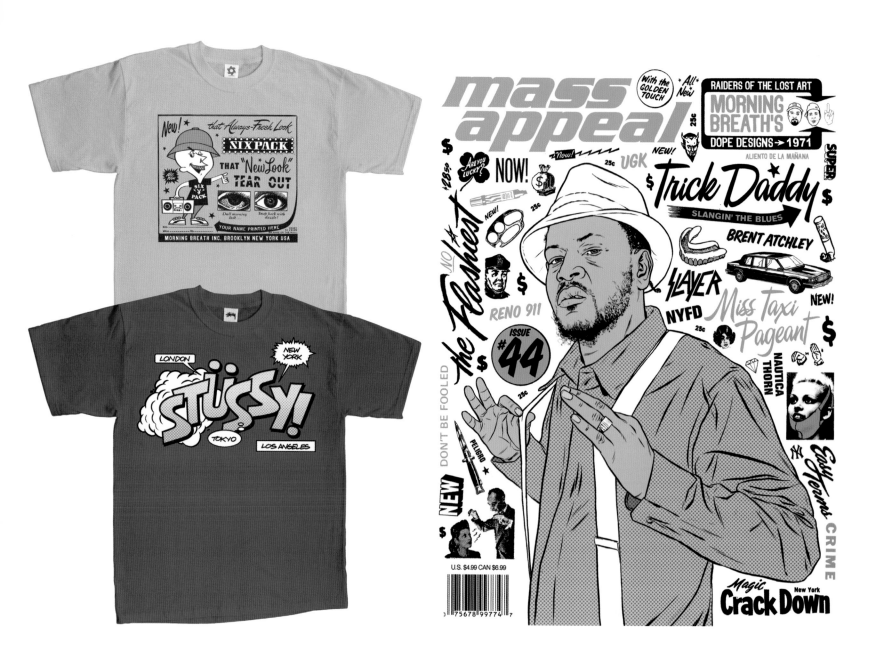

MORNING BREATH
Graphic T-shirts, 2007
Cover of *Mass Appeal* magazine, 2007

Clockwise from top left:
CLAW MONEY
Camouflage hoodie, 2007
Hamburger shirt, 2007
Stack of Claw Money T-shirts, girl wearing Nike Blazers, 2007
Claw Money wall, 2005

Page 182:
JANETTE BECKMAN
Slick Rick, 1990

Page 183:
SANTE D'ORAZIO
Mary J Blige, 1994

ABOUT CEY ADAMS

A native New Yorker, Cey Adams didn't have to read about hip-hop to get the word. He was, he says, "born into" the culture. He grew up in Jamaica, Queens, and was "bombing trains," graffiti-style, as a teenager. By the early 1980s, Adams was associated with the East Village art movement, exhibiting his paintings in shows with Jean-Michel Basquiat and Keith Haring. He went on to study painting at the School of Visual Arts.

Following the birth of his son, Eric, in 1984, Adams began working for Russell Simmons, another Queens native. Simmons was managing the careers of a growing roster of rappers and had just gone into business with a recent college graduate named Rick Rubin on a record label called Def Jam. During the next few years, Adams was a one-man graphic design whirlwind—painting giant stage backdrops for the rappers on tour; designing flyers for Run-DMC, Whodini, and Big Daddy Kane, and logos for LL Cool J, the Beastie Boys, and Slick Rick; and creating a boatload of wearable merchandise, including T-shirts, hats, and tour jackets. (His first album cover design was for The Real Roxanne's *Bang Zoom!*)

In 1986, Adams started working with Steve Carr, a young artist who had recently graduated from New York's School of Visual Arts, and who is much better known today as the director of a slew of Hollywood movies, like *Next Friday, Dr. Doolittle 2,* and *Daddy Day Care.* "We played off each other, like Felix and Oscar," recalls Adams. "Steve was my partner in crime. He showed me that there was a career in graphic design."

When Def Jam took over a lot of the design responsibilities from Columbia Records, its parent company, Adams recalls, "there was too much work for the two of us to do personally." The pair became executives, hiring and supervising the work of other artists. Adams traces the decision to create his own company to Russell Simmons, saying, "I wanted to control my own destiny. It's what I saw Russell do." Carr and Adams formalized their partnership with the creation of their company, the Drawing Board, which successfully steamed along until 1999. The Drawing Board boasted a notable range of clients, including Def Jam and Sean "Diddy" Combs's Bad Boy label, for which the Drawing Board designed the cover of the Notorious B.I.G.'s *Ready to Die.*

Adams has since launched a series of new endeavors with clients such as Nike, Adidas, Coca-Cola, HBO, Earvin "Magic" Johnson, and radio stations Hot 97 and WBLS. In 2000, Adams designed the hip-hop wing of the Experience Music Project, Paul Allen's Seattle-based rock 'n' roll museum; in 2003, he created the logo for *Chappelle's Show;* in 2006, he began teaching art at the Brooklyn Academy of Music; in 2007, he curated *Untitled: An Exhibition of Original Skateboard Art* for the Eyejammie Fine Arts Gallery in New York.

He lives and works in New York City.

ACKNOWLEDGMENTS

Derrick Adams of the Rush Arts Gallery, Eric Adams, Charlie Ahearn, Julian Alexander, Julie "Jigsaw" Ashcraft, Jason Atienza, Greg B., B+, Eric Bailey, Michael Bair, Sunny Bak, Randy Barbato, Cbabi Bayoc, Beastie Boys, Janette Beckman, Michael Benabib, Signe Bergstrom, Nico Berry, Beau Boeckmann and Tiffany Walker of Galpin Auto Sports, Angela Boatwright, Charlie Braxton, Imani Brown of Artistic Sole, Justin Bua, James Campbell of Baby Phat, Ann Carli, Steve Carr, Keene "Team" Carse, Raquel Cepeda, Henry Chalfant, Arlo Chan of Warner/Chappell Music, Jeff Chang, Seth Cheeks, Raymond Choy, Claw Money, Chef of Gourmet-Kickz, Keith Clinkscales, Lyor Cohen of the Warner Music Group, Cheo Coker, Martha Cooper, Craig "KR" Costello, Chuck D, Chucho, Cope 2, Cycle, Sparky D, Dalek, Andre LeRoy Davis, Dee DeLara, Jeremy de Maillard, Dennis Dennehy of Universal Music Group, Doc TC5, Tristan Eaton, Sally A. Edwards and Sarah J. Edwards, David Ellis, Buddy Esquire, EZO, Fafi, Faust, Shepard Fairey, Amber Fosse, Bob Frank of Koch Entertainment, Glen E. Friedman, Jim Fricke, FTD56 and KID56, Bobbito Garcia, Derek Gardner, Gerard Gaskin, Mike Giant, Michael Gonzales, Kenny Gravillis, Akisia Grigsby, the Estate of Keith Haring, Eric Haze, Myorr Janha of Phat Farm, Todd James, Sacha Jenkins, B.E. Johnson and Joy Day of Spherical Magic, Will Johnson, Jor One, Oliver Kahn and Valerie Delevente of Adidas, Kel 1st, Dave Kinsey and Blk/Mrkt, Lady Pink and Mr. Smith, Greg "SP One" LaMarche, Michael Lavine, David Lee, Spike Lee, Carlton "C.L." Lester, Laura Levine, Rebecca Levine, Amy Linden, Monica Lynch, Carlo McCormick, Ralph McDaniels, Jacob McMurray of the Experience Music Project/Science Fiction Museum and Hall of Fame, Dennis McNett, MAD, Mike Mack of Rap-a-Lot Records, Mad Mike of Galpin Auto Sports, Roberta Magrini of Sony/BMG Music Entertainment, Maurice Malone, Mare 139, Michelle Matthews of the Ford Motor Company, Maxx 242, MCA of Evil Design, Mint & Serf, Sara Moulton, Muck, Jarret Myer of Rawkus Records, Jason Noto and Doug Cunningham of Morning Breath, Fahamu Pecou, Phase 2, Posdnuos of De La Soul, Ricky Powell, Steven Pranica and Dominick King of Creative Exchange Agency, Lee Quinoñes, Quik, Antonio "L.A." Reid and Sandie Smith of Universal Music Group, Dr. Revolt, Simone Reyes, Brent Rollins, Scott Rubin, Denise Sandoval of California State University, Cara Santiago of Triple 5 Soul, Nika Sarabi, Mike Schreiber, Michael Segal, John Silva and Jen Hall at SAM, Joseph "Rev Run" Simmons, Russell Simmons, Franklin Sirmans, Dave Sirulnick and Ashley Mastronardi of MTV, Sket, Vincent Skoglund, Beverly Smith, Karyn Soroka, Jeff Soto, Dalton Sry, Bryan Stevens of the Petersen Automotive Museum, Charles Stone III, Matt Takei at BAPE, Jeff Staple, Sye TC5, Gavin Thomas of Nike, Mike Thompson, Michael Uman, Heidy Vaquerano of the Tupac Amaru Shakur Foundation, April Walker, DL Warfield, Tamara Warren, Winter Watson of Alfred Publishing, Armond White, Kehinde Wiley, Brad Willard of Delicious Vinyl, Angela Williams, Zulu Williams, Kiku Yamaguchi, Chris Yormick, and Zephyr.

ABOUT THE CONTRIBUTORS

BILL ADLER currently runs the Eyejammie Fine Arts Gallery in New York City. As the director of publicity for Def Jam Recordings and Rush Artist Management, he spent the latter half of the 1980s promoting the careers of hip-hop legends Run-DMC, the Beastie Boys, Public Enemy, LL Cool J, 3rd Bass, Slick Rick, and many others. In 2004, Bill wrote and produced *And You Don't Stop: 30 Years of Hip-Hop*, a five-part documentary history, for VH1.

The former editor in chief of Russell Simmons's *Oneworld* magazine, **RAQUEL CEPEDA** is a filmmaker and an award-winning editor and journalist. Cepeda is the director and producer of *Bling: A Planet Rock*, a feature-length documentary film about American hip-hop culture's obsession with diamonds and how this infatuation correlated with the ten-year conflict in Sierra Leone, West Africa. Cepeda is currently in production on *BLOW U.S. UP!*, a wartime concert documentary that delves into America's past to uncover truths about modern-day Iraq and Vietnam. She lives in New York City with her daughter, Djali.

CHEO HODARI COKER is a graduate of Stanford University, a former staff writer for the *Los Angeles Times*, a screenwriter, and the author of *Unbelievable: The Life, Death, and Afterlife of the Notorious B.I.G.* (Three Rivers Press, 2004). His favorite car was the second he ever owned, a 1966 Mustang, which he regrets selling every single day. He lives in Los Angeles.

Harlem native **MICHAEL A. GONZALES** has been down with hip-hop since he first head-bopped to DJ Hollywood in the summer of 1977. Since then he has become a king of urban media, penning cover stories for *Stop Smiling*, *Vibe*, *Essence*, *Latina*, *The Source*, and *XXL*. In addition, Gonzales has penned hip-hop fiction for *Bronx Biannual*, *Uptown*, *Ego Trip*, *Blackadelicpop.com*, *Brown Sugar*, Russell Simmons's *Oneworld*, *Trace*, and *Darker Mask*. Currently, he lives in Brooklyn.

SACHA JENKINS is a writer, painter, and television producer who grew up in Astoria, Queens. Graffiti has had a major influence on Jenkins, so much so that just thinking about it brings tears to his eyes. He is the editorial director of *Mass Appeal* and the Cofounder of *Ego Trip*, the classically trained hip-hop think tank.

Senior editor of *Paper*, **CARLO MCCORMICK** was the curator of *The LP Show*, which displayed some six thousand record covers to explicate the form's design history, and exhibited at Exit Art in New York, the Warhol Museum in Pittsburgh, and the Experience Music Project in Seattle. He lives in New York City.

FRANKLIN SIRMANS is curator of Modern and Contemporary Art at the Menil Collection in Houston and curatorial adviser at PS1 Contemporary Art Center, New York. A former editor of *Flash Art* and *Art AsiaPacific* magazines, he has written for several publications, including the *New York Times* and *Essence*. He was cocurator of *Basquiat* (Brooklyn Museum, Los Angeles Museum of Contemporary Art, and the Museum of Fine Arts, Houston, 2005–2006), *Make it Now: New Sculpture in New York* (Sculpture Center, NY, 2005), and *One Planet Under a Groove: Contemporary Art and Hip-Hop* (Bronx Museum of the Arts, Walker Art Center, Spelman College Art Gallery, and Villa Stuck, Munich, 2001–2003). He lives in New York City.

Motor City native **TAMARA WARREN** has written about pop culture, music, art, and cars for seventy-five magazines. Her articles have appeared in *Rolling Stone*, *Northwest Airlines*, *World Traveler*, *Men's Journal*, *Vibe*, *XXL*, *Remix*, *Juxtapoz*, *Forbes Autos*, *Ad Week*, and the *Detroit Free Press*. She lives in Brooklyn.

ARMOND WHITE, film critic for the *New York Press*, is an internationally published pop-culture author and curator. His books include *The Resistance: Ten Years of Pop Culture That Shook the World* (Overlook, 1995) and *Rebel for the Hell of It: The Art-Life of Tupac Shakur* (Thunder's Mouth Press, 2002). His annual music video program has been a mainstay of the Video Festival at the Film Society of Lincoln Center.

DEFINITION
THE ART AND DESIGN OF HIP-HOP

HarperCollins books may be purchased for educational, business, or sales promotional use. For information, please write: Special Markets Department, HarperCollins*Publishers*, 10 East 53rd Street, New York, NY 10022.

First published in 2008 by:
Collins Design
An Imprint of HarperCollins*Publishers*
10 East 53rd Street
New York, NY 10022
Tel: (212) 207-7000
Fax: (212) 207-7654
collinsdesign@harpercollins.com
www.harpercollins.com

Distributed throughout the world by:
HarperCollins*Publishers*
10 East 53rd Street
New York, NY 10022
Fax: (212) 207-7654

Library of Congress Cataloging-in-Publication Data

Adams, Cey.

DEFinition : the art and design of hip-hop / Cey Adams with Bill Adler.

p. cm.

ISBN 978-0-06-143885-1

1. Hip-hop--Social aspects--United States. 2. Subculture--United States. I. Bill Adler II. Title.

HN59.2.A33 2008

306.4'70973091732--dc22

2007050323

Book Design by Michael J. Robinson/Nowhere

Printed in China
First Printing, 2008

CREDITS

With the following exceptions, all artwork provided courtesy of the artists: p.9: Russell Simmons/Johnny Nunez Phat Farm ad courtesy of Phat Farm; Pages 24 25: © The Estate of Keith Haring; p. 30: David Ellis artwork courtesy of Savannah College of Art and Design; p. 33, near left: photography © William Nash; p.45, left: photography © Carlos Rodriguez; p.62.: Tone Loc's "Loc'ed After Dark," © 1989 Delicious Vinyl, LLC; p.64: Covers of Craig Mack's "Funk Da World" and Total's "Total" courtesy of Bad Boy Records, LLC; p.70: Cover of Run-DMC's "Raising Hell" courtesy of Sony BMG Music Entertainment p.72: Eminem's "The Marshall Mathers LP" © 2000 Aftermath Ent./Interscope Records, 50 Cent's "Get Rich or Die Trying" © 2003 Shady/Aftermath,Interscope Records, Young Buck's "Straight Outta Cashville" © 2004 G Unit/Interscope Records, Lloyd Banks's "The Hunger for More" ©2004 G Unit/Interscope Records, Mobb Deep's "Blood Money" © 2006 G Unit/Interscope Records, Lloyd Banks's, "Rotten Apple" © 2006 G Unit/Interscope Records; p.75: Goodie Mob's "One Monkey Don't Stop No Show" © Koch Entertainment 2004; p.75: OutKast's "ATLiens" courtesy of Sony BMG Music Entertainment p.79: *Ego Trip* photography © Bill Adler; p.85: photography © Eric Ogden; p.86 "Ladies First," Words and Music by SHANE FABER, QUEEN LATIFAH and MARK JAMES © 1989 WARNER-TAMERLANE PUBLISHING CORP., NOW& THEN MUSIC, WB MUSIC CORP., QUEEN LATIFAH MUSIC INC., FORTY FIVE KING MUSIC, FORKED TONGUE MUSIC and SIMONE JOHNSON PUB. DESIGNEE. All Rights on Behalf of itself and NOW & THEN MUSIC. Administered by WARNER-TAMERLANE PUBLISHING CORP. All rights on Behalf of itself, QUEEN LATIFAH MUSIC INC., FORTY FIVE KING MUSIC, FORKED TONGUE MUSIC and SIMONE JOHNSON PUB. DESIGNEE Administered by WB MUSIC CORP. All Rights Reserved. Used by Permission of ALFRED PUBLISHING CO., INC.; p.96: photography © Vincent Soyez; p.101: photography © Albert Watson; p.115: *Awesome: I Fuckin' Shot That* movie poster, courtesy of Oscilloscope Studios; p.118: "Sucker MC's" -- Words and Music by JOSEPH SIMMONS, DARRYL MCDANIELS, AND LARRY SMITH © 1987 RABASSE MUSIC LTD. and RUSH GROOVE MUSIC. All Rights in the US and Canada administered by WB MUSIC CORP. All Rights reserved. Used by permission of ALFRED PUBLISHING CO., INC.; pp.122-127, Used by Permission of MTV/PMP (Pimp My Ride) and Galpin Auto Sports, LLC, photography by Joey Julius for Galpin Auto Sports, LLC; p.132: photography of Funkmaster Flex © A.J. Mueller, courtesy of the Ford Motor Company; p.134: photography © Richard Drew, AP Images, 2005; p.146: Claw Money Nike Vandal and Blazer, photography © Haley Wollens; p.149, 172, A Bathing Ape Images © Nowhere Co., Ltd. p. 152: courtesy of Nike; p.154: all Carlton Lester sneakers, photography © April PhotoQueen Pabon; p.168: Dapper Dan photograph © John Pedin, *New York Daily News*, 8/25/88;

Page 188:
VINCENT SKOGLUND
Cey drawing in DUMBO, Brooklyn, 2006

CEY ADAMS
WWW.CEYADAMS.COM

ERIC BAILEY
WWW.BIRDSANDBULLETS.COM

CBABI BAYOC
WWW.BAYOCSTUDIO.COM

JANETTE BECKMAN
WWW.JANETTEBECKMAN.COM

BUTCH BELAIR
WWW.BUTCHBELAIR.COM

MICHAEL BENABIB
WWW.MICHAELBENABIB.COM

BLK/MRKT
WWW.BLKMRKT.COM

ANGELA BOATWRIGHT
WWW.KILLEROFGIANTS.COM

JUSTIN BUA
WWW.JUSTINBUA.COM

MR. CARTOON
WWW.MISTERCARTOON.COM

SETH CHEEKS.COM
WWW.SETHCHEEKS.COM

CHUCHO
WWW.CHUCHO-ARTE.COM

CLAW MONEY
WWW.CLAWMONEY.COM

MARTHA COOPER
WWW.NYCITYSNAPS.COM

COPE2
WWW.COPE2KINGSDESTROY.COM

CYCLE
WWW.CYCLEWASHERE.COM

DALEK
WWW.DALEKART.COM

ANDRE LEROY DAVIS
WWW.MELANININC.BLOGSPOT.COM

DOC TC5
WWW.TCFIVE.COM

SARAH J. EDWARDS
WWW.BLAGCOMPANY.COM

DAVID ELLIS
WWW.FRESHWATERCATFISH.ORG

EZO
WWW.THEGSPOTCOLAB.COM

FAFI
WWW.FAFI.NET

SHEPARD FAIREY
WWW.OBEYGIANT.COM

GLEN E. FRIEDMAN
WWW.BURNINGFLAGS.COM

GIANT
WWW.MIKEGIANT.COM

GRAVILLIS INC.
WWW.GRAVILLISINC.COM

AKISIA GRIGSBY
WWW.ADESIGNSINC.COM

KEITH HARING
WWW.KEITHHARING.COM

HAZE
WWW.INTERHAZE.COM

INFORM VENTURES
WWW.INFORM-VENTURES.COM

B. E. JOHNSON
WWW.IMPERIALEARTH.COM

KINSEY
WWW.KINSEYVISUAL.COM

KRINK
WWW.KRINK.COM

LADY PINK
WWW.PINKSMITH.COM

GREG LAMARCHE
WWW.GREGLAMARCHE.COM

LAURA LEVINE
WWW.LAURALEVINE.COM

MARE 139
WWW.MARE139.COM
WWW.STYLEWARS.COM

MAXX242
WWW.MAXX242.COM

BILL MCMULLEN
WWW.BILLMCMULLEN.COM

MINT + SERF
WWW.1134NYC.COM

MORNING BREATH
WWW.MORNINGBREATHINC.COM

MUCK
WEB.MAC.COM/MUCKHOUSE

FAHAMU PECOU
WWW.FAHAMUPECOUART.COM

RICKY POWELL
WWW.RICKYPOWELL.COM

QUIK
WWW.QUIKNYC.COM

BRENT ROLLINS
WWW.BRENTROLLINS.COM

NIKA SARABI
WWW.CADE2.COM

MICHAEL SEGAL
WWW.MICHAELSEGALPHOTO.COM

VINCENT SKOGLUND
WWW.VINCENTSKOGLUND.COM

SLANG INC.
WWW.SLANGINC.COM

JEFF SOTO
WWW.JEFFSOTO.COM

SYE
WWW.SYETC5.BLOGSPOT.COM

TEAM
WWW.KEENECARSE.COM

MIKE THOMPSON
WWW.MIKETARTWORKS.COM

TOY2R
WWW.TOY2R.COM

ERNI VALES
WWW.ERNIDESIGNS.COM

DL WARFIELD
WWW.GOLDFINGERCREATIVE.COM

KEHINDE WILEY
WWW.KEHINDEWILEY.COM

KIKU YAMAGUCHI
WWW.BABYALPACA.ORG

CHRIS YORMICK
WWW.CHRISYORMICK.COM

ZEPHYR
WWW.ZEPHYRGRAFFITI.COM